The Politics of Museums

New Directions in Cultural Policy Research

Series Editors: **Eleonora Belfiore**, University of Warwick, UK, and **Anna Upchurch**, University of Leeds, UK

New Directions in Cultural Policy Research encourages theoretical and empirical research which enriches and develops the field of cultural policy studies. Since its emergence in the 1990s, the academic field of cultural policy studies has expanded globally as the arts and popular culture have been re-positioned by city, regional, and national governments and international bodies, from the margins to the centre of social and economic development in both rhetoric and practice. The series invites contributions in any of the following: national and international cultural policies, arts policies, the politics of culture, cultural industries policies (the 'traditional' arts such as performing and visual arts, crafts), creative industries policies (digital, social media, broadcasting and film, and advertising), urban regeneration and urban cultural policies, regional cultural policies, the politics of cultural and creative labour, the production and consumption of popular culture, arts education policies, cultural heritage and tourism policies, and the history and politics of media policies. The series will reflect current and emerging concerns of the field such as, for example, cultural value, community cultural development, cultural diversity, cultural sustainability, planning for the intercultural city, cultural planning and cultural citizenship.

Titles include:

David Hesmondhalgh, Kate Oakley, David Lee and Melissa Nisbett
CULTURE, ECONOMY AND POLITICS
The Case of New Labour

Lachlan MacDowall, Marnie Badham, Emma Blomkamp and Kim Dunphy
MAKING CULTURE COUNT
The Politics of Cultural Measurement

Clive Gray
THE POLITICS OF MUSEUMS

New Directions in Cultural Policy Research
Series Standing Order ISBN 978–1–137–53305–0 (hardback)
(*outside North America only*)

You can receive future titles in this series as they are published by placing a standing order. Please contact your bookseller or, in case of difficulty, write to us at the address below with your name and address, the title of the series and the ISBN quoted above.

Customer Services Department, Macmillan Distribution Ltd, Houndmills, Basingstoke, Hampshire RG21 6XS, England

The Politics of Museums

Clive Gray
University of Warwick, UK

palgrave
macmillan

First published 2015 by
PALGRAVE MACMILLAN

Palgrave Macmillan in the UK is an imprint of Macmillan Publishers Limited, registered in England, company number 785998, of Houndmills, Basingstoke, Hampshire RG21 6XS.

Palgrave Macmillan in the US is a division of St Martin's Press LLC, 175 Fifth Avenue, New York, NY 10010.

Palgrave Macmillan is the global academic imprint of the above companies and has companies and representatives throughout the world.

Palgrave® and Macmillan® are registered trademarks in the United States, the United Kingdom, Europe and other countries.

ISBN 978-1-349-57753-8 ISBN 978-1-137-49341-5 (eBook)
DOI 10.1007/978-1-137-49341-5

This book is printed on paper suitable for recycling and made from fully managed and sustained forest sources. Logging, pulping and manufacturing processes are expected to conform to the environmental regulations of the country of origin.

A catalogue record for this book is available from the British Library.

A catalog record for this book is available from the Library of Congress.

To Mum and Dad,
Joan and Ron,
and to my sister, Claire

Contents

Figures and Tables

Figures

Tables

Acknowledgements

Many thanks in the first instance to all of those toilers in museums who have talked to me about the experiences and practices of their everyday work. My promise to preserve your anonymity prevents me from thanking you individually, but I am extremely gratefully to all of you for giving me your time and for your willingness to answer my questions and promptings. It would be perverse in a book of this sort, however, for me not to mention individual museums that I have enjoyed visiting (usually not for reasons of picking the brains of their staff). So, New Walk Museum and Art Gallery in Leicester (my local museum) should be much more widely recognised for its expressionist art collection (and *Mrs. Conder in Pink*) and local dinosaur fossils (long live the Barrow kipper, I say). The best home-made cakes are to be found in Wolverhampton Art Gallery, although the best place to eat is a toss-up between the Victoria and Albert Museum and the Wallace Collection. St Paul de Vence is the most scenically located that I have visited, even if you do have to walk a bit to get to the best bits of the walled town. The Rodin Museum has the most impressive garden if only for *The Thinker*, although the totem pole at the Horniman takes some beating. Every museum and art gallery, however, has something worth visiting and I still have a long list of places around the world that I would like to visit – maybe one day Chrissie and I will get to them all.

Thanks are also due to people from the Centre for Cultural Policy Studies at the University of Warwick – particularly David Wright and Ele Belfiore – for talking to me about the horrors of book writing (and that is the only example of irony that there is in this book), and how progress has been going in our various endeavours. In addition, Liz Brennan, Sarah Shute and Paula Wilkins have answered all of my technical questions and have been of inestimable help in answering my other questions concerning my administrative duties, both of which have made my job easier than it would otherwise have been. Thanks also to Charlotte Woodhead and Eric Jensen from Warwick University, Andrew Newman from Newcastle University, Lisanne Gibson from Leicester University and Vikki McCall from Stirling University who have all told me things about museums and museum practices that are derived from their own work and which have informed my own, and who have shared references, coffee, tea and cake at appropriate times. The librarians at

Warwick (particularly Richard Perkins, the only person whose e-mails I laugh at for the right reasons) and Leicester Universities were extremely helpful in pointing me in the right directions for information: many thanks to the staff in both institutions. Thanks also to my students, past and present, who have heard some of the arguments and ideas in this book already – your questions and patience have been much appreciated.

Chrissie, Caitlin and Laurie have been the usual supporting cast and have provided a welcome reminder that there are more things in life than book writing (even if they do not entirely share my particular enthusiasms in poetry, novels, history, crossword puzzles, 1970s/80s British jazz-rock/Canterbury music and jazz in general). This time, however, I am dedicating a book to my parents and sister. Mum and Dad took my sister and me to museums from a very early age – I still have vivid recollections of paintings by John 'Mad' Martin and Turner (of course) in the Tate, railway carriages in the transport museums in Swindon and Clapham (now all gone to York), musical instruments and shrunken heads in the Horniman, and dinosaur fossils and the dodo in the Natural History Museum. It has taken me a long time to get round to this book but Mum, Dad and Claire deserve my thanks and gratitude for helping to form my enthusiasm for all things museal, and while Mum and Dad are dead Claire continues to beat her own path – go get 'em, Claire, and never give up.

1
Museums and Politics:
An Introduction

Introduction

Concerns about the source of items in museum collections follow-
ing the abstraction of material from, and the outright pillaging of,
sites of antiquity in countries such as Afghanistan, Iraq, Cambodia
and China have certainly demonstrated that the heated arguments
about the Elgin marbles in the United Kingdom and the remains of
Kennewick Man in the United States have not produced conclusive
solutions to such concerns, even if they have contributed to the pro-
duction of present-day international codes of conduct to cover such
events. Being political, however, involves more than the simple pres-
ence of matters of contention – it also involves the mechanisms by
which these may be resolved, who is rightfully involved in producing
such resolutions, and the basis upon which they can then be justified to
local, national and international communities. To this extent it is not
the fact that museums are political institutions that is important but,
rather, how this political dimension of museums can be understood
and made sense of. This book is centrally concerned with providing
explanations of the multiple ways in which museums are political,
ranging from their relationship to globalisation and post-colonialism,
to how policy choices are made within individual museums, to the
role of professionals and members of the public in influencing what
occurs inside both the museum itself as well as the museums sector as a
whole.

What is evident is that the ways in which the politics of museums are
pursued varies according to the exact issue that is concerned and the
level at which these issues are dealt with. Thus the politics of conserva-
tion standards involves different sets of actors from those involved in

the preservation of intangible heritages, and the ways in which national governments manage their patrimony differs considerably from how community museums manage theirs. Identifying and explaining why these differences exist and what their consequences are for museums is thus a central concern in succeeding chapters. The means by which this identification and explanation is undertaken lies in both the development of a conceptual armoury to underpin the argument, as well as in establishing a focus for the discussion around a set of key questions. Both are provided in this chapter and the questions will be directly returned to in the concluding chapter to show precisely why and how museums are political entities.

The core concepts and ideas that are involved in this enquiry are developed from the fields of political science, public administration and public policy and are built around questions of power, ideology, legitimacy and rationality. These are then applied in terms of the way in which both the museums sector and individual museums intersect with the actions and choices of individuals – whether as elected or appointed policy- and decision-makers, managers, curators, conservators, education and outreach staff, volunteers and other actors (such as marketing and audience development officers) *within* particular institutions, or whether they are concerned as visitors, cultural tourists, customers, audiences, co-creators or tax-payers *external* to the specifics of the sector as a whole. What is, perhaps, surprising is that such an investigation has not been attempted before. While there are voluminous museums studies and heritage studies literatures – parts of which are directly concerned with matters of power, ideology and legitimacy – the politics literature is largely silent on the subject: Gray (2011) found the grand total of five articles on museums and galleries in a total of 413 years of publication in nine leading politics and public administration journals in the United Kingdom, and there appear to be only two books from political scientists (Luke, 2002; Sylvester, 2009) that are concerned with making sense of museums as direct sites of political action. This book fills this gap to demonstrate and explain both the political nature of museums and the political effects that they can produce.

To do this the focus will be on central areas of political analysis and on the following core questions: who are the key actors in the museums field? Which organisations have the largest effect on how the sector functions? How are the host of pressure, interest and community groups that exist incorporated into, or excluded from, the system? How is museums policy framed, understood and actually made? And which are the

political issues that are associated with the workings of individual museums and the museums sector as a whole? Discussion of these issues will vary from the general to the specific, from discussions of principles and values to specific examples of museum practice.

The current book, then, intends to demonstrate the limits of isolationist views that 'politics' should be kept away from the workings of museums and the museums sector in general and will show how an awareness of the tools of political analysis can illuminate the workings of the sector. As such the book provides an original analysis of the political meaning, content and consequences of museums as institutions and organisations and of the activities that are associated with them, as well as providing an alternative perspective on the subject to the dominant ones that are to be found in the heritage and museums studies literatures. This first chapter provides a general overview of how political analysis can illuminate the key questions concerning the museums world. It leads on in subsequent chapters to an investigation of how this world operates at the international, national and local levels, identifying key differences in how it functions and what the key issues are for the sector, at each level of analysis. A concluding chapter brings the discussion together by considering the overall implications of viewing museums as: sites for the exercise of political power; their role in the creation and maintenance of forms of technical, political and social legitimacy; their function as expressions of ideological and hegemonic preferences and practices; and their elaboration and presentation of particular rationalities and justifications for social action. Through this broad analysis I will demonstrate the role of museums as important, if largely underestimated, means for the exercise of a variety of political practices that have important consequences for societies and for their individual members.

What are museums for? (Part I)

A point of entry for a consideration of the political nature of museums can be found by returning to an old concern with functional analysis. In the present case this does not mean a return to the largely conservative political and sociological assumptions associated with forms of systems theory (Easton, 1953, 1965) and structural-functionalism (Parsons, 1937, 1951), both of which built upon ideas of societal and systemic necessity for explaining the organisation and functioning of social life, but, rather, with a more simple focus on what specific functions are undertaken within a particular organisational form. At this

level functionalism is simply a descriptive means to an analytical end, providing a map to the territory which is to be investigated. As will be seen, however, the existence of this map provides not only a geographical coverage but also the foundations for identifying a distinctly political view of the museums sector. In this context the functions that museums undertake can be divided between

- those which allow museums to carry out their multiple roles (*core*);
- those which can be seen to be inherent to museums as organisational forms (*intrinsic*);
- those which make use of museums and museum spaces (*use*); and,
- those which arise from the community and social effects that museums have (*community/societal*).

Desvallées & Mairesse (2010, 20) identify five major, individual, functions that are undertaken within museums: *preservation, research, communication* (incorporating *education, exhibition* and *mediation*), *management* and *architecture*. These, however, are largely confined to the first three functions, being descriptive of *what* is done in museums rather than of *why* they are done (with these functions being seen as intrinsically necessary to the museums field), or what the *effects* of doing them may be for society, and it is these latter questions that are captured in the fourth function.

Even though there can be considerable overlaps between them, these sets of functions operate and are understood in very different ways, with some being seen as part and parcel of the entire museum enterprise whilst others are either the intended or unintended consequences of the very existence of museums and the activities that are undertaken within them. This listing makes it clear that museums are multi-functional in orientation, even if it does not help to explain why and how this is the case. A more detailed examination of these functional groupings is required to provide a clearer understanding of the central political issues that are involved in both individual museums and the museums sector as a whole.

At the most basic level, museums undertake a number of functions that are specific to the internal requirements of their existence. Thus, museums are intimately concerned with the acquisition of collections and the preservation, conservation, display and exhibition of their collections, as well as their status as an educational resource. Indeed, the definition of a museum provided by the International Council of

Museums (ICOM) – the leading pressure group operating on behalf of museums around the world – and which was adopted in 2007, stresses these dimensions of their activity:

A museum is a non-profit, permanent institution in the service of society and its development, open to the public, which acquires, conserves, researches, communicates and exhibits the tangible and intangible heritage of humanity and its environment for the purposes of education, study and enjoyment.

(ICOM, 2013)

Alongside these 'intrinsic' functions are those which enable such central activities to be undertaken. These are largely administrative requirements that all organisations are expected to conform to for reasons of, for example, legal necessity (ensuring that relevant taxes are paid, for example, and that employment laws are abided by), or for reasons of 'good' organisational practice. In the latter case the attraction of visitors to museums, which is a perennial concern in the museums world and is frequently used as a measure of organisational performance, could be undertaken through a variety of marketing and audience development strategies and activities – and these are predicated on there being appropriate organisational arrangements in place to allow them to be undertaken (Rentschler & Hede, 2007). If museums are to exist, then, some combination of these functions is required to enable them to do their job – even if the museum were to exist only in a 'virtual' realm of representation through images or information technologies (Parry, 2007; Pollock, 2007) these 'core' functions would still be necessary and would need to be undertaken.

The third set of functions is concerned with other dimensions of the museums world. Firstly, they are concerned with the explicit uses to which museums can be put. The educational role of the museum, for example, is a long-established function for the sector, being recognised as such in the nineteenth century (Greenwood, 1888 [1996], 25–34; Hooper-Greenhill, 1991, 16–24), and continuing to be recognised today (Black, 2005, 123–75; Golding, 2007; Black, 2012, 77–142). In this instance museums can serve as both an alternative site to schools and classrooms for learning to take place within, and as a provider of resources – in the form of the contents of the museum's collections – that would usually be beyond the reach of most teachers and learners. Whether this educational role is central to the museum enterprise in its own right, or whether it is an example of an instrumentalisation of

the museum for the attainment of non-museum ends that deflects the focus of museum staff away from collections acquisition, conservation and display is a question that cannot be simply answered by *fiat* (Gray, 2008), even if the general assumption is that education is not only central to the museums sector but is actually an intrinsic component of it, as Desvallées & Mairesse (2010, 20) argue. However, a consideration of the wider roles that museums can be seen to have that extends beyond their own walls is required to establish whether this centrality of education is a matter of political choice or imposition, or whether it is, in fact, an inescapable component of the sector. In either case, however, museums are being *used* for educational purposes and not necessarily for museum ones.

In the same fashion, the fear that museums have become part of a generalised arena of cultural and creative industries that are as much focused on entertainment as they are on their collections is concerned with the range of functions that they are involved with and the ways in which their contents and buildings can be utilised for multiple purposes that extend beyond the idea of 'core' and 'intrinsic' functions. The mounting of concerts in museum spaces, for example, as seen by the performances of Kraftwerk at the Tate Modern in London, could be seen to be either an example of the selling-out of museums to the forces of neo-liberal ideology (McGuigan, 2005) or to more specific private interests (Janes, 2007), or as an example of the creative use of otherwise redundant space during the hours that museums are normally shut, thereby providing income for the museums concerned and potentially broadening their visitor base (Merriman, 2012, 47). The fact that such activities have been taking place in museums since the nineteenth century appears to have affected only the nature of the specific arguments that take place about the issue; these are largely dictated by the common division in the cultural field between the intrinsic and extrinsic nature of action in terms of 'core' and 'other' functions. In practice, the core argument is also pitched in terms of *who* museums are dealing with.

The common claims that museums are largely focused upon the core interests of particular social groups, and that their operations are predicated upon some idea of the public interest – the ICOM (2013) definition, for example, excludes all profit-making museums (as well as any number of transient, virtual and mobile collections) which are assumed to be working for private interests – raises all sorts of questions about the purposes of museums as well as about *which* publics they *can* be, or *should* be, aimed at. The new museology, starting in

the United Kingdom and the United States in the 1960s and France in the 1970s (Desvallées & Mairesse, 2010, 55), sought to shift the focus of museums away from the internal world of collections and buildings towards the societies and communities that they were a part of, and, as part of this ideological shift, the number of names for those who interacted with museums increased, providing a differentiation that extended far beyond a simple division between 'visitors' and 'non-visitors' to incorporate, for example, audiences, customers, stakeholders, co-creators, participants, learners, funders and clients alongside other labelled groupings. This fragmentation of focus is associated with a rethinking of what the functions of museums actually are: what are appropriate functions, for example, for a set of learners need not be the same as those for customers or co-creators. At the very least this reinforces the idea of the museum as providing a set of multifunctional activities that are intended to fulfil multiple purposes for multiple sets of actors, but it also shifts attention to the social, economic and political uses to which museums can be put. One of the more explicit recent examples of this could be found in the use of museums in the United Kingdom as mechanisms for social inclusion (Sandell, 1998; Newman & McLean, 1998, 2002, 2004; West & Smith, 2005; Tlili, 2008; McCall, 2009) where museums were encouraged to view part of their social role as being to incorporate socially disadvantaged and disconnected groups into their activities so that they could be meaningfully involved in the wider social world that they were a part of. While the new museology had already forcefully argued for such a social role for museums and museum professionals (Harrison, 1993; Stam, 1993) it is not always evident that this has actually been put into practice except partially and only in some museums (McCall & Gray, 2014), indicating that there is not necessarily a clear agreement about the functions and roles that museums might be seen to have. The existence of these disagreements about functions and roles raises questions about the exercise of power within the museums sector – and also asks questions about whose values and ideas are seen to be the dominant ones within the sector, and how the distribution of power and the exercise of ideological control are provided with the legitimacy and justification that is necessary to allow them to function as they do. These concerns are covered in detail in later chapters and are clearly part of the general conceptual realm of political analysis and require some clarification to establish how they can be usefully employed in the analysis of museums and the museum sector.

Museums and power

To claim that museums can be both the sites where the play of power is worked out and the means through which power is exercised is, equally, to state a pair of truisms and to identify different ways through which power enters the museums sector. To change the focus, it can be argued that there is both a structural and a behavioural dimension to the matter of the relationship between museums and power: museums can be seen to establish a means to represent the manner in which power is distributed within societies in terms of what is believed to be worthy of exhibition within them, the manner in which this exhibition takes place, and whose interests are represented within these exhibitions. At the same time, the mechanisms through which these things are done depend upon how individuals and groups make their decisions, the basis upon which these decisions are made, and the means through which these decisions are then put into practice. In this respect, power is centrally concerned with the key questions of who the key actors are in the museums field, which organisations affect its functioning and how interests are represented within it.

Power itself is not necessarily tied in with the simple possession or lack of possession of particular physical resources such as money or property: it can equally be dependent upon social characteristics such as gender or ethnicity that are not directly transferable in the same way that physical resources can be. Equally, it can be dependent upon social attributes such as status and prestige that can be transferable but not through the same exercise of legal property rights as are usually involved in the transfer of physical resources. These social characteristics and attributes can, and do, affect the ways in which physical resources are distributed within societies and they also contribute to the establishment of the social significance of different behavioural and structural settings within which social life takes place; and, while there are questions that can be raised about the difference between power and influence (Morriss, 2002; Hearn, 2012), the basic idea that there are differences in the sources of power remains in place. At this level the emphasis is on how power is *distributed* within societies rather than with the *nature* of power itself but both need to be considered to establish the terrain within which the exercise of power *actually* takes place.

The distinction between 'power to' and 'power over' is the starting place for this consideration: there is a difference to be drawn between getting one's own way through positive action and controlling the nature of the debate so that effort is not actually required to attain one's

ends. Lukes (2005) argued that there are three dimensions to 'power' – the actually observable exercise of power in the making of decisions (2005, 19); the use of power to prevent decisions being made over potential issues (2005, 24–5); and the use of power to control the political agenda in such a way that potential issues are excluded from consideration in the first place (2005, 28). The first of these is concerned with 'power to' attain one's ends, and the last is concerned with 'power over', where the grounds for decision are controlled in such a way that 'power to' does not need to be exercised. The second dimension is effectively an intersection between these two forms of power where 'power to' is used to control 'power over'. Morriss (2002, xiii–xiv) argues that in practice both forms of power require analysis if a broad understanding of its uses at both the individual and societal levels is to be gained.

While Lukes (1986) is concerned with the relationship of power with specific outcomes, the interests of individuals and groups of actors, and the location of power within social collectivities – all of which are concerned with the 'power to/over' distinction – others have argued that power can be conceptualised in ways that point in other directions of interest. Thus Hindess (1996) discusses power in terms of the capacity to act and the right to act – which raises questions about legitimacy and the exercise of power – while Mann (1986) concentrates on identifying particular bases (economic, ideological, military and political) upon which the exercise of social power rests. It has also been argued that the work of Foucault sees power not as 'the property of particular classes or individuals', nor as an 'instrument' for people to use but, instead, as a set of 'structural relationships – institutions, strategies and techniques' that are built into every element of social life (Garland, 1990, 138). In this view what requires analysis is the nature of these structures and their consequences rather than more traditional political concerns such as the sources of and distribution of power. In some ways this structural analysis could be seen as simply a variant of the 'power over' concern, with a strong measure of implied ideological analysis being required to make sense of the means by which the structures of power affect the lived realities of everyday life (as in Foucault, 2002, where this is evident). These variants in understanding the nature of power – as a mechanism affecting social interaction; a capacity; a social characteristic; or a structural phenomenon – open the possibility for multiple analyses to be undertaken of power in action. The ways in which power is utilised and structured, and their associated social mechanics, can lead to very different ways of thinking about power – not only in terms of the 'power to/over' distinction, but also in terms of the motivations behind the uses

of power and the consequences that its exercise can give rise to. These complexities need to be borne in mind when we think about the ways in which power operates within, is produced by, and affects the operations of museums as both individual institutions and as a policy sector. An alternative starting-point for considering the question of power and museums derives from an examination of the practical exercise of political and policy choice. In this context the relationship of power to the forms of ideology, legitimacy and rationality that underlie its use requires investigation. The ways in which particular versions of ideological values, attitudes and beliefs become either accepted by or are imposed on the members of a social collectivity, the forms of legitimacy that are required to allow these ideological factors to become accepted as the basis for making choices and for accepting the particular choices that are made within and for societies, and the particular rationalities that are used to justify specific courses of action, are all dependent upon the exercise of power in one way or another. 'Power to' allows for the actual choice of ideology, legitimacy and rationality in the first place, while 'power over' incorporates the ways in which these factors can be seen to influence the specific political and policy choices that are then made within societies. In the case of the latter, for example, Smith (2006, 11) has identified

> a hegemonic discourse about heritage which acts to constitute the way we think, talk and write about heritage... (it) promotes a certain set of Western elite cultural values as being universally applicable,

and this has the consequence of allowing for a depoliticisation of issues of heritage in favour of a technical rationality that delegitimizes 'cultural and social claims on the past' (Smith, 2004, 11). Viewing ideology, legitimacy and rationality as macro-level mechanisms through which power can be exercised and justified is a relatively mundane position to hold; but it does, however, raise questions about the precise ways in which the interactions between power, legitimacy, rationality and ideology take place: which people and institutions are involved in these activities and how do they get them accepted as being the 'right' or 'best' ways to function?

This shift in focus towards the specific uses of power – power 'for' in effect – raises more traditional political concerns with how power is distributed within societies as a whole as well as with how it is distributed within particular arenas of policy and political action. While societies as a whole could be characterised as having relatively pluralist

or elitist forms of power distribution, it is also possible for quite different distributive patterns to be found within particular policy sectors or technical arenas, depending upon the nature of the actors involved in the process, the role of governments, how access to the policy system can be understood, the structural and technical composition of the sectors involved and the principles upon which action is predicated. These concerns imply that there will be no simple pattern of power distribution that operates in the same way at all times and in all places. At the very least a consideration of the relationship between macro-level (societal), meso-level (sectoral) and micro-level (institutional) distributions of power are informative about patterns of activity that could be expected to take place at each level, as well as asking questions about why and how differences and similarities between them are generated, and these form the focus of Chapters 2–4.

A focus on the distribution of power reflects a concern with the structural dynamics of political action that might be thought to be quite distinct from a concern with the uses to which power is actually put. In practice the two are intimately connected: structure may provide the framework within which particular choices are made but, equally, the choices that are made will also affect the structures that exist. This interplay between structure and agency affects the ways in which the museums sector operates. In some cases it will be apparent that the structural dimension has a dominant role in establishing what might be seen as examples of new institutionalist path dependency (Cairney, 2012, 76–9), where individuals have little direct control over what occurs, and past choices limit present-day room for manoeuvre. In other cases, the specific choices and actions of individuals and groups will clearly be seen to have the dominant role in making things happen, with Fyfe (1996), for example, arguing that galleries have not only institutional and structural dimensions that constrain what occurs within them, but they also act as creative agents in the production of cultural meaning for societies, indicating that it is not simply the case that museums are confined by the structural limits that are imposed on them by external societal and political forces and the weight of the past. The ability of museums and their staff to actively manage and control the demands that external actors place upon them (Lawley, 2003; West & Smith, 2005) can lead to outcomes that usually have unintended consequences for all the parties involved, and this casts doubts on the mechanistic view of structural constraint that is implicit in the path dependency metaphor. The reasons why the centre of political gravity can be seen to shift between cases and over time, even within the same organisation and/or country,

has important implications for understanding both the specific and the general politics of the museums sector.

In terms of the general distribution of power within political systems and museums sectors there are few core generalisations that can be safely made: the relationship between the societal and the sectoral needs to be examined in specific detail to make sense of the variations that exist in practice. Indeed, even within a single country's museums sector there can be distinct differences in how power is distributed: national and local museums, for example, are often managed differently, and the expectations of museums at different geographical levels can be quite distinct. National museums are quite often used to make particular political claims about nationhood and the meaning of nationality (amongst many other things) (Knell, 2011), whilst local museums are seen to have a different focus on local identities and 'the popular symbolism' (Hill, 2005, 32) of communities. While these are both concerned with the representation of the self to the members of social collectivities the focus of the respective efforts (the national and the local), and the meanings that they contain (both tangible and intangible), are distinct in each case, and these differences are, in part at least, reflective of different power distributions between the local and the national levels, different intentions behind how power is used and different assumptions about what the utilisation of power can achieve.

If particular generalisations are potentially misleading about the specifics of any given case, is the implication that all that can be meaningfully produced are a series of case-studies to show how power functions? This rhetorical question raises issues of ontology and epistemology that will not be addressed here (although see Moses & Knutsen, 2007; Gray, 2010). Instead, a number of empirically and theoretically informed hypotheses can be used to provide a basis for making sense of the complexities of power in the museums world. In common with the rest of the general cultural sector museums are rarely of any great centrality to the activities of governments and states. This lack of policy significance for culture (see Gray & Wingfield, 2010) does not, however, mean that museums are consequently politically unloved and uncared for. The perceived importance of museums in symbolic terms for expressing identity and conveying meaning as well as for their functions as preservers of the past (Wilson, 2002), providers of educational opportunities (Hein, 1998), creators of social improvement and/or development (Dewdney *et al.*, 2013), and producers of economic regeneration (by no means as new a phenomenon as might be thought: see, for example, Lorente, 1996, 36–7) provide multiple justifications for

supporting them, and politicians of all shades in the political spectrum have given vocal – and occasionally vociferous – support for museums in both general and specific terms.

At the same time that museums and museum sectors are supported by political representatives they can also become the subject of political debates that are not concerned with the specific details of how they operate but, instead, with their status as representatives of broader political concerns. These debates are usually ideological in nature, and museums can become symbolically representative of core beliefs and values within societies and their political systems. Whose ideologies carry the day is rarely a matter of the validity of the positions that are at stake – or even, at times, their logic – and much depends upon the distribution of power, and the uses to which power is put, within societies. The same argument is valid when the issue of legitimacy is considered, as the developing concern since the mid-1980s with the relationship between particular communities and their tangible and intangible heritages makes clear. This issue has implications for most traditional museums, particularly those that are claimed to be 'universal' ones which protect and exhibit artefacts that are of common meaning to all humanity (itself a deeply ideological position to hold). The 'right' of museums to retain control of material that has deep significance to communities for religious, spiritual or ritual reasons – however long ago it was collected – has led to much discussion over issues of ownership, restitution, morality and ethics, and these are largely determined as individual cases (Handler, 1985; Crooke, 2007; Gulliford, 2007; Hill, 2007; Diakhate, 2011; Harrison, 2013), although the increasing significance of UNESCO in this area should not be underestimated (see Chapter 2). Again, the exercise of 'power over' rather than 'power to' is a key component of these discussions as these issues are rarely decided by the exercise of 'might is right' but much more often by appeals to general ideological principles and values. Clearly, these questions of ideology are closely tied in with the examination of the exercise of power, and it is to this that the focus of discussion shifts.

Museums and ideology

If ideology is taken as the active expression of values, norms and beliefs within societies it would be difficult to imagine a position where museums could *not* be ideological in one way or another. Claiming that museums are ideological is not the same, however, as demonstrating that this is actually the case, and while some of the preceding discussion

provides examples of how ideology can be seen to be important to the sector, a broader discussion is required to demonstrate why this concept is central to understanding the politics of museums, particularly in terms of the core question of how museums policy is framed, understood and made.

The content of ideologies can vary greatly from the values that underpin broad philosophical positions, such as humanism or the enlightenment, to various ontological positions that affect how the world is understood and may be interpreted, such as positivism or realism, to more specific combinations of values, norms and beliefs that form the content of political frameworks such as conservatism, liberalism and socialism and which provide a set of motivating predispositions to action and inaction in particular cases. The intersection between these versions of 'ideology' can serve as a means to reinforce the acceptance or rejection of particular political, social, economic and policy choices that social actors may decide to make. In practice it is rare for policy decisions to be simply the result of ideological predispositions – although examples do exist where there is such a clear linkage, ranging from varieties of 'official' art in the Soviet Union (Zhdanov, 1950) to the results of the 'culture wars' in the United States (Hunter, 1991, 225–49). More commonly, a range of intervening variables affects the movement from ideological predisposition to actual practice. Indeed, arguments deriving from the Gramscian notion of hegemony (Gramsci, 1971, 57–60, for example; Adamson, 1980; Bocock, 1986) assume that the sphere of ideology is itself an arena of political struggle and it is through ideological conflict that cultural norms and social relations are created: the implication here is that everything is ideological, which means that it is difficult, if not impossible, to draw any distinction between ideology and the totality of everyday life. At the same time it means that no meaningful distinction can be drawn between ideological effects and those that are generated by other social or intellectual sources of action, change or stasis. In this case analyses that attempt to identify multiple causal mechanisms for complicated social activities become rather pointless exercises. While not identifying the actual complexities of social activities can simplify analysis it does not help to develop more nuanced explanations of social action: what is required is some means of understanding how ideology has both specific and general effects on museums and the museum sector without lapsing into oversimplifying generalisations. A distinction between different dimensions of ideology will be used for these purposes.

Firstly, a view of ideology as a set of ontological choices and predispositions has implications for how an analysis of the political nature of museums can be undertaken. A positivist orientation, for example, posits a straightforward relationship between 'facts' and reality: the former are objective phenomena that can be used to understand and explain the latter. The consequence of this is that analysts would be seeking to identify the 'facts' as a basis for explaining how and why things are as they are within individual museums or within the museums sector as a whole (Chalmers, 1999, 1–18) and what can be done about these things: a position often to be found in, for example, economic analyses of culture and heritage that employ quantitative methodologies (Frey, 2003; Peacock & Rizzo, 2008). A constructivist ontology, on the other hand, would be more concerned with how individuals understand, for example, the relevance of tangible and intangible heritages for their own sense of self-worth or their place within neighbourhoods, communities and societies (Smith, 2006) often through qualitative or, more generally, phenomenological methodologies. Regardless of the precise differences between ontological positions they have clear implications for the meanings that are attached to particular policy outcomes, how these will be evaluated and how they will be made use of.

Secondly, a view of ideology as sets of normative concerns concerning what is seen to be 'right' or 'proper' or 'correct' adopts a different understanding of how ideology functions. This position is concerned with mapping sets of core values that can serve as a basis for guiding 'political' action, inaction and choice. At the most basic level, for example, this could involve expressions of what role the state should be expected to adopt towards intervention in the museums sector and whether or not the state should affect the choices that are made within individual museums. More generally it involves consideration of the relationships that should exist between the state and citizens, either collectively or individually. There can be no doubt that normative beliefs based around principles of individualism lead to different results in comparison with those derived from a collectivist set of principles, even if at one remove from the central normative issues that are involved. Beliefs, for example, that are based upon normative arguments about the importance of the autonomy of art and sport – as in the case of claims for maintaining 'arts for art's sake' (Royseng, 2008) and for 'keeping politics out of sport' (see Allison, 1986, 17–21) – lead to the creation of clear sets of policy presuppositions that are only indirectly concerned with the role of the state in society. In these examples the underlying normative principles are concerned with the autonomy of art and sport, not with the

general relationship of states and citizens that is to be found in the ideological position of, for example, individualism, even if this is implicitly present within these principles. This is a question of the relationship of the specific to the general and implies that ideologies are not necessarily simple and clear-cut sets of positions but are, instead, made up of multiple component parts. Thus positions on liberty, choice, the nature of political organisation, the social responsibility (or otherwise) of individuals, and autonomy – as well as matters of free will – can all be seen as contributing to the overall normative beliefs that are to be found within societies.

A third view of ideology exists in the form of specific political ideologies that are used to organise and justify matters of policy choice. These ideologies overlap with both the ontological and normative dimensions in so far as they contain ideas about the nature of social reality and action and provide detailed claims about power and its distribution, and the roles of citizens and states within societies. Between them these provide the basis for an understanding of the willingness or reluctance of governments to intervene in the museums field in the first place, and for an understanding of the choices that are then made about the individual policies that the sector requires. At the most trivial level this can be seen in the relative reluctance of national governments in the United States to directly intervene in the making of museums policies for the entire country. This stance is related to a party ideological position that emphasises limited government, federalism, individualism and individual liberty, and a financial conservatism that is dubious of the merits of public expenditure (Alexander & Rueschemeyer, 2005, ch. 2; Mulcahy, 2006; Peters, 2007, 15, 22–6; Rushefsky, 2008, 24–7, 36), all of which militate against an active and interventionist government. Even in the general field of heritage itself, where the federal government is much more important in terms of setting the agenda for public action, there are real limits to the extent to which the actual practices of the federal government serve as an effective guide to action for the individual states of the Union (Smith, 2004, 13, 143). By contrast, French governments have been much more directly active in the museums sector (Poulot, 2009), a stance closely related to ideas of 'national culture' (Looseley, 1995, 11), patronage and dirigisme (Eling, 1999, 1), universalism (Kiwan, 2007) and democratisation (Looseley, 2005), all bound together by the slogan 'liberté, égalité, fraternité' and the idea of the 'one and indivisible (French) Republic' (Hayward, 1983). Such a characterisation of national differences does not, however, explain precisely how and why these particular sets of values and norms contribute to

levels of state intervention or, indeed, whether it does anything more than establish a set of national stereotypes. This note of caution indicates that a simple direct equation of ideology with policy action needs to be treated with some care.

A fourth view of ideology is concerned with how it is embodied and practised through the representation, exhibition and display of tangible and intangible forms of material in the museum context. The content of these activities, and the ideological statements that can be identified within them, can both be used as mechanisms for making general statements about what is seen to be worth preserving and exhibiting as well as for the production of sets of statements about what the collection 'means'. This view of ideology derives from the view that museums are a set of 'texts', the meanings of which have to be unearthed through their effective 'reading'. This view is derived from a combination of post-structuralist, cultural studies and literary criticism approaches to cultural analysis, and has been used to identify the ways in which political and social beliefs and practices are given effect through the choices that are made about what is displayed in museums and galleries and how it is displayed. The furore, for example, about the Enola Gay exhibition at the Smithsonian Institution in 1995 that dealt with the dropping of the first atom bomb and the start of the Cold War raised questions about what, how, and why it would be shown (Zolberg, 1996; Gieryn, 1998), with the final display giving rise to heated debate about each of these issues. The role of museum displays in affecting what are to be seen as key issues and lessons for the members of present-day societies has been recognised for many years (Hooper-Greenhill, 1992), and changing display practices are seen as being important in questioning the meanings that exist within museums (McMaster, 2007) In this respect museums are the sites within which ideology is displayed just as much as they are sites where collections of artefacts are displayed. In addition to this museums are also sites where meaning is actively created (Mason, 2005; O'Neill, 2012, 40) and, by extension, are sites which actively contribute to the overall ideological underpinnings of societies.

While it is possible to identify different ways in which ideology exists within the museums sector, in practice it is difficult to demonstrate the precise mechanisms through which ideological effects take place (Gray, 2011, 48–9), even if at a common-sense level it would appear to be obvious that they do exist. Neither is it the case that the relationship between ideology and policy is unidirectional. While ideology can function as a structural constraint upon policy choice (Gray, 2014) it is also the case that policy can be used as a mechanism to

reinforce ideological preferences within societies through the provision of practical effects that demonstrate how relevant these ideologies are to individuals, groups and entire societies. Equally, policy can be used as a means to change ideologies themselves through their utilisation of new beliefs, norms and values as means to justify and legitimise policy choices. While the most obvious example of this can be found in states where effectively revolutionary governments assume power and pursue radically new ideological paths (see Chapter 3), it can also be seen in circumstances where there are more simple shifts in emphasis within continuing prevailing ideological conditions. Thus, recent arguments about the increasing dominance of 'neo-liberal' ideas in the field of culture (McGuigan, 2005) are more concerned with a second-order ideological effect within the context of a continuing, and dominant, liberal-democratic capitalist ideology rather than with the introduction of a completely new ideological formation. At the very least this indicates that there are multiple connections between ideology and policy that are based upon complicated causal relationships, and an analysis of the role of ideology in the case of museums is no exception to this. The importance of ideology for the functioning of the museums sector can be illustrated by examining the third major concept to be considered here – legitimacy.

Museums and legitimacy

The various uses of ideology to provide core sets of values, norms and beliefs to underpin policies and political practices are intimately related to the nature of the legitimacy that justifies their utilisation. This justification must be actively granted (or, at least, consented to) by the members of any social group that operates within this ideological setting. The rules for social conduct and organised action may be derived from ideological preferences, but getting them to operate with any effectiveness depends upon the willingness of societal members to abide by them. While this may seem to be rather a trivial point – without agreement about the rules then social life becomes immensely difficult if not quite leading to a life that is 'solitary, poore, nasty, brutish, and short' in Hobbes' terms (1997 [1651], 70) – the consequences of failing to establish and maintain such an acceptance can be politically catastrophic for any system of power relations and organisational rule, as the experience of revolutionary change effectively demonstrates. Indeed, one of the defining characteristics of revolutions is the replacement of one set of ideological underpinnings for a particular political, social and

economic system by an alternative that re-establishes an acceptance of the exercise of authoritative power by some over others. While this can be most starkly seen in full-scale revolutions – such as the classic examples of the French, Russian and Iranian revolutions (Krejci, 1983; Skocpol, 1994) – it can also be seen in smaller-scale changes that only affect some parts of the existing system, but which are designed to allow for a regeneration of legitimacy that can provide a basis for effective rule to be exercised. Such changes could vary from reforms of electoral systems to enfranchise previously excluded groups, to reallocations of functions between tiers of government to allow local communities a greater or lesser degree of control over the services that they can provide to the public. In this respect the development of forms of critical museology that are committed to the opening up of museums to newer forms of participation and management (Barrett, 2011) have a directly legitimising function through the demonstration that museums are for everybody – including groups and individuals who were previously seen to be excluded from them. In a similar vein, the 'new museology' (Vergo, 1989; Harrison, 1993; Stam, 1993) was not only concerned with opening up, and 'democratising', the museum but was also concerned with providing a mechanism for the creation of a new legitimacy for the museums sector as a whole.

It is important to recognise that internal changes to policy systems do not necessarily need to be positive ones for any particular group within a society so long as the changes concerned produce an overall effect that allows the system as a whole to function effectively. In this respect policies that actively discriminate against particular groups could serve to provide legitimacy for societies as a whole – provided that the members of society actively accept the validity of the changes that have been introduced. The potential of this to lead to the oppression of minorities through the exercise of majority power is a well-recognised problem for liberal and liberal-democratic ideology (Mill's, 1974 [1859], 62–3, comment on 'the tyranny of the majority' being a classic statement of this) and one that cannot be overcome by simple appeals to people to exercise their better natures. Instead, an appreciation of the principles upon which legitimacy rests is required to understand the ways in which it may function to allow for the effective exercise of political (or social, or economic, or technological) power within societies to take place in such a fashion that active consent to such systems of rule can be generated. In this respect legitimacy is a core concept for understanding all the central questions for the politics of museums that were outlined earlier.

The usual starting-place to discuss the principles upon which legitimacy rests derives from Weber's arguments (1978, 212–99) about the nature of authority in societies. In this line of argument legitimacy derives from the beliefs that are held by people about why they should obey the decisions of policy-makers. Such beliefs may derive from the personal characteristics of the policy-maker (charismatic authority), the sanctioning of particular systems of authority through custom and usage (traditional authority), or from the system of formally established rules and laws that have been developed to regulate social action (legal-rational authority). Other bases for legitimacy can also be identified, such as legitimation through discussion or ideological imposition (itself a form of hegemony) (Goldfarb, 2012, 44) or through forms of patron–client relationships, but these are less commonly analysed (Hearn, 2012). In the Weberian tradition, so long as power-holders act within the accepted form of authority – so that decisions within a traditional system of authority are justified by reference to the sources of that tradition – legitimacy more or less automatically follows. If, however, things were that simple in practice then it would be difficult to explain either why challenges to legitimacy arise or why one form of legitimacy can become replaced by another. The underlying principle is that a given pattern of legitimacy will remain in force for as long as the decisions and policies that are produced within it are seen to be effective and efficient by the population that they are being imposed upon, and the system of authority that is in force continues to be acceptable to the population (Johnson *et al.*, 2006). Failures in either case – such as failures of traditional authority systems to deal with rapid social change, or when the death of a charismatic leader creates a power vacuum that cannot be filled by other individuals – will lead to changes in how legitimacy is given force (see, for example, Weber, 1978). In all this there is an assumption that legitimacy derives from a form of instrumental, means–end, rationality, with its basis resting upon the ability of the established authority system to provide sufficient justification for its continuation in terms of both the logic of the system and the policy requirements of society at large.

In these circumstances the nature of these policy requirements also requires examination if the meaning and principles of legitimacy are to be understood. These requirements are not simply dependent upon the general authority system that is in place, they also depend upon the specific political system that is present: both theocratic and monarchical systems can be understood as resting upon forms of traditional authority but they also rest upon different mechanisms for their justification;

the former is usually to be found in works of religious authority and the latter upon rules and principles of inheritance sanctioned through past traditions and customs. (The latter of these can also be seen to have a basis in forms of legal-rational authority in so far as rules of primogeniture, or the use of Salic law to determine inheritance can have a substantial impact upon precisely who can inherit: see Finer, 1997, 75.) The relative infrequency today of either of these traditional forms of government means that concerns with their legitimacy are of less significance for most people than are the justifications for legitimacy that are claimed by governments based on varieties of legal-rational authority. While such governments can be of many different forms – authoritarian, liberal democratic, constitutional monarchical, military, single-party and so on – they all make reference to sets of constitutional rules and the rule of law as the underlying principles that provide them with legitimacy. This may, of course, sound surprising in the context of military governments but it is often, if not normally, the case that the military justifies its overthrow of civilian governments by reference to the need to maintain the existing constitution or to replace a government that, it is argued, has itself been playing fast and loose with the law and constitution (see Finer, 1976, 243, for a summary of military justifications for intervention into civilian politics). In a similar fashion, the idea that curators in museums provide some form of unimpeachable authority in terms of the choices that they make about displays, exhibitions, labels and information has come under increasing strain in recent years (McCall & Gray, 2014), with many new sets of actors claiming their own legitimacy to tell their own stories within museums and galleries (see, for example, Smith, 2006; Crooke, 2007). The basis upon which all the groups concerned justify their claim to control what is shown, how it is shown, and who it is shown to, depends upon the making of claims about the legitimacy of their status in terms of the rules and principles that they see as being relevant to their own case – and these may not rest upon the same legal-rational basis that current museum and gallery practice does. At their core the debates that are generated by the claims and counter-claims that are involved in this process are concerned with the political issues of who has the power to make to make decisions, and normative statements and beliefs about who *should* have the power to make them. At this level questions of legitimacy inevitably spill over into broader political issues of power, ideology and control.

Beetham (1991, 100–14), for example, has argued that an understanding of the maintenance and reproduction of legitimacy within societies extends beyond the simple facts of authority structures and requires an

analysis of the ways in which power relations and the choices of active social agents affect the structural and structuring roles that authority relations have. The mutual interdependence between power and legitimacy in this respect becomes another question of the relationship between structure and agency in social life. The emphasis that Beetham (1991, 16) places on the 'moral grounds' that underpin the acceptance of the subordination of some to others within societies extends to the importance of these grounds for the continued active granting or withholding of legitimacy by actors within the system. Rather than being subjects to a power that is effectively imposed upon them with few, if any, opportunities to exercise choice over the nature of the structures that they are enmeshed within, individual citizens can become active participants in the process of making and re-making the social contexts within which they are operating, as well as in creating the meanings that they attach to these activities. As such, rather than citizens being constrained beings who only have the freedom to adopt the chains that bind them (as in the more structural versions of Foucault's (1977) analyses of self-discipline – as seen, in the case of museums, in Bennett, 1995), they can instead be seen to have an active role to play in making and remaking the worlds that they inhabit (as in, for example, Bourdieu, 2010, 563). This active choice is, itself, tied in with the legitimacy of the structures within which actors are functioning, a point which runs the risk of leading to a line of circular reasoning: the operation of power within society depends upon the existence of forms of legitimacy that justify its use and this operation is undertaken through particular organisational forms of expression that serve to underwrite the claims for legitimacy that are being used within society – thus Weber (1978, 956–1003) argued that bureaucracy was the organisational form that was the most efficient and effective for the exercise of legal-rational authority.

The politicisation of the museums sector over recent years is in many ways a story of the conflicting demands for legitimacy that confront those who deal with individual museums and galleries, whether as visitors, consumers, members of the source communities from which museum and gallery exhibits originated, curators, education officers, those who hold positions of accountability and control over the policies that are pursued, or as non-attenders who still pay for the maintenance of museum buildings and the provision of museum services through taxation, even though they do not actually make direct use of them. The justifications for continuing with existing patterns of operation or for developing new approaches to the sector depend upon how these multiple and conflicting demands are politically managed, and the grounds

upon which legitimacy for the sector is based. The various United Nations Educational, Scientific and Cultural Organisation (UNESCO) conventions before 2003, for example, that covered the cultural sector (Singh, 2011, 86) derived from the idea of universal human rights that was to be found in the Universal Declaration of Human Rights (1948) of the United Nations, but this universalist approach was criticised for failing to accept ideas of cultural diversity and difference. One of the consequences of this was a 'shifting away from UNESCO's language' (Singh, 2011, 103) during the development of the more recent Conventions on intangible cultural heritage (2003) and cultural diversity (2005). In both of these cases the emphasis has changed to the specific particularities of individual cultural forms and expressions and this effectively denies the existence of a universal human 'culture' that is shared by all: they also provide justifications for claims to control museum contents, displays and exhibitions on the behalf of particular cultural groups. The legitimate right to determine what occurs in museums and galleries thus shifts from the expertise of museum professionals, operating on the basis of legal-rational principles of authority, towards groups who claim legitimacy from (normally) traditional forms of authority; and this affects views of who the key actors should be in the museums sector, how groups should be integrated into the museums world, and how policy is framed and understood by the participants in the system.

Museums and rationalities

Legitimacy depends upon accepting the logic of the authority system that underpins its exercise, with different forms of legitimacy resting upon different forms of logic. These logics, or rationalities, provide the justifications for why the decisions that are made within societies should be accepted by their members, and they can take a number of forms. Diesing (1962), for example, identified distinct social, economic, legal and political rationalities at work within societies to which can be added different behavioural (Hindmoor, 2006) and ritual (Royseng, 2008) rationalities as well, while Boltanski & Thevenot (2006) discuss six *cites* – fame, civic, inspired, market, industrial and domestic – through which justifications can be generated for forms of social action and which function as the means to rationalise and justify the choices that are made by social actors. Alongside these there is also the means–ends, goal-oriented, instrumental rationality that has been commonly seen to be the most significant form of rationality for the functioning of (primarily) Western, capitalist societies (Parsons, 1995, 271–84) and which has

been seen to contribute to the 'suppressing' (Royseng, 2008, 10) of other forms of rationality. Given its dominance in large parts of the world this instrumental view will form the starting-point for discussion here.

Instrumental rationality is effectively a form of calculation whereby policy choices are assessed against desired outcomes and the 'best' policy to achieve these outcomes will become the one that is chosen. Such an approach is based upon rather heroic assumptions – ranging from having perfect information and the available mechanisms to allow assessment to take place – that are not necessarily (if ever) accurate reflections of the messier day-to-day realities of policy activity. Indeed, for many years a great deal of the public policy-making literature was concerned with pointing out the limitations on, and problems of, such a purely rational approach, and with the provision of a range of alternative approaches to thinking about policy such as incremental (Lindblom, 1959), garbage-can (Cohen *et al.*, 1972) and punctuated equilibrium models (True *et al.*, 2007), amongst many others, each of which explicitly denied an instrumentally rational view of policy. More recently Saint-Martin & Allison (2011) have argued that the procedural rationality that underpins instrumental rationality has only survived as a symbolic claim that governments make as a means to justify and legitimate their particular policy choices, rather than as a model of how policy could or should be made in practice. Such a view of policy-making, however, underestimates the extent to which instrumental rationality provides the understandings that policy-makers employ in their actions and choices. In the case of museum policy, for example, there are normally quite clear means–ends relationships being posited by policy-makers – such as the idea that exposure to museums will improve the educational performance of schoolchildren – even if there is little in the form of effective evidence to back up the assumption. Indeed, much of the discussion of instrumental policies in the cultural and museums sectors quite clearly makes similar means–end claims for the social and economic effects and consequences of policies that extend far beyond their specific cultural and museums contents. Indeed it is possible to argue that *all* policies must contain some element of means–end instrumental rationality if they are to have any meaning at all: policies, after all, are meant to achieve *some* end, whatever it may be (Gray, 2007, 2008). A consequence of this has been an increasing interest in the assessment and evaluation of museums and cultural policies in a strictly means–ends fashion and these have increasingly been used as a means to justify continued state funding for museums and galleries, as well as becoming a major part of advocacy arguments

across the cultural sector as a whole (Madden & Bloom, 2004; Madden, 2005).

Other versions of rationality, however, have rather different starting-places, and their effect on how museum policies can be justified consequently take different forms. Behavioural rationality, for example, is based upon the assumption that there are various 'rules of the game' which identify what are acceptable and unacceptable practices for people to undertake in their relationships with each other. Within the confines of these rules – whether 'formal rules, compliance procedures, and standard operating procedures' (Hall, 1986, 19) or informal practices, conventions and customs (Lowndes *et al.*, 2006) – actors will operate with a full awareness of the costs and benefits of obeying or infringing the rules, and this implicitly assumes that some form of legal-rationality underlies social behaviour. In this context the implication is that there are structural constraints within which actors will act, where the latter may be making their own histories, but certainly not of their own free will, nor in circumstances of their own choosing (see Marx, 1973, 146 for the development of this paraphrase). These structural constraints will have an effect on the decision-making processes that are utilised for the production of policies at both the sectoral and institutional levels, and will also have an effect upon the distribution of power within organisational settings. In this context the professional values of curators and conservators can serve as powerful determinants of the choices that will, and can, be made within both individual museums and the museums sector as a whole as they will establish the ground-rules of acceptable behaviour and will specify what are the appropriate actions to take in any given set of circumstances, thus informing how policy is framed, made and understood.

The point here is not to show precisely how individual types of rationality lead to different forms of justification for the decisions that are made by social actors but, rather, to demonstrate that there are complex inter-relationships between the rationalities that are employed by individuals within organisations, and the ideologies, legitimacies and uses of power to which they are attached. This complexity means that care must be taken when making claims about why and how decisions are made, and how and why individuals and organisations operate in the fashions that they do. The interaction between the claims and justifications that underlie these decisions and the actual practices that result from putting them into practice, means that there is no simple causal relationship in place that links all these factors together in a clearly definable, straightforward, fashion. This difficulty in establishing simple

causal relationships between structures, actors, outputs and outcomes is not peculiar to the museums sector: the whole field of cultural policy is shot through with causal and attributional complexity (Gray, 2009) to the extent that single-variable explanations of what takes place within it are unlikely to be much more than optimistic guesses about why things turn out as they do, indicating, again, the problems of making valid generalisations about the politics of museums.

Politics and museums

Given that individual museums and galleries – and the museums sector as a whole – are affected by the operations of power, ideology, legitimacy and rationality, an effective political analysis of these institutions and organisations must take these concepts on board. To do this, however, is not simply a case of demonstrating how each of these concepts, either individually or collectively, affects both specific examples of museum functioning and the overall operations of the sector: such an approach could lead to an informative but highly descriptive set of case-studies with limited opportunity for the establishment of more generally valid understandings of the workings of the sector, even given the difficulties of making generalisations about it. Instead the focus in this book is on the inescapably political nature of museums and the museums sector and the ways in which political concepts can illuminate this fact. The following chapters demonstrate that there is no simple singular 'political' dynamic to the sector. Instead, that dynamic is to be understood as operating within multiple political forms that take different shapes depending upon what subject is looked at and whether the focus of analysis is to be found at the international, national or local levels. In effect, the politics of museums is to be analysed as a combination of the specific and the general: the general concepts of power, ideology, legitimacy and rationality providing an organising framework that allows for the practical analysis of specific dimensions of the museums sector and the organisations of which it is comprised.

The chapters which follow move from the geographical and organisational level of the general to the specific. Chapter 2 investigates the international trends and tendencies that affect the operation of the museums sector as a whole, concentrating on the manner in which international organisations such as UNESCO, the ICOM and the Council of Europe, amongst others, establish treaties, conventions, codes of 'best practice', standards and agreements for managing the sector. Alongside this the multiple effects of different forms of globalisation

and glocalisation and the impacts of colonialism, post-colonialism and neo-colonialism will be examined to assess the political nature of the arguments about the value of the 'universal' museum for humanity, and the restitution of cultural artefacts to source communities. Each of these sets of arguments involves different understandings of the nature of political activity and will establish the deep divisions that there are at the international level about the nature and purposes of the museums sector.

Chapter 3 changes the focus to the national level. The relationship of museums to ideas of heritage, their role as part of 'world heritage' and their contribution to cultural tourism leads to a consideration of the use of museums and, in particular, 'national' museums by national governments as mechanisms for economic development and regeneration, the establishment of statements of national identity and prestige, and their use as mechanisms for educational and health provision. This raises questions about whether the museums sector is considered by national governments as being an end in itself, with the focus on cultural meanings, or whether it is utilised as simply an instrumental means for other policy ends altogether. The multiple uses to which the sector is put have implications for questions of ideology and legitimacy, as well as establishing expectations about the functions of museums for societies as a whole, and this provides the context of opportunities and constraints within which individual museums and galleries will operate.

Chapter 4 moves to the level of the individual museum and gallery. These institutions form the places where international, national and local expectations, demands and pressures are turned into arrays of actual practices through the choices and decisions that are made by local actors. Empirical evidence is utilised to demonstrate the importance of specific organisational factors – ranging from professional background to hierarchical position, functional role and patterns of accountability – for their effect on the specific choices that are made by those who work within museums and galleries. Alongside these the impact of specific contextual variables – such as local population structures, political control and accountability and museum size – in having an independent effect on the range of choices that are available to local actors is discussed. The power resources that these actors have, and the inter-relationships between professionalism, pragmatism and policy demands, form a key focus for this discussion of the politics of the local.

Chapter 5 brings the discussion to a close by returning to a consideration of museums and galleries as political institutions in their own right and returns to the questions provided at the start of this chapter.

The discussion thus focuses on the manner in which museums and galleries can be understood as operating as sites for: the exercise of political power, both directly and indirectly; the creation and maintenance of forms of technical, social and political legitimacy; the expression of ideological and hegemonic preferences and practices; and for the elaboration and presentation of particular rationalities and justifications of social action. Apart from stressing the inescapably political dimension of museums, the consequences of this for understanding museums as institutions and sets of working practices, as well as for understanding the nature of the choices that are made within them, will be discussed. Finally, the implications of discussing the politics of museums for theories of politics and public policy will be highlighted to demonstrate that the specific case of museums has general consequences for how politics functions within societies.

2
The International Politics of Museums

Introduction

Museums and galleries do not exist independently of the societies that they are a part of. Equally, they do not exist independently of the wider patterns of thought, argument, expectation and belief that are to be found at the international level of organisation and action (Sylvester, 2009, 3–6). These international factors have an important part to play in the establishment of legitimations for the variety of museum practices and customs in different countries and regions of the world, as well as in providing justifications and rationalisations for the entire museum enterprise: Duncan (1995, 16), for example, argues that 'through most of the nineteenth century, an international museum culture remained firmly committed to the idea that the first responsibility of a public art museum is to enlighten and improve its visitors morally, socially and politically', thus providing a purpose and focus for museums that was rooted in an accepted set of ideas that were commonly shared. In practice, the world of museums today is neither simply the product of some basic human need to collect and exhibit material that is meaningful to groups and societies, nor simply the result of some evolutionary development that can be explained as leading, in the traditionally Whiggish fashion, to a continually better set of collections, patterns of display, conservation techniques, exhibition and labelling. Instead there is a continuous process of argumentation about all these aspects of museums, with these debates taking place across a complex organisational, institutional and ideological universe that extends far beyond the borders of any one country. This chapter examines two inter-related international issues that affect how museums are understood and organised not only at the global level but also at the national

and local levels. These issues are concerned with the exercise of power in the international organisations, treaties and agreements that have been established in and for the museums sector, and with the relationship of the practices of museums curators, conservators and education staff with internationally sanctioned ideas of 'best practice', professionalism and organisational efficiency and effectiveness.

Almost inevitably these concerns will be seen to intersect with larger arguments concerning globalisation/glocalisation and the world of post-colonialism as both of these serve to locate the particular case of museums in the general context of international and longitudinal change, and which provide arguments that explain the nature of these developments and their specific effects on museums and museum practice. While this discussion demonstrates the complicated nature of the international politics of museums it also serves to show the importance of particular sets of professional actors in setting the context within which the national and local politics of museums take place. It equally explains why the setting of international standards is both difficult and extremely hard to police and enforce, and thus illustrates why so many pressing museum concerns have not been resolved despite international and national demands for their solution. The location of these particular museum concerns within the context of much wider geo-political matters reinforces the claim that the politics of museums involve much more than simply the interests of the actors and organisations that make up the museums sector itself but also concerns how museums and galleries have their own independent effects on the world of which they are a part.

'It's the Same the Whole World Over... '

International debates about museums take place over a range of issues, from claims about the roles of museums within the world as a whole to those concerning the governance of museums and museum collections. In the case of the former, the claims for the 'universal' nature of their status that were made by certain major museums in 2002 (Prott, 2009, 116–17) has continued to give rise to criticism that such universalism was merely a fig-leaf to cover a deeply patronising reassertion of the importance of western cultural values (O'Neill, 2004; see also, Duncan & Wallach, 1980), and a denigration of the claims of source communities for the return and/or restitution of items held in museum collections (Mathur, 2005). In the case of the latter, the differences in consideration of the critical components of effective conservation strategies not only

arise in terms of the materials concerned, whether metal, wood, canvas or plastic, for example (compare discussions in Bachman, 1992; Knell, 1994; Ambrose & Paine, 2006; May & Jones, 2006), but also in terms of which country is being looked at, and with different conservation standards present in different countries largely, though not always, as a consequence of the very different physical environments within which museums and galleries are located. A simple comparison of the require- ments of museums and galleries in terms of, for example, humidity and temperature management in Finland and Kenya clearly demonstrates the relevance of national context in this case Such technical matters may appear to be concerned with 'politics' in a different sense from how the term may be applied to matters of cultural value and ownership but, in practice, both are concerned with the same political concepts of power, legitimacy, ideology and rationality – even if they are being applied to different types of subject and are employed in different ways by the actors who are concerned with them.

The national and global positions that are adopted by the various sets of participants in these debates provide a context for the develop- ment of the international politics of the museums sector that extends beyond the expression of cross-national differences. The relationship of these positions to matters of globalisation, imperialism, colonialism and post-colonialism has real meaning for the nature of the international frameworks within which museums function, and for the day-to-day practices that are undertaken within individual organisations and insti- tutions. In many respects the international dimension of the museums sector is much the same as that which applies to any other policy area that is of common interest across a number of countries. The concern with establishing common standards and agreed definitions of core con- cepts can be found in areas ranging from food safety and labelling in the European Union, for example, to the establishment of standards of universal human rights at the level of the United Nations, amongst many other such areas of perceived and accepted common concern. The museums sector is no different in this respect: the United Nations and UNESCO Conventions, and the decisions of the World Trade Organisa- tion (WTO), for example, all have direct relevance for museums (and the field of heritage more generally) across international borders. The man- ner in which these international decisions, standards and agreements are agreed upon and are then put into effective practice, however, is far from straightforward.

Two immediate questions arise in this context. What are the inten- tions behind the establishment of these international level decisions,

standards and agreements? And what functions do they actually serve in terms of museum practice and the institutionalisation of museums? These questions imply that there is no single intention or function that is fulfilled by the choices that are made by actors and organisations that are operating at the international level but, instead, that they are reflections of complex sets of activities between multiple actors who hold a range of divergent views about the issues that are involved. Put in this way, it might appear that the international arena – at least as far as the museums sector is concerned – operates as a form of pluralist political system, with the implication that the final decisions that are made are the consequence of bargaining, negotiation and compromise between organised groups of interests. Such a view depends, however, on how power is assessed to be distributed within this international community. In the pluralist case power would be seen to be dispersed, with no one group able to dominate all others, and with each actor able to make their own case and to be heard by all other actors (with the added assumption that this contributes to the development of democratic legitimacy for the results, outcomes and outputs of the process: see Dahl, 1998). If, on the other hand, power is seen to be relatively concentrated in ways that lead to a dominance of some interests over others in a consistent fashion, where debate is effectively stifled (as with Lukes' [2005] second and third dimensions of power), and where effective participation is restricted, then an alternative understanding of both how conclusions are reached and why they are reached is required (see the discussion in Gray, 1994, 94–119).

This is particularly important in terms of the status of the outcomes of these international debates. If they take the form of binding agreements which participants *must* put into practice or adhere to, then this is different to conditions where they are seen, more simply, as preferred states of affairs to be aspired to. In turn this then raises questions about the enforcement mechanisms that are available to international actors to ensure that elements of compulsion can be effectively made use of, or that appropriate forms of encouragement and support are made available to actors with aspirations to change existing states of affairs. In practice many international organisations, such as the WTO, have mechanisms in place to allow for the arbitration of disputes that arise from their decisions which can allow for the imposition of penalties on those actors who are seen to be failing in their duties. In other cases the expectation is that international agreements – such as United Nations Conventions – need to be put into law in the signatory countries concerned before they have practical effect, and it is up to the

individual country as to how the workings of these agreements are managed, including the creation or extension of their own national enforcement mechanisms. At the tail-end of these approaches to controlling national and international practice lie the somewhat vaguer cases of the establishment of international standards which have nothing other than persuasive means for their acceptance and enforcement. In the case of museums these can be seen in international technical and professional standards of 'good practice', supported by ICOM, that have been put forward 'for museums of all types that have few professional staff and limited financial resources' (Ambrose & Paine, 2012, 3). At best these can serve as the means to chivvy national governments to provide financial support to allow international standards to be agreed and adhered to, but there is certainly nothing in them that implies elements of compulsion, or that a failure to meet them will have any effect on the status of the institutions concerned: a total failure to meet them would not stop an institution being able to call itself a museum, but it could engender a perception in terms of international comparison and standards that it might not be a very good one. Each type of mechanism, however, has implications concerning the importance attached to these international creations, and those that make use of direct compulsion and enforcement are effectively seen as of greater importance than are those that simply rely on goodwill and willingness to conform: if they are that important to the international community the means must exist to give them effect, and if these means do not exist then, by implication at least, they must have a lesser importance. In this respect the presence of 'power to' serves as an indicator of the significance and importance of the issue concerned for the international community, which would imply a rather limited status for the museums sector in the grand scheme of things given that there is a marked lack of compulsion and an absence of effective *international* enforcement mechanisms in the overwhelming majority of cases concerning conventions, standards and practices, even if *national* mechanisms may exist (as, for example, in the trade in antiquities where enforcement is undertaken at the national and not the international level, and often functions by means of the legal system).

To return to the questions of the intentions and functions that are associated with international-level activity in the case of the museums sector, a key element to consider is the context within which this activity takes place, and this differs in terms of the nature of the intended outcomes that are concerned. In relatively simple terms, the search for an international *agreement* is intended to produce a set of principles

which all parties concerned are prepared to abide by, and this involves not only identifying what these principles may be but also finding a form of words to express them that satisfies everybody involved. The making of an international *decision*, on the other hand, involves a somewhat shorter-term horizon that involves the production of a solution to a problem or the production of a practical proposal for the parties concerned to put into practice, and while this may imply the existence of principles to underpin the validity and legitimacy of the solutions that are produced it does not require the creation of such principles in the first place. The establishment of international *standards* involves establishing criteria that multiple actors accept as being appropriate ones for the undertaking of particular activities. These criteria, again, imply the existence of underlying principles to justify their importance but, equally, do not require their creation. In practice international standards are often determined on the basis of forms of technical and professional knowledge that can be claimed to be either non- or a-political in nature, thus reducing the likelihood of conflict over principles in the first place as a result of the depoliticisation of the issue concerned that arises from its removal from questions of value and ideology in favour of technocratic resolution. This does not mean that these issues have no political content at all, only that they are treated as if they did not.

Each of these outcomes – agreements, decisions and standards – is intended to produce different results for the parties concerned, and each implies that the basis upon which actors will operate will differ in each case as well. In a similar vein the functions that are fulfilled by each of these forms of international action will differ in each case. The establishment of effective standards for museums, for example, can have the objective to establish acceptable levels of technical competence covering the gamut of museum activities from conservation to marketing to lighting to planning to disposal policies (Ambrose & Paine, 2012, v–xi): in this case the emphasis is firmly on the intended improvement of museum practice. With international decisions, on the other hand, the focus is on the production of solutions to matters of common concern for a variety of international actors – as with the restitution (or not) of museum objects to source communities (Greenfield, 2007) – with this contributing to a function of satisfying the needs of the external communities with which museums interact, as well as establishing an enhanced legitimacy for the collections that remain. One of the aims in forging international agreements is to construct a common framework that can be appealed to in justification of the particular choices that are made at the national level. These multiple common frameworks are

often predicated on the basis that there are values that are shared across international borders and these can therefore be utilised to establish principles of behaviour and action for all actors: a form of equivalence that can provide both a justification and a legitimacy for action and choice. As such they serve to establish an accepted framework for action which states can ignore or rewrite but only through either providing alternative justifications and legitimations that may not be acceptable to other states, or through being prepared to be labelled as being in some sense beyond the pale of internationally agreed and accepted custom and practice. Either of these choices will give rise to political costs in the international arena that would need to be weighed against the potential benefits that failing to conform to the accepted framework for action would generate.

These differences between intentions and functions give rise to questions about the underlying motivations for action at the international level which require some consideration. The sheer diversity of thinking behind what international activity is expected to provide implies that there is unlikely to be a single form of motivation that is applicable in all cases and at all times. In this respect matters of rationality and legitimacy assume real importance for understanding the international dimension of the museums sector as it is these that provide the context within which choices and decisions will be made. As this, in turn, implies that there is no expectation that the assumptions of rational choice arguments (Mueller, 2003), that the motivations of individual actors are simply to be found in terms of common self-interested value optimisation, will be lived up to (see Hindmoor, 2006, 181–99 on the rationality assumptions of this approach), a wider notion of actor motivation is required to make sense of this international dimension as claims and counter-claims are often based on views of museums that are not dependent on individual actor interests but, rather, on views of sectoral necessity and/or appropriateness. This extension of actor motivations also demonstrates the inherently political nature of the museums world by emphasising the multiple uses to which museums and galleries can be put in the international arena. While it may be agreeable to imagine that museums and galleries are institutions that are, and should be, independent of the messy, mundane world of political choices and actions – if only to provide some normative validity to the multiple metaphors and functional claims concerning the place of museums within societies, whether seeing them as the modern equivalents of temples and sites of ritual (Duncan, 1995), or as mechanisms for overcoming problems of social and cultural exclusion

(Hooper-Greenhill, 1997), the representation of difference (Sherman, 2008) or the establishment of social justice (Sandell & Nightingale, 2012) – the reality is very different. Each of these ideas of what museums are, and what they represent, contain within them political claims concerning ideology and legitimacy, as well as assumptions about what the 'correct' or 'proper' roles of museums may be within the international, as well as the national, arena. The latter of these forms the focus of the next chapter, for now the emphasis remains at the international level.

Museums: International statements and instruments

The role of museums and galleries in the context of international agreements, decisions and standards is manifold and cannot be simply organised into a set of clearly defined categories, not least because at any given time museums and galleries will be involved in multiple forms of action that incorporate quite distinct sets of functions that are concerned with diverse sets of intentions. Alongside this complexity it is also the case that museums are consistently expected to meet the aims of diverse sets of actors that can be both complementary and contradictory at the same time, including: the international community as a whole, riven with dissension as this more often than not is; national governments, political parties and pressure groups with a variety of ideological, policy and strategic positions to defend and advance; professional organisations that have both international and national perspectives contained within them; and national and local communities that can be divided along many social dimensions, such as gender, class, ethnicity, language, religion and age. Not surprisingly, in such circumstances it is difficult to find the common ground that will allow international agreements to be made. International decisions and standards would certainly be expected to be easier to make given their more limited intentions but, even so, they are by no means, in any absolute sense, expected to be simple in their making. This difficulty is not simply, however, a matter of the sheer numbers of participants involved – after all there are already a considerable number of international frameworks for action in existence on subjects, such as international trade and issues of international development, that are a great deal more politically complicated than the heritage and museums sectors are (even those these are immensely complicated in their own right) – it is also a matter of the underlying political centrality of the subject under debate for the relevant participants.

In this respect the museums sector suffers from the same weaknesses that cultural policy in general is affected by: a lack of comparative significance in the face of multiple demands on government time and other resources; a lack in many cases of comparative legitimacy in terms of the roles of government actors and agencies; a lack of financial resources to mount effective programmes of publicity and propaganda; and a lack of an effective basis in evidence – in terms of causality and the attribution of effects at the very least – to demonstrate the importance of the sector to both governments and societies as a whole (Gray, 2009). While the underlying bases for justifying national, regional and local governmental involvement in the museums sector are highly developed in terms of the functions that the sector fulfils, it still remains difficult to claim that these functions are either peculiar to the sector itself (the education role of museums, for example, being carried out by a large number of other organisations, not least schools), or that they are actually more important than many other functions that governments are expected to fulfil (such as national defence and the provision of a functioning system of justice, both of which are normally seen as being core requirements for any effective state system). The consequential dependence on normative arguments to legitimise state action in the museums sector inevitably leaves it in a weaker position than is the case with many other public activities, and this is reflected in the difficulties that there are in developing effective international agreements, decisions and standards that will carry weight with the many actors who operate at the international level, let alone those at the national level.

A consequence of this is the large degree of ambiguity in the documents produced for the museums sector. While a certain amount of ambiguity may be expected given the multiple opportunities for disagreement and outright conflict in the reaching of international concord on any subject, the sheer vagueness of most international museums documents is noticeable. Some of this can be explained on the basis that the international agreements that are concerned largely depend upon their translation into national laws or policies to give them effect and, as such, too much precision in the framing documents may be seen as infringing matters of national sovereignty. Likewise, with international standards, exactitude may be inappropriate in terms of the precise conditions and circumstances that national, regional and local museums and galleries may be confronted with. Attempting to produce a set of museum standards that cover every eventuality would either lead to the creation of a host of exemptions or to precisely those infringements of national sovereignty that ambiguity can serve to by-pass. It is not

therefore surprising that international statements (of whatever form) leave a great deal of room for the exercise of national choices and the making of national decisions in how museums are dealt with, leading to diversity across national boundaries. Given this effective national independence from international agreement and control over the sector, questions will inevitably be raised about what the point of international discussion actually is. The short answer is that it is more concerned with establishing forms of legitimacy for established practices and the extension of these across national boundaries than it is with anything else. The consequence of this legitimation exercise is that the museums sector becomes a focus for the establishment of not only core practices but also the principles that underlie these. This is not exactly what Prosler (1996, 22) meant when he argued that 'museums form a significant part of the global diffusion of ideas and roles' but the end result is much the same: the establishment of a commonly agreed set of standards, decisions and agreements depends upon an acceptance of the basic frameworks upon which they rest, and who controls these frameworks becomes an important element in understanding where power lies at the international level of museum politics.

Determining this depends upon the direction of focus that is applied to the question – whether it operates from the bottom up or from the top down. Addressing it simply from the international level itself would identify national governments and key international organisations (particularly UNESCO and ICOM) as forming the central hub for the production of such frameworks, with governments providing political legitimacy to the results of international discussion and debate, and ICOM, in particular, providing forms of technical and professional legitimation that can establish the rationality and justification that policy agreements require for their acceptance by the wider world. Approaching the question from the bottom up, however, would emphasise the role of societal and community groups in establishing such acceptance in the first place, with this then providing the framework within which common beliefs can be located – and appropriate practices can be created – that will give meaningful international expression and form to specific and particular local claims. As may be expected the reality lies somewhere between these two extremes meaning that international documents can never be entirely divorced from national, regional and local expectations, demands and requirements, but, equally, they are never simply the end-product of some form of international level neo-pluralistic or neo-elitist exercise of group activity between competing local, regional and national interests. Instead there will be constellations

of interests that will revolve around particular issues of importance to the museums sector, with these differing according to what the issue consists of and its centrality to particular sets of participants. Thus, in some cases – for example, in technical areas such as conservation standards – it would be expected that groups of international professional experts would dominate the discussion, whilst in others – such as the treatment of issues of intangible heritage in museums, or the restitution of cultural artefacts to source communities – it would be anticipated that local and community groups would be far more involved in establishing the terms of the debate as it directly affects their specific interests, with this eventually affecting the nature of the international argument that takes place to deal with them, if not actually resolve them (Smith, 2006).

This, in turn, implies that there will be a great deal of variability in terms of how the international politics of the museums world functions, and claims that there is one dominant understanding of policy and policy processes that underpins the entire sector – whether this be in claims about punctuated equilibrium (True *et al.*, 2007) or policy streams (Kingdon, 1984), or about the nature of governmentality (Bevir, 2012) or complexity (Morcol, 2012) – are only ever going to capture a part of the overall nature of policy activity within the sector. While the detail of individual cases can provide the specific story of how international decisions were made, what the nature of the argument was that carried the day, the balance of power between competing understandings of the core issues, and how these combined to produce the agreement, decision or standard that appeared, such a focus on individual examples requires careful treatment before valid generalisations can be made about the international politics of the museums sector. The difficulties that exist in trying to establish a clear, let alone parsimonious, explanation of policy outputs at the international level is multiplied when the mechanisms that are used to put international documents into practice are added to the discussion.

As noted earlier there has been a marked reluctance to create strong international enforcement mechanisms to ensure that the creations of international discussion and debate are put into practice: instead, there is a reliance on what is effectively the goodwill of national governments – and individual museums and galleries – to give practical meaning to the variety of conventions, treaties and codes of conduct that exist. In some cases, as with the return of human remains from many museums, not only anthropological ones, this has fed in to already existing ideas about the relationship of museums to the

communities from which their collections derive, with this co-incidence of interest meaning that there is often little debate or argument about the principle of return (although sometimes it can lead to the generation of new forms of ill-will between the parties involved – see Smith, 2004, 161–73). In other cases, however, where the core principles of the issue concerned are subject to disagreement and debate, it is evident that more would be required to ensure that national, regional and local actors pay heed to decisions that have been reached over their heads. Thus the United Nations Convention on cultural property allows nations to claim effective control of all material unearthed within their own borders since 1970, allowing them to decide, for example, what nearly unearthed material can be exported to overseas museums. Older material acquired before 1970 is exempted from this control thus generating a great deal of argument about the potential for the return of cultural artefacts that were gathered through monetary acquisition, theft, looting or colonial adventuring in earlier times. Greenfield (2007, 225) points out that the convention only comes into effect when a state signs up to it and thus any material acquired before that sign-up date could be excluded from its provisions and thus the 1970 date is not necessarily the only, or even the most appropriate, one to bear in mind in this context. The arbitrary nature of this cut-off point could be seen to be a matter of convenience for the ex-colonial powers (which are largely implicated in the less salubrious sources of acquisition) as it ensures that their right to retain and display many artefacts remains in place, regardless of the claims that could, and can, be made by the source communities from whom such artefacts derive. With post-1970 material, however, in most countries responsibility for ensuring the appropriate provenance of the material concerned rests with individual museums, dealers, curators and individuals rather than with national governments, and rests as much on moral sanctions as it does on criminal or civil liabilities before the law of the land both of which, in some cases at least, are rudimentary in the extreme and, in any case, extremely difficult to enforce (Greenfield, 2007, 236–37), leading to a position where 'the actual utility of these various international instruments and resources for indigenous groups is very variable' (Moore, 2008, 27).

 To some extent at least this marks the level at which ideas about the 'correct' role that museums should play in the international sphere become relevant. If museums are concerned with the display of artefacts then what these artefacts are and where they are derived from become important issues to consider. The early models from which

modern museums have developed – based on the idea of a private space for the representation of the collector's view of the world (Findlen, 1989) – were based on an idea of the 'museum' as a creation of private initiative rather than the more commonly held modern view of the museum as a public space – even if this space is one that carries a world of ideological content within it (Duncan & Wallach, 1980). The acceptance, however, of a public role for the museum changes the dynamic of the relationship between the museum as an institution and the societies within which they are located. The development of an international set of conventions, agreements, decisions and standards serves as a marker of the acceptance of a commonly accepted set of criteria against which museums can be evaluated and, by implication, a set of ideas of what roles museums should be fulfilling with regard to not only their local communities and societies, but also to the much wider international community. One consequence of this has been the development of an increasing number of demands for the return of artefacts from museums to their source countries and communities, and the parallel development of legalistic devices to justify the return or retention of these artefacts. The increasing legalisation of this issue has occurred as the international arena has become a key location for the creation of accepted criteria that are shared by large numbers of countries, with this creating the conditions within which it is necessary for signatories to international accords to change existing legislation, or to write completely new legislation, to fit in with international agreements. At the same time the underlying ideological concern with the need for museums to be responsive to the demands that are now being placed upon them by the international community makes it ever more difficult for them to ignore these demands. The result is that museums are becoming increasingly tied in to a set of internationally agreed sets of ideological principles – even if the precise meaning of these principles tends towards such vagueness that individual countries can continue to exercise independent choice as to how they put them into practice. Clearly the relationship between the international arena and what occurs at the level of national and individual museum policies and practices demonstrates the complexities that can be generated by the search for agreement about the ideological conditions which surround the sector as a whole. The balance between international and national assumptions and ideas in this respect becomes part of the much wider debate about globalisation, globalising tendencies and glocalisation, and it is to this that our attention now turns.

Globalisation and museums

The order of the words used in this subheading is deliberately chosen, as the focus to the discussion that follows is on the perceived impact of globalisation on museums, rather than on the role of museums in contributing to globalisation itself. Globalisation as a concept is often used as a short-hand term to represent the consequences of a variety of changes that have been seen to occur across the technological, economic, social, political and cultural dimensions of societies. This use of 'globalisation' as a generic label unfortunately fails to adequately differentiate between the sometimes complementary, and sometimes contradictory, results of the changes that have been created along these dimensions in recent years – and, indeed, there should be a certain scepticism about the extent to which the generic term is adequate for capturing the sheer variety of changes that have taken place in each of these dimensions, either nationally, internationally or, indeed, globally. Saying this does not mean that global patterns of change cannot be identified but, rather, that these patterns are not necessarily accurately to be seen as being the simple result of a singular process of globalisation. Instead they could be seen to be the end-product of multiple processes of 'stretching...intensification...accelerating...(and) deepening' that between them lead to 'a structural shift in the organization of human affairs' (Held & McGrew, 2007, 2–3). The following discussion is based upon differentiating between the currents of change that have affected the museums sector in the relatively recent past (approximately the last 50 years) and questioning the underlying consequences of these for the international sector as a whole.

Attempting to undertake this differentiation on the basis of the specific impacts that can be identified as arising from particular elements of change is extremely difficult as the different currents of change that exist are part of a general process of continual social, political and economic rearrangement that makes the attribution of specific results to individual components of change hard to establish. The complexity of the 'global transformations' (Held *et al.*, 1999) that are commonly seen as the consequence of a range of globalising tendencies means that any simple account of their impact on museums, either individually or collectively, is likely to provide only a part of a much more fragmented overall picture of change. Indeed, the extent to which this complex picture of change is the result of processes of general 'globalisation' rather than of any other specific underlying mechanisms of reorganisation, reform and development at the international level needs to be continually borne

in mind to allow the contested nature of the globalisation label to be made clear. In this respect a distinction between top-down pressures for change associated with multiple transnational forms of structural development and the bottom-up management of these pressures by active national and local agents becomes important for making sense of the claims that are made about the impact of international patterns of change on policy. The former of these positions can be seen to rest on the idea of an inescapable mesh of exogenous mechanisms of control (usually understood as economic or ideological in nature, as in McGuigan, 2005) that inevitably drive policy and practice along clear developmental pathways that actors are not able to control or even influence in any significant way. The latter, in distinction, emphasises the role of active, knowledgeable agents in managing the content and direction of change for, in particular, local communities (as seen in some of the early arguments about the nature and meaning of indigenous museums for their local communities in comparison with how 'Western' museums were understood and used by their visitors, as in Mead, 1983). Almost inevitably the intermediate ground where both structure and agency have distinct roles to play in the creation of new forms of organisation and practice in the museums sector is also evident in the debate, where ideas of continuous processes of negotiation and 'dialogue' between the global and the local (Message, 2006, 142) underpin the direction and nature of changes within the sector and, at the very least, indicates that the effects of globalisation on the sector are not necessarily as unidirectional as they are sometimes presented (Mathur, 2005). Indeed, one of the important developments arising from these different positions is that they point to the need to consider the lived practices of museums through the use of examples and case-studies to evaluate the adequacy and shortcomings of each of them: it is not enough to simply *claim* that structures or agents or the interplay of both affect change in the museums sector, instead these effects need to be *shown*. Not surprisingly, it is possible to identify evidence that will support each of these distinct positions in terms of the relative impact of distinct forms of globalisation in any individual case, but it is less possible to develop generalisations about the relative adequacy of each position for explaining what is going on in the sector as a whole on the basis of the weight of the evidence across multiple examples. This is the consequence of the fact that these generalisations depend upon different forms of evidence for their support that rely upon different rationalities to make sense of them. Bearing in mind that the dynamics of change cut across the diverse dimensions

of globalisation, rather than simply operating on each dimension by itself (Message, 2006), any generalisations that are employed need to be treated with caution rather than being simply accepted as definitive statements of the 'truth' about the overall relationship of globalisation and museums.

Economic globalisation and museums

One of the most commonly accepted dimensions of globalisation is that concerned with economics and the nature of the international economy. Crudely put, the argument is that changes in international trade and production processes, influenced by global institutions such as the WTO, the World Bank (WB) and the International Monetary Fund (IMF), have effectively undermined the ability of nation-states to manage their own affairs, with power passing over to a range of technocratic and politically unaccountable actors whose interests are economic rather than social, and whose accountability lies with private individuals and management boards rather than with any collective idea of society or nation. The effect of globalisation in these circumstances is to pass responsibility away from citizens towards what can only be seen to be an international oligarchy that is not tied to notions of community or social responsibility. As far as the museums sector is concerned the consequence of this shift is to make individual institutions increasingly dependent upon meeting the interests of those who hold the purse-strings: the modern version of 'whoever pays the piper calls the tune'. This shift, however, is not simply restricted to an increasing economic dependence on private money. To give this economic dependency legitimacy changes would need to take place across a number of dimensions – ideological, organisational and managerial in particular (Gray, 2000) – not least to create the conditions where such a shift is seen as not only inevitable but also necessary.

This categorisation of the effects of economic globalisation is crude but it does serve the purpose of providing a basis for thinking through the logic of the claims that are made about the museums sector in the light of changing economic circumstances. What is clear is that there is no single set of effects arising from economic globalisation for all museums in all places. In part this simply reflects the idea that some states are managed by globalisation processes, some states manage globalisation and some states are simply ignored by globalisation. In practice this argues that there is a situation of uneven development in terms of globalising effects that is dependent on the nature of the state that is

concerned. More than this, however, the nature of the structure of the museums sector within individual states will interact with exogenous globalising pressures to produce particular types of effect in individual cases. Thus the dominant model in the United States, for example, where state subsidy/investment for museums is at a much lower level than that provided by fee-paying visitors, charitable donations from businesses and individuals, and charitable legacies from the dead (as evidenced by the Smithsonian, Frick, Martha J. Stewart, Guggenheim and Getty museums) has produced a situation where there is already a high reliance on private sector financing, and economic globalisation simply reinforces this dependence. In Europe, on the other hand, where the state has taken a much greater role in funding museum provision at both the national and local levels since the nineteenth century (Sherman, 1989; Hill, 2005), the effect of economic globalisation has been much diluted and there continues to be a strong assumption in favour of state rather than private finance in the museums sector, even if the more general heritage sector has seen significant shifts in emphasis towards private finance in some countries (see Benedikter, 2004, on Italy, for example). In other parts of the world the impact of globalisation appears to be rather minimal, even at a mediated distance from individual museums themselves where the impact of globalisation on national economies appears to have little, if any, direct effect upon their museums and museum sectors (Bhatti, 2012).

The impact of economic globalisation on the museums sector should not, however, be understood as being simply a consequence of the relationships between national states and the global economy, and national states and the organisation of their systems for funding museums. After all, the same sets of relationship are also present in the textiles and agriculture industries, and each of these *has* been affected by economic globalisation – not least through the workings of the WTO (Swinbank, 2005; Lanoszka, 2009, 96–9). This difference between policy sectors can itself be partly explained by differences in how these sectors are viewed by policy actors on the international stage where their relative economic importance can go a long way to explaining why museums are seen to be of such relatively small significance. Bulpitt's (1983) model of 'high' and 'low' politics can be applied to this issue: the increasing emphasis in the global economy on matters of trade liberalisation – which are a core component of economic globalisation – shifts the focus of policy actors away from matters of 'purely' national interest, such as the representation of the nation to the nation through national museums (see Knell *et al.*, 2011), to concerns that are at least international if not fully

global in themselves. As a consequence, national policy actors could be expected to become less concerned with the local and the particular, and more concerned with the international and the general. In this respect the political logic of economic globalisation leads to a differentiation of interest and concern between policy sectors rather than to the imposition of a singular model of activity across the board. In the case of museums this leads to the sector being assigned a low level of political priority in comparison with policy sectors that are perceived to be of greater economic and political significance on the global stage.

It is in this fashion that economic globalisation can be seen to affect the museums sector, not through the imposition of new models of economic liberalism, or through the establishment of new forms of ideological and hegemonic control, but through the assignment of particular levels of comparative importance and significance to the sector itself. This political assignment then locates the museums sector within particular structural settings that establish a hierarchy of relevance for individual museums to function within. In this manner it can be understood why national museums acquire greater importance than do local ones, and why all of them are the subject of much less direct political concern than is given to other production sectors which employ many more people and which produce much higher levels of direct economic benefit than the museums sector does. If anything, arguments about economic globalisation simply show that museums are not economically important to national – and international – political actors, a view that is hardly startling news. This, however, raises questions about where the importance of museums actually lies at the international level and for this other dimensions of globalisation require examination.

Political globalisation and museums

The earlier discussion about international agreements, decisions and standards demonstrated the deeply political nature of these, with each involving the exercise of power in the context of particular ideological positions and the exercise of particular forms of legitimating arguments. These were, however, concerned with the national expression of these political positions rather than with ideas that transcend the national and which can be argued to represent a developing 'globalised' form of politics. As with economic globalisation, it is possible to start with an extremely crude version of political globalisation before developing a more sophisticated position. This starting-point can be found in different places where the traditional role of the state in making decisions on

the behalf of the public is seen to have been increasingly replaced by either dominant economic (Boggs, 2000) or, much more recently, electronic (Carswell, 2012) sources of power, or where there is only type of political power that is relevant to the world following the collapse of the Berlin Wall, that deriving from liberal democracy (Fukuyama, 1992). In each of these cases the politics that is created draws its legitimacy from rather different sources than have been seen before. At this level the political globalisation argument assumes a distinctly structuralist position, where the actions of individuals, groups and parties are subservient to larger forces that are beyond their direct control.

This extreme picture of globalisation as a juggernaut that destroys the possibility of effective local and national action in the face of changing circumstances certainly indicates a belief that for many (if not all) people in many (if not all) places the reality is one of severely circumscribed opportunity to choose and to do. However, there are two questions that need to be answered in the light of this bleak picture: if the 'real' decisions are not being made by 'political' actors, then who *is* making them?, and, is the world subject to only one set of meaningful motors of action? In the former case it is always possible that there exists some sort of shadowy cabal that controls the destinies of the world – although there do not appear to be anything other than conspiracy theories to support this position. It is equally possible that there does exist some form of pure elite power structure that determines the direction that societies will take through its control of ideology and societal values and its exercise of hegemonic power (Parry, 2005 [1969], 13). Even though there are many difficulties in actually identifying who the members of such an elite may be at the local and community level, let alone at the level of nation-states or internationally, recent debate highlights the development of new groups of actors who are argued to operate as a de facto elite, with their source of power derived from the consequences of economic globalisation (Robinson, 2012), thus contributing to the structuralist bent in explaining globalisation. In either case, however, it is assumed that there is some form of conscious decision involved in the processes of political globalisation, with members of the new cabals or elites promoting this process for their own reasons and advantage. Thus, while the actors involved in political globalisation may not be directly 'political', in the sense of being a part of the formal political system of power distribution within societies, the consequences of their choices and actions have clear political implications for how and why power will be exercised within these societies, with liberal democracy, along with all the other forms of political organisation that can be

currently identified in the world, becoming replaced by new forms of action and organisation. The basis for understanding these new forms would thus have to be found in the underlying rationales and ideologies that underpin the choices of the new global power-holders, and in the identification of the benefits that they accrue through the changes that are being created by their actions. Inevitably this leads to the need for a political analysis of what is happening in the world, even if the focus of this analysis is not necessarily directed to the classic ideas of parliaments, presidents and pressure-groups or the usual questions of political mobilisation and engagement. To undertake such an analysis in the case of museums it would be necessary to accept the assumption that change within the museums sector is the consequence, not of matters of professional development and practice, for example, but, instead, of much wider patterns of advantage for particular groups of societal actors whose focus is not on museums per se but, instead, on matters of their own ideological and technical advantage. Thus the increasing importance of private corporations for the museums sector in northern America (Janes, 2007) is a consequence of the economic motivations that these corporations have, not their museological concerns. The result is that making sense of change within the museums sector requires a shift in focus towards a range of exogenous factors and away from the more normally considered endogenous characteristics of the specific details of museum organisation and action. Thus, an examination of the meanings that are to be found in museum exhibitions depends as much upon how external ideologies are understood as it does upon the explicit choices that are made by curators and exhibition designers (Luke, 2002; Macdonald, 2002).

An alternative to these attempts to identify or label groups who make up a concrete elite power bloc is to assume that there is a form of 'invisible hand' at work (analogous to the classical economics notion of the 'invisible hand' of the market) – an accumulation of the multiple choices and actions that people make and take – which determines how societies function. In this picture there is nothing intentional about the creation of political globalisation. Instead it is the by-product of the sum of everything that individuals, groups, communities, societies and nations do on a daily basis. The end product of this is assumed to be a drive towards the creation of larger and larger concentrations of power which gradually, but inevitably, overwhelm the individual and local in favour of the global. In this respect the creation of international agreements, decisions and standards concerning museums and heritage would be anticipated to lead to the establishment of a core

repertoire of actions and practices that will replace the peculiarities of divergent national patterns of organisation with an homogenous framework that will be applicable to all museums in all places and for all the time. The content of this framework will be generated through continuous processes of interaction between a host of participants operating at all levels from the highly parochial to the global. This allows for the analysis of the agreements, decisions and standards that are made in the international arena by standard political ideas of power, ideology and legitimacy, and the focus of attention is on the processes by which the framework is created rather than on the precise combination of actors (whether individuals or groups) who are involved in these processes.

This preliminary discussion, however, is really only establishing the background for a consideration of the consequences of political globalisation for the museums sector. If it is taken that political globalisation is concerned with the development of new patterns of organisation that transcend the strictly national then how are these displayed in the museums context, and what are their effects upon the functioning of the museums sector? It is here that the second question assumes importance: is political globalisation a sufficient explanation of the changes and developments that the sector has been undergoing in recent years? At this point some differentiation between museums again acquires importance: what may be true of developments in museums that are increasingly behaving like multinational corporations (Mathur, 2005, 700), such as the Guggenheim or the Louvre, need not necessarily be true of local and community museums that have a very different ethos and relationship to visitors than the world's largest and most internationally recognised museums do. While each type of museum *may* be bound by the same internationally accepted principles and standards for museums that are applicable in all places at all times, the differences between them are still quite evident in terms of their organisation, their relationships to their core communities, and their orientation and focus, particularly given the lack of effective control of museum practice at the national, let alone the international level. Thus, the phenomenon of the 'blockbuster' exhibition may be of real significance for the largest and richest museums but it has little meaning for the local, if not parochial, museums that make up the overwhelming majority of the museums that exist today. Indeed, given the still evident cross-national differences in the legal status, organisational structure and financing mechanisms of museums it is difficult to see what role, if any, political globalisation may have in explaining change at the international level if the weight

of exogenous factors has yet to overwhelm the continued importance of endogenous, and particularly specific national and local, factors for how and why museums function as they do. This is reinforced when consideration is given to the extent to which tendencies have developed towards a convergence around particular forms of organisation (the increasing dominance of the 'Western' model of what a museum is: see Wan-Chen, 2012) and practice (as exemplified by the ICOM and SPECTRUM standards of museum management and documentation: see Sully, 2007, for example) in the world of museums that are driven by more than simply 'political' actions. Such forms of convergence have been posited to take place through processes of institutional isomorphism which are driven by a variety of underlying causes. In particular these causes can be seen to result in the creation of different motors that affect the development of similar organisational responses to a combination of a variety of endogenous and exogenous pressures. Coercive isomorphism (driven by direct political control mechanisms based on a requirement for sectoral legitimacy), mimetic isomorphism (arising from organisations adopting the same responses to common problems of managing environmental uncertainty) and normative isomorphism (arising from endogenous beliefs about the most effective and efficient ways of organising work) have been proposed as forming distinct ways of understanding how organisational similarities can be generated (DiMaggio & Powell, 1991). This process is argued to occur differently in different policy sectors for different reasons, including the dominant sources of organisational finance that exist within sectors and the extent of professionalization within them (Frumkin & Galaskiewicz, 2004, 302–3), leading to the establishment of sectoral differentiation around a limited number of organisational forms in each sector. In the case of museums DiMaggio (1981), for example, has identified a number of discrete pressures – particularly ideological and hierarchical ones, in conjunction with a developing professional control of the sector – that supported such a convergence in American museums between 1920 and 1940. In any event, whatever is happening in this case has little, if anything at all, to do with political or economic globalisation and a great deal more to do with the organisational logic of functional management in the museums sector. While it may be possible that globalising pressures can provide an account of the context within which sectoral change is taking place – including the idea that economic globalisation can provide an explanation for the relative lack of centrality that museums have within political systems – this is not quite the same thing as arguing the case for a direct link between exogenous

pressures and the specifics of particular instances of change within or across the museums sector.

As can be seen, attempting to provide an unambiguous answer to the question of what role 'globalisation' plays in affecting the museums sector at the international level is by no means easy. Accepting the underlying assumptions of the globalisation argument leads to an emphasis on forms of structural determinism that underplay the role of, in particular, local groups and individuals in favour of attaching greater significance to the role of much broader national and transnational influences – such as ideological changes and shifts of power within societies – to establish new power-groupings that operate at a decidedly non-local level. It would be foolish to deny that changes in each of these have taken place but that is not the same as assigning them the dominance that the general globalisation argument assumes. To explore the implications of this position a more detailed examination of particular international issues is required to allow for a more precise understanding of how and why change occurs at the international level in the museums sector. To pursue this three issues will be examined to identify the complexities that exist in discussing the international dimension of museum politics.

Universal museums and practices and museums collections

The three issues to be discussed here are concerned with attempts to either establish or claim international standards, agreements and decisions for all museums in the world. As will be seen, none of these attempts was entirely successful in creating the forms of international accord that they were intended to. In turn, these issues concern the passions that were generated over the claims made about the nature and status of the 'universal' museum in 2002, particularly in the light of post-colonialist arguments about the functions of museums (see, for example Bhatti, 2012, 83–4); the clashes that are created over the very idea that there is a single model of museums to which all societies should conform, with this single model being based upon Western constructs of heritage that need not actually have any meaning at all in non-Western societies (McLeod, 2004; Winter, 2014); and the continuing arguments that there are about the repatriation and restoration of at least parts of museum collections to the source communities from which they were derived (Greenfield, 2007; Prott, 2009).

These issues have already raised their heads in this chapter which, in itself, demonstrates how they form part of the common landscape

of international debate within the museums world. At their core these issues are concerned with two sets of arguments: firstly, the status and value that museums have in terms of the peoples of the entire world, rather than in terms of the intrinsic merits of museums per se, and, secondly, the content of museums in terms of their collections and their display and exhibition practices. Much of the debate associated with the first of these arguments casts doubt on whether there is any validity to the idea that museums have intrinsic merits in their own right, and questions the extent to which museums can be understood independently of the political ideologies and legitimation strategies that underpin their existence and functioning. The second argument inevitably becomes entangled with further questions about the relationship of museums to various types of community – whether defined nationally, ethnically and religiously (that is, who these communities consist of), or seen as source-communities, or co-producers of meaning (that is, what role these communities play in the context of the museum) – and the collected items (both tangible and intangible) that more usually than not form the core of the museum as an institution.

In practice these two sets of arguments often overlap with each other with common concerns cutting across each of them. Thus, the original claim about 'the importance and value of universal museums' (Prott, 2009, 116) that was made by 18 museums in Europe and the United States was as much to do with the content of their collections, if not more so, as it was to do with the significance of their status as repositories of material that represent what is meant to be an 'eternal principle and a transcendent truth' about the 'essential unity of humankind' (Singh, 2009, 123). Developing from this, a concern with the sources of museum collections inevitably raises questions about the processes that underlay their acquisition, with this feeding into questions about whether present-day museums are simply representative of colonial mentalities and capitalist concerns about property ownership, rather than with them being the neutral places of learning and contemplation that they may wish to be seen as. The increasing self-consciousness that is evident within the museums field concerning the relationship of museums with direct questions of 'representation, the relations of power, and the historical practices that underlie ... appropriation[,] recontextualisation and interpretation in public displays' (Arnoldi, 1992, 429) demonstrates how these arguments, in turn, have an effect upon what actually occurs within individual museums – affecting what is displayed, how it is displayed and why it is displayed – even if the debate itself often takes place in the much

more rarefied environments of international debate and negotiation, or within the specific contexts of international laws and conventions.

Questions about the status and value of museums, however, are as much concerned with the functions that museums are intended or expected to fulfil as they are about ideology and legitimacy, and it is the combination of these that will be discussed here. The Declaration on Universal Museums (Prott, 2009, 116–17), for example, made claims about the role of these museums in terms of providing a resource that is available for all people that could serve to 'foster knowledge' of other cultures and, by implication, could serve to generate closer links between all cultures through the recognition of their common humanity. Apart from the rather circular logic of this view, it also rests on the assumption that cultural difference is something of an epiphenomenal construct which, rather unfortunately, denigrates the very cultural differentiation that the universal museum is intended and expected to cope with. These problems make the entire claim to universality rather less self-evident than the Declaration asserts, but by claiming such a commonality of humanity and universality of human experience these museums are able to identify themselves as the appropriate mechanism through which nation can speak unto nation and people can speak to each other: the fact that their collections are so large and are drawn from so many different parts of the world provides them with the legitimacy to claim this functional centrality because, after all, which other institution has access to such varied and wide-spread resources?

The validity of the claim to universality may rest on some less than steady logical foundations but that is not really the point of the argument, which is as much to do with the *claim* to universality as it is to anything else. The common interest between museums that is expressed in the Declaration extends to the justifications that it contains for exempting them from calls for the repatriation of material that is contained within their collections, in particular allowing the claim to be made that repatriation would be 'a disservice to all visitors' (Prott, 2009, 116) and that, therefore, the act of repatriation detracts from the common human store that these major museums contain. In other words, without the implicit claim that anybody can have access to the material that these museums contain this legitimating appeal to exemption from repatriation becomes less certain. Given that the Declaration was drawn up during a period when questions of repatriation were being seriously debated at the international level (as they still are) it could also be argued that the museums concerned were also staking a claim to being the sole arbiters of what could be seen to be either right or, at least, acceptable in

terms of their own collections. Given the evident difficulties that there are in implementing international decisions, agreements and standards as a result of the absence of effective enforcement mechanisms, the museums concerned were thus also demonstrating a determination to have the power of decision about questions of collections repatriation vested in them rather than anybody else. Existing remedies concerning the right of museums to retain items in their collections have often depended upon the creation of new national legal mechanisms which have themselves generated long-drawn-out battles in the courtroom (such as in the 'Kennewick Man' case in the United States: see Smith, 2004, 161–73) without necessarily establishing legal principles that can be easily applied in the international sphere. While this may raise questions about the extent to which globalising pressures will lead to an inevitable convergence of policy and practice in the museums field, it may also point to the fact that solutions to repatriation issues have developed in a relatively ad hoc and case-by-case fashion, or have been overtaken by issues that are deemed to be of greater significance for local, national and international communities. Many countries, including the United Kingdom, for example, have seen the disposal of human remains from their collections taking place under the auspices of legislation developed to cover the treatment and disposal of genetic material, with this legislation acquiring a moral and ethical standing that museums have found hard to resist but which originates in concerns that are far removed from those of museums and their collections. Ad hoc and case-by-case solutions rather than those based on matters of principle, on the other hand, are kept firmly under the control of museums and their staff (see, for example, Robbins, 2011) and can, at best, give rise to institutional precedents and procedures for repatriation at the level of the individual museum, and may contribute to national codes of practice (as exist in many countries), but they require a great deal of international debate, argument and straightforward haggling before they can become accepted as providing an international standard that is applicable in all cases and at all times.

At the international level this issue becomes even more complicated by the sheer fact that in many – if not all – cases dealing with museums the concerns of the policy-makers are not simply about museums themselves but, instead, involve matters of international relations and, as a part of these, cultural diplomacy as well. At this level the idea that matters of museum policy should be left to the resolution of museums professionals and practitioners becomes subject to debate and raises questions about where power lies within the international system.

While there is no doubt that crude questions of party and pressure-group politics affect the functioning of national and local museums (as will be seen in Chapters 3 and 4) this dimension of museum politics has only been marginally touched on in the current discussion. The processes by which decisions get made at the international level have never been a simple matter of people of good will reaching a mass consensus about principles and processes that nobody could possibly disagree with. Instead, as any introduction to international relations points out, there are many forms of disagreement between state actors at the international level that can be identified and understood differently depending upon which pair of analytical spectacles are being worn at the time – whether realist, liberal, structuralist, critical, postmodern, feminist or green (as covered in Steans & Pettiford, 2001, and Viotti & Kauppi, 2010, for example). Such a multiplicity of reasons for why disagreement can be generated at the international level runs alongside an increasingly messy framework within which international decisions are reached: older forms of multi-national fora (such as the UN and WTO) where individual states and blocs of states cut deals with each other on the basis of their relative strengths have seen developments that allow for the integration of a wider range of non-state actors than was previously the case. A fragmentation of the traditional mechanisms by which international agreements were worked out and decisions made is seen to be the consequence of this. This fragmentation, in turn, has seen the development of transnational forms of government, alongside the growth of new groups of political actors, whose decisions, interests and concerns contribute to a reconfiguration of power (Cerny, 2010, 64–82) at the international/global level that creates the conditions for these new actors to have an effect on how international decisions are made – and what these decisions will consist of.

The remaking of international politics that is involved in this process could be seen to be a part of a process of top-down political globalisation, where the central decisions affecting societies are made by groups of actors who are not concerned with the particular national interests of publically controllable state actors but, instead, with the specific transnational concerns of particular groups of private interests. It may be more appropriate, however, to see this remaking as forming a part of a widening of participation that has been driven from the bottom up, with groups of actors defined by particular personal interests (such as national, ethnic, religious and class interests) or particular functional interests (such as health, trade, defence or museums) demanding or requiring involvement in international decision-making processes. The

basis for these demands or requirements may be seen to lie in the realm of normative justifications concerning the democratisation of decision-making, or in the realm of functional efficiency, where including expert knowledge and information can provide technical legitimacy for whatever decisions are finally made. In this light it is possible to re-evaluate the manner in which the three core questions being discussed here can be understood.

Firstly, the post-colonialist argument about museums and their collections can be seen to have developed from the changing relationships between the ex-colonisers and their ex-colonies, with these changes feeding in to an increasing assertion of independence and the right to decide for themselves amongst the latter. De-colonisation created the opportunity for the newly independent states of the world to develop their own models of what museums might be and how they might be organised – but this was always within a dominant context that was constructed on ideas derived from what were seen to be the concerns of the Western world which involved a 'singularity of museum conceptualisation, theorisation, practice and appropriation' (Bhatti, 2012, 28). This dominance can be seen to be expressed in the ICOM definition of museums and in its guide to appropriate museum practice (Ambrose & Paine, 2012), both of which derive directly from Western standards and models. Whether such ideas are necessarily applicable in contexts that may have rather different ideas about the meaning of heritage and the status of museum collections is a matter of some concern, particularly when alternative ideas of community engagement become a part of the argument. While this can be, perhaps, most clearly seen in the context of cultural tourism where alternative ideas of authenticity can have a major effect upon what is displayed (Su & Teo, 2009, 112–21), the questions of who has the legitimate right to make decisions on the behalf of national and local communities, and whose meanings are to be made central to the content of displays and exhibitions – let alone whether such displays and exhibitions are appropriate to these communities – are important ones that cannot simply be answered on the basis of what could be seen to be culturally inappropriate assumptions.

In this context the professional and functional underpinnings of the ideas and practices that dominate the existing international perspectives of what forms a 'good' museum are subject to pressure. This pressure stems from a non-museums perspective which is incapable of being managed by the standard claims to professional and institutional autonomy that are currently used. The result is that a range of alternative arguments and positions is increasingly introduced to the existing status

quo and these positions require more and more adjustments to be made to the justifications and legitimations that are given to support current practices – the Declaration on Universal Museums is but one example of this at work. An almost inevitable consequence is that questions concerning museums are being argued about by groups of actors who do not share the professional and functional beliefs that have dominated the international discussions of the past, and new concerns are being increasingly used as part of the debate about what museums are, what they could be, and how they should function. Hardly surprisingly, the widening of the debate to incorporate new groups of actors who are concerned with radically different matters than those previously dealt with in the museums world leads to an increasing politicisation of the sector at the international level in terms of generating new patterns of power inter-relationships, new ideologies, new rationalities and new legitimacies. Thus, while the museums world itself attempts to remain an independent terrain of action, dominated by common core technical and sectoral concerns and understandings, the political reality is one where these are no longer the central matters for discussion, argument and debate. The fragmentation of the previously existing policy-making mechanisms that existed in the international arena can be argued to be leading towards the creation of new arenas of political action that incorporate many new actors who operate on distinctly new bases, even if they have yet to produce completely new international decisions, standards and agreements as a consequence.

Such a result does not mean that the international realm of museum politics is leading inexorably towards either a simple concentration of power in the hands of neo-elitist actors whose concerns extend transnationally across a range of policy sectors, and neither does it imply the simple establishment of forms of neo-pluralism where multiple groups compete to get their interests made central to the functioning of the policy sector. In practice there would seem to be an uncomfortable mixture of the two in operation, with some issues being most heavily influenced by an effective dominant grouping of multi-national actors who share common ground, whilst others are much more open to the interaction of multiple groups of actors whose interests can be advanced by reaching agreement with each other about general principles rather than specific actions. Thus, many areas of museum work are directly affected by the professional standards that are seen to be more or less appropriate to all museums (as, for example, on conservation techniques – although even these have national variations). Other areas, such as repatriation of items from museum collections, however, are much more open in

terms of who the relevant participants may be in any given case, and what the criteria are that may be applied to them, and how legitimacy may be created to justify the solutions that are produced.

Not surprisingly, the consequences of these differences in policy-making style have implications for what may be expected to be the forms of policy agreement that are produced. Thus, the professionally dominated policy-making arenas are likely to produce policies that can be implemented without the need for large-scale debate about the specific detail of what these policies are to contain. While these policies may not be easy to police or enforce at the international level their basis in agreed forms of technical rationality and legitimacy will generally provide them with sufficient force to make such policing and/or enforcement an unnecessary concern as the participants have already agreed upon what the rules of the policy game are to be. More open and less formally technical policy issues, however, will lack such underlying support, leading to conditions where clashes over values, meanings, technical justifications and legitimations are commonplace and, moreover, where the basis for establishing agreement is decidedly unclear. This means that agreements become subject to individual negotiation between groups of actors who need to determine not only what the result of the negotiation will be but also the basis upon which the negotiation will take place in the first instance. As might be expected, the chances of creating a set of international enforcement mechanisms that can be applied in most, if not all cases, of museum practice is extremely limited in these circumstances. The development of agreements in instances where there are major disputes between a limited number of participants about the validity of existing practices can be difficult – although certainly not impossible – but establishing an overarching framework that can cover all instances of practice when there are, or potentially are, much larger numbers of participants to take into account is, to say the least, even more so.

Thus the international level is subject to multiple tensions between actors operating on widely divergent lines of practice and belief. These tensions have become increasingly evident as the balance of power within the global museums system has become more fragmented and as the nature of the debates that are generated within the system become more diverse. When the world of international museum politics was more or less limited to questions of technical efficiency and effectiveness, and the range of actors who were involved was limited to professional technocrats, it was capable of being managed fairly easily as underlying justifications of action and forms of legitimacy were, more

or less, accepted by all the key actors involved in the system. When these conditions started to be challenged then cracks in the superficial uniformity of the system began to appear. The rising challenge to professional dominance that has been produced was not simply the result of new exogenous political pressures being applied to the system: it was also affected by the reappraisal of professional practice from within the system itself. The reappraisal and reapplication of underlying ideological commitments within the museums community from the 1960s onwards contributed to the development of attitudes and practices that cast doubt on many of the previous certainties that the museums world rested upon, not least the perceived inward-looking nature of professional practice that the 'new museology' was particularly concerned with (Vergo, 1989; Harrison, 1993; Stam, 1993). How this worked in practice at the level of individual museums is considered in much greater detail in Chapter 4, but it certainly contributed to the fragmentation of the international consensus about museums that had developed over previous years.

Conclusions

It is difficult to arrive at any simple conclusions about how the politics of museums operates at the international level. Certainly any attempt to produce meaningful generalisations about the subject that are based on a limited number of case-studies and examples is likely to be misleading, if only because of the complexity of the range of political issues that are generated cross-nationally. As the discussion about repatriation, post-colonialism and the museum as a Western cultural construct demonstrated these issues feed into a range of other concerns that extend the argument far beyond the specific matters that these core questions raise. Certainly this explains why this discussion has not investigated the tangled nature of the precise positions that are commonly adopted in the consideration of these issues but has, instead, been more concerned with the overlapping of matters of power, legitimacy, rationality and ideology that lie at the heart of the debate. The lack of a stable consensus at the international level about these key political variables accounts for the complexity of the arguments that are generated within the museums world, and this absence is a direct consequence of the changing relationships that exist between key groups of actors within the sector, particularly those between national governments, professional technocrats and the diverse sets of interests that represent individual communities and ideological positions. Despite this, however, some

generalisations can be made that are concerned with the consequences that are generated by the complex workings of international actors and organisations who are involved at the international level of museum politics.

Changes in the relative position and political centrality of these groups have undoubtedly led to a position where the older certainties of museum practice are becoming replaced by newer *un*certainties, and a key concern is where these changes are leading. The 'punctuated equilibrium' model (True *et al.*, 2007) would imply that a new systemic policy stability will eventuate, even if this claim largely rests on a number of assumptions, not least that large-scale policy change is much rarer within policy sectors than is policy stability and, therefore, the establishment of a new framework within which stability can function is the likely outcome of large-scale changes to existing systems of organisation and practice. If this is the case in the museums sector the implication is that the international level of museum politics is seeing a shift from being a largely technocratic and politically unimportant issue area to one where multiple political concerns can find an environment for their expression, leading to a probable increasing politicisation of the sector, and, consequently a replacement of professionally based rationalities and ideologies by other legitimating factors. These factors will, in turn, provide new conceptions of the validity and propriety of social action (Johnson *et al.*, 2006, 55) within the sector that may well lead to, as appears to be increasingly the case, the introduction of new actors into the system. This could then become a mutually reinforcing cycle of change: new ideas are supported by new groups who contribute further new ideas, which encourages the introduction of more new groups. At what stage such proliferation of group involvement would actually stop is unknowable although, following the standard neo-pluralist model which underlies punctuated equilibrium arguments, it would be likely to be when all relevant group interests are finally integrated into the system, however complicated and long drawn-out this process may be.

A major concern with such an analysis, however, is that it tends to view the museums sector as being a single entity. If this assumption is changed to one where the sector is seen as being already fragmented into multiple sites of action – a polycentric view of the system – then what is occurring in one part of the system need not necessarily be reflected in other parts. Certainly the museums sector can be seen to be divided across a number of dimensions, both vertically and horizontally: vertically, the concerns of the sector are effectively divided

between multiple policy sectors that operate on the same subject matter (thus museum education is closely related to general educational policy concerns that are part and parcel of a quite separate policy arena), while at the same time the museums sector is itself vertically divided between separate functional concerns (such as education, conservation and curation) which overlap and bleed into each other. Horizontally, the core geographical division between matters of international, national and local or community concern changes the nature of the issues that are seen as being appropriately discussed at each level (the museums equivalent of the concept of 'subsidiarity' as employed in the European Union: see Jones, 2007, 55; McCormick, 2011, 147), as well as who the appropriate policy actors at each level are seen to be. In this respect the presence of multiple groups of actors pursuing diverse (if not positively divergent) policy ends would be seen as being absolutely normal. Change, in this case, is not being driven by changes in the number of groups or their nature but, instead, by changes in the policy significance that issues have. This shifts attention away from the structure of the policy environment and much more towards the policy agendas that underpin the international politics of the museums sector and its component sub-sectors.

Thus, to understand the difficulties in international museum politics requires an examination of the complex interactions between policy interests, the ways in which policy issues are understood by differing actors, the parameters of action that actors believe themselves to be constrained by, and the distribution of power within the component element of the policy system that is being investigated. Not surprisingly, the combination of national interests, group dynamics and control of key resources that vary across specific policy issues within the museums world contributes to the creation of a situation where the establishment of common territory to provide general principles to underpin the functioning of the system is immensely difficult. When the added complexity of globalising tendencies, with their differential effects on ideologies and legitimating principles, and their impact on much more than simply the museums sector, are added to this it is hardly surprising that there is no single model of international museums policy and politics in place that can provide a set of uncontested principles, agreements, decisions and standards that is appropriate for all actors. In these circumstances it is equally as unsurprising that those areas of museums policy where some form of international unanimity has been created are those where technical considerations have acquired a position of prime importance. The establishment, for example, of sets of technical and

professionally endorsed standards and codes (or, at least, ideas) of good practice by ICOM (Ambrose & Paine, 2012) is posited on the assumption that such technical matters are independent of the preferences of individuals or groups and rely, instead, on ideas of means-ends instrumental rationality that are expected, in classically bureaucratic fashion, to lead to the establishment of technically superior forms of administrative organisation (Weber, 1978, 973). This devolves power and authority into the hands of those who control the necessary technical knowledge that is used to legitimise this position – a further display of circular reasoning within the museums sector. This perceived technical necessity then reinforces the depoliticisation of this dimension of the museums sector by denying the relevance of exogenous factors for the effective and efficient management of the sector.

Once again, this discussion establishes the idea that much of the international political dynamic of the museums sector is constructed on the basis of countervailing currents where pressures in one direction (such as a politicisation of the museums agenda at the international level as a consequence of the integration of new groups into the arena) are met by opposing tendencies (such as a depoliticisation of the sector through control of technical knowledge by professional groups) that are operating on quite different principles and which rely upon different legitimating arguments and justifications for their significance for the system. The status that different groups have within the system, and the roles that they undertake within it, are largely determined by the nature of the individual issue that forms the heart of the debate at any given time. This means that there is an inevitable variability about how the system functions, and what are perceived to be central matters of concern for resolving matters in one case are potentially, if not probably, unlikely to carry much weight in other circumstances. Thus, the moral and ethical concerns that are commonly associated with the rights of individuals, groups and nations to control the representation of their cultures through the display of elements of their tangible and intangible heritages (Kearney, 2009, 218; Harrison, 2013, 220–2) can be of central importance for museum managers if these elements carry particular meanings within them that can justify the return of these elements to source communities or which affect how they can be displayed. If, however, the underlying principle of authenticity upon which such moral and ethical concerns rest are not taken seriously by the participants who are involved – as, for example, in many areas of cultural tourism (see Timothy, 2011, 103–26) – then these concerns lose their relevance and may well be replaced by such matters as using museums

for increasing or creating employment opportunities, or regenerating run-down urban areas if these are seen by policy-makers, managers and community members as being of greater importance for their own particular interests and concerns.

To say that the international politics of museums is complicated is something of an understatement. This is not simply to do with the multiple and shifting sets of participants who are involved in the sector, it is also to do with the lack of simplicity in terms of the issues that underpin political activity at the international level. As is evident, multiple levels of debate and context inform activity within the museums world, and many of these derive from policy concerns that may be far removed from those of museums themselves. As will be seen in Chapter 3, the pressures for an instrumentalisation of museums and museum policy to incorporate these extra-museal concerns can be extremely tempting for policy-makers, either within the museums sector itself or external to it. At the international level the multiplication of demands and expectations that arises from the multi-functional nature of museums and the museums sector as a whole simply adds to these pressures whilst denying the prospect of an easy discovery of acceptable solutions to what are often seen or understood as being intractable social, political, moral or ethical problems. To this extent museums, when considered at the international level, are in an extremely difficult position – expected to resolve multiple problems, or to form the battleground within which these problems can be fought over, but lacking any unifying basis upon which either of these could be done in such a fashion as to satisfy all the participants. The developing division between endogenous, professional, standards and agreements and a wider world that does not necessarily see such technical or technocratic solutions as being appropriate for the resolution of their concerns means that it is unlikely that such a basis will be constructed in the foreseeable future.

3
The National Politics of Museums

Introduction

Chapter 2 focused primarily on the difficulties of creating an internationally agreed arena within which common questions about museums could be debated and commonly acceptable solutions to these questions could be found. Inevitably this involved discussion not of the actual questions themselves but, instead, of the complex nature of the structures and processes that underpin the search for international agreement in the museums sector. If nothing else the chapter demonstrated that the international politics of museums and the museums sector are largely associated with a host of issues and problems that are not specifically concerned with the functioning of museums themselves but, rather, with much more far-reaching matters, such as post-colonialism, globalisation and community recognition. Apart from those areas of museum functioning that are dominated by professional interests based upon largely technical ideas about appropriate behaviour and practice, this has meant that it has proved difficult to establish much in the way of effective guidance or agreement about what museums should be doing, how they should be doing it, and what purposes might be seen to be worthwhile ones for museums to pursue. In practice, however, these concerns do have a number of clear solutions associated with them, but to find these requires a shift in focus away from the international and towards the national arena. This chapter, therefore, is concerned with identifying how museums are used at the level of national political activity; which functions they are intended to fulfil on the behalf of national political actors; and why these political choices are the ones that get made rather than any of the other possible choices that could have been made. A focus on these concerns provides the opportunity

to establish how the national arena differs from the international one, and to identify both the causes of these differences and their consequences for what actually takes place within museums. As will be seen, this involves a consideration of different combinations of actors, organisations and interests to those which are central to the international level, with these producing quite different ideas about how museum policy is to be understood, who is responsible for making it and which issues are of central concern for the participants in the system. Alongside these, the ways in which museums are made use of reflects the importance of the specifically political choices that national politicians make and the consequences that these have for the inhabitants of different countries.

What are museums for? (Part II)

Chapter 1 identified four sets of functions that museums can be seen to have: core, intrinsic, use and community/societal. In practice none of these is unaffected by the choices that are made at the national political level. While 'intrinsic' functions may, by their very title if nothing else, be thought to operate in isolation from the mundane realities involved in the exercise of political power they are, in fact, intimately bound up with questions of legitimacy and ideology, leading to conditions where museums are, whether consciously or not, affected by the political context within which they are functioning. To illustrate this consider how museum collections are exhibited and displayed. Even if there is no direct pressure placed upon those with the responsibility for organising the layout, content and labelling of exhibitions and displays – and there is certainly a great deal of that in evidence, as later discussion will demonstrate – these activities can be seen to contain political messages of their own, even if only at the level of what is included and excluded for presentation within museum galleries and rooms. This fact leads to the creation of two arguments to understand the essentially political nature of museums at the national level: the first is concerned with the classic humanities approach of 'reading the text' of the museum, and the second with the empirical analysis of the choices, and non-choices, that museums staff make as part and parcel of undertaking their intrinsic functions, as well as the perceived effects and consequences of museums in terms of visitor appraisals and other outcomes of museum activities including their social and economic impacts.

The former of these approaches is commonly to be found in the museums studies literature, leading to a range of discussions concerning the

uncovering of what museums stand for within societies on the basis of how patterns of display work to create everything from new patterns of social control and status differentiation in the context of changing relationships between power and knowledge (Bennett, 1995, 59), to ideas of national identity itself (Hooper-Greenhill, 2000, 25), to the elaboration of how dominant political ideologies are given corporeal form through processes of exhibition and display (Varutti, 2014, 120–43). Much of this discussion is as concerned with the post-structuralist identification of *absences* within what it is that museums present to the viewing public as with the specific content that is on display. Given that this discussion essentially boils down to either implicit or explicit criticism (or, at least, a critical reading) of the choices that museums staff make about what to show and how to show it, it is as much a reflection of the particular ideologies that are to be found in the museums studies world as it is of anything else. In consequence, this form of analysis is itself deeply political in nature, displaying not only potential differences in ideologies between practitioners and academics, but also differences in the nature of the legitimations that are put forward in support of the positions that have been adopted by the protagonists in the debate. This is not to say that the arguments themselves are wrong, simply that they have their own political axes to grind and this should be recognised as being part and parcel of the range of critical approaches to analysis that underlie these debates (Bennett, 1998, 1–8; Gray, 2010). The focus within these approaches and debates is usually decidedly upon the specific content of museums, although it can also be concerned with much wider issues concerning how museums, both individually and collectively, undertake their varied functional roles. Questions of museum architecture, for example, and its role in establishing the frameworks within which meaning is created through the presentation of material and immaterial parts of museum collections (MacLeod, 2005, 2013; Ekman, 2012; Hanks, 2012) point to issues of institutional form (both literally and metaphorically) that extend far beyond what is contained inside the walls of the museum itself in terms of their actual collections.

The second, empirical, approach differs from this humanities-derived approach at both the methodological and epistemological levels (and, sometimes, at the ontological level as well). The focus within it is not so much, if at all, on the meanings and understandings that can be gathered from an examination of museum contents as on the detailed analysis of the processes that are involved in the making of decisions about museums per se, both as an institutional form and as a collections repository. While the end result of these decisions forms the

major focus for more humanities-based approaches to museums, the more empirical approach that is adopted elsewhere is concerned with how these decisions were arrived at in the first place. Neither approach completely ignores the questions and issues that their alternative gives rise to, and both are explicitly concerned with the exercise of power by individuals, groups and governments and how this is used to create ideological meaning and to provide a legitimacy for whatever it is that museums are doing. The differences in favoured analytical approach, however, do tend to focus attention on different dimensions of the national politics of museums. Thus humanities-based approaches have a tendency to focus on immaterial matters concerned with feelings, emotions and meanings, while more empirically based approaches tend to be more hard-headedly concerned with direct forms of evidence that are more commonly quantitative rather than qualitative (although, again, both approaches can, and do, make use of their alternative as well). Returning to the question of museum functions provides an opportunity to identify how their analysis has produced some common sets of ideas and images of what the national politics of museums looks like. As will be seen, there are, however, in some areas clear differences between humanities and empirical approaches in terms of these ideas and images that demonstrate that the national politics of museums can be understood in different ways depending upon where analysis starts from.

The difference between these approaches point in the direction of different dimensions to politics, with the more humanities-based approach being concerned with implicit political meanings as conveyed through the ideological content of museum displays, and their role in providing forms of legitimacy to museums and their activities, while more empirically based approaches are more explicitly concerned with directly overt versions of the politicisation of museums and their contents by particular sets of actors. To illustrate this line of argument the manner in which each set of museum functions are seen to operate at the national level will form the focus of the following discussion. Almost inevitably it will become apparent that any simple differentiation between groups of functions serves only an analytical role as, in practice, there are numerous overlaps and necessary inter-linkages between them. It will also become apparent that there is a large degree of difference between nation-states in the roles that they expect museums to fulfil and how they expect museums to undertake their functions: in some cases museums are used as directly political tools with an expectation that they will undertake a clearly political role on the behalf of national

governments; in others a much more 'hands-off' and 'arm's-length' approach is adopted where direct control of museums is uncommon but an unspoken set of political beliefs can be seen to underpin what occurs within them. To a large degree this difference is explicable by reference to straightforwardly political variations between nation-states – as in the crude distinction between western-style liberal democracies and variations of authoritarian or totalitarian systems of government – with the specificity of museums forming a much smaller part, if any part at all, in this explanation.

To illustrate these cross-national differences a number of particular issues that derive from the variety of functional activities that museums undertake will be used to demonstrate the multiple ways in which national politics informs the politics of museums. For core functions an examination is made of how much national governments spend on their national museums: this can serve as a proxy for whether national governments care much about museums in an absolute sense in the first place (that is, do they put their money where their mouth is?), and how important they feel their national museums are in a relative sense (how big a share of public expenditure national museums receive can act as an indicator of the place of such museums in the political and policy pecking-order of nation-states). For the intrinsic functions of museums the freedom of curators to determine the content of museum exhibitions and displays forms the focus, with special reference to periods when there is, or have been, significant changes in the political structures within which national museums are functioning, as in the period following the collapse of the iron curtain in Europe (see, for example, Badica, 2011; Kaluza, 2011; Runnel *et al.*, 2011; Sharenkova, 2011) and the more drawn-out periods of change following market liberalisation in China (Law, 2014; Varutti, 2014, 159–63), and the establishment of the new, post-revolutionary regime in Cuba after 1959 (Gonzalez, 2015): how free are curators to exercise their professional judgements in the context of governments who determine a clear political role for national museums in the provision of systemic legitimation and ideological support? For the use functions of museums, their instrumentalisation (or not) by national governments will be used. Explicit instrumentalisation implies that political, economic and/or social values and rationalities are seen as being more important than those endogenously provided by museums; while perceived instrumentalisation, as a consequence of museums staff undertaking processes of policy attachment (Gray, 2002), identifies a much more politically aware and active control by professional staff over what happens to and within museums than might

otherwise be anticipated to be the case, providing a greater level of local and internally determined political control over what museums do, and how they do it, than a straightforwardly top-down focus on national politics provides. Finally, the manner in which the staff within national museums manage demands for improved community and societal engagement will be used to examine the outward-facing functions that museums undertake. This will focus on the top-down demands of national political actors for engagement with, for example, ethnic or religious minority groups within society, or working-class people – all of whom are commonly found to be less frequent museum visitors in the first place (and thus not benefitting from them) – or who are commonly assumed to be less well integrated into the political system than other societal members and would, therefore, benefit from museum engagement as a means to effective social integration. (The opposite position of bottom-up activism where community groups actively seek to engage with museums, or where museums actively seek to engage with local communities, regardless of the demands of national political actors, will be discussed in Chapter 4.)

Are national museums politically important?

In terms of being capable of undertaking their whole array of functional activities national museums require a number of things to be made available to them. At the very least these would include some sense of legitimacy to underpin their status as being 'national', with this often being found in ideological constructs of 'nationhood', 'nationalism' and 'nationality' (see the discussions in Smith, 1971, 1995, 1999; Anderson, 2006 [1983]; Mason, 2007; Preziosi, 2011; Shelby, 2014). Secondly, the basic resources of finance, staff and accommodation are needed to provide an embodiment of what these ideological constructs stand for. While it is perfectly feasible for this ideological representation to occur through the simple practice of everyday lived experience – as in the case of intangible heritage – without the requirements for a formal location to house it or official staff to curate, manage, display and explain it, the more normal idea is that these formally identifiable components are what make and give a museum its meaning, particularly in the context of preserving the nation's core memories and artefacts. Thirdly, the *national* museum as a generic type of institution must have as its central role the presentation of a nation to itself: its contents, and how these are explained, must contribute to perceived and accepted notions of what the nation is. This then reinforces the dominant ideologies that

surround the idea of the 'national museum' with these in turn then reinforcing the legitimacy that the institution rests upon.

In practice, each of these requirements depends upon the extent to which governments support their national museums. Whilst it may be anticipated that the role of national museums in contributing to the presentation, if not the direct idealisation, of what the nation stands for (McLean, 1998) would be something that governments would be in favour of and, consequently, would actively support, the level and nature of this support need not necessarily be positively wholehearted. The commitment that governments have towards their national museums will be influenced by multiple factors that rarely have anything at all to do with their status or the role that they are expected to fulfil, and a great deal to do with the circumstances within which governments are functioning. The ex-British Prime Minister Harold Macmillan was once asked what were the underlying issues and ideas that had had the greatest influence on what he did. His reply was 'events, dear boy, events'. Such a view that political action is simply a matter of contingency may well be overstating the case, but to deny that 'events, dear boy, events' can be of central importance for governmental activity would certainly be to underestimate their importance for everyday political practice.

One way of assessing the extent to which governments are committed to their national museums lies in examining the financial support that such museums get from governments. Rather than look at this in the crude terms of how much individual governments spend on their national museums – which may say nothing more than that some countries have bigger economies than do others – a more sophisticated approach would involve examining two things: the relative amount of public expenditure that governments commit to their national museums, and a longitudinal analysis of changes in financial support for them. The first of these will provide an indication of where national museums lie in the hierarchy of importance that governments give to the multiple activities that they fund. The second will indicate whether museums are more or less favoured than other policy areas when public expenditure grows or declines. The second of these is important as there are clear financial differences between the functions that governments have committed themselves to: providing a national system of social security, for example, is always going to be more expensive than providing a museum will be, simply in terms of the numbers of people involved in the former as tax-payers and recipients of benefits; equally, defence will be more expensive as a result of the heavy, and ongoing, capital costs that are involved in providing this function which are

not normally to be found in the case of museums. To take account of these functional differences a longitudinal analysis would identify how national museums fare in comparison with other policy sectors with this serving to demonstrate the extent to which political support for national museums feeds into concrete policy commitments and outcomes. Gray & Wingfield (2010) applied these ideas to the central British national government culture department, the Department for Culture, Media and Sport (DCMS), for example, and found that it had a low status in comparison with other departments.

Longitudinal analysis can also be used to allow for an incorporation of how different states respond to a combination of national and international factors when making their policy decisions. Aronsson (2011, 46–8) has argued that the historical context within which national museums are functioning has important implications for state-museum relationships and the uses to which museums will be put, with these altering in the light of changes in the level of state development. Thus it might be anticipated that the political status of national museums would be greater in the early stages of state development or post-revolutionary change than it would be when states are well-established and have long periods of ideological stability (if not stasis) and accepted legitimacy behind them: the role of national museums in supporting the establishment of images of what the new nation-state is, and what it stands for, will be politically more acute in the former rather than the latter case. To establish the validity of such a view requires longitudinal analysis rather than the taking of snap-shots of particularly politically fraught periods. In a similar vein, the impact of international events can, and does, have significant implications for how governments will behave, and will affect what they perceive their limits to action are. The impact of this on the relationship of national governments to their national museums can be important not only for governments but also for the populations of nation-states, with national museums having the potential to reinforce established perceptions of national identity and meaning, or to change these to take account of new circumstances. If the financial support that governments give to their national museums stays at the same level (either absolutely or relatively) or noticeably declines during periods of national and international tension then the assumption would tend to be that governments do not consider that these museums have any significant role to play in national affairs, certainly not politically. If, on the other hand, levels of financial support grow then the assumption would be that national museums are seen to have a positive function to fulfil, and this can only be done if the resources are

made available to allow this to be effectively undertaken. Thus empirical analysis provides the basis for examining all these concerns.

While the identification of the importance of empirical analysis to inform any understanding of the national status of museums is reasonably evident it is quite another matter to establish the evidence base that can be used to answer the questions that have been asked: specific expenditure data on museums is not the easiest thing to find in most national accounts and budgets. This in itself is indicative of the relatively low status that the museums sector as a whole has in most countries and reflects the absolutely (and relatively) small amounts of money that governments spend upon them. For this reason a brief examination of national museums funding in the UK, where expenditure data is reasonably easy to obtain, is used to illustrate what can, and cannot, be said about these museums in terms of their political status for national governments at a preliminary level. The analysis that is provided here is by no means a complete one and should be seen as a starting-point for more detailed investigations of how the UK's national museums are ascribed political meaning, with this also establishing a starting-point for the analysis of the status of national museums within other political systems as well. Table 3.1 provides a summary of the public expenditure on the museums sector in England that was undertaken by the DCMS between 2001/2002 and 2013/2014, with this expenditure being divided between the grants that were given to the 15 national museums and galleries which the government directly funded, and the more general forms of financial support that the government provides to the rest of the museums sector through the grants that it makes which are passed on to local authority, university, private and community museums through the means of state supported quasi-governmental organisations (in the UK these are known as Non-Departmental Public Bodies).

The focus in this Table on England points to one key factor above all others – the national cultural department in the UK does not provide direct financial support for the national museums and galleries in Scotland, Wales and Northern Ireland: responsibility for these was devolved and/or delegated to the Scottish Parliament and the Welsh and Northern Irish Assemblies as part of the constitutional reforms undertaken by the Labour Party in the late 1990s. The consequence is that there is now a clear hierarchy of status between those museums that are truly 'national', intended for the people of the entire country and directly funded by the national government, and those that are regional (or 'provincial') ones. Even though these regional museums and galleries

Table 3.1 National government expenditure on museums in England, 2001/2–2013/14

Year	National Museums	Museum Support	Total
2001/2	193,147	19,658	212,805
2002/3	216,106	22,040	238,146
2003/4	229,589	17,589	247,178
2004/5	239,681	18,693	258,374
2005/6	257,469	47,790	305,259
2006/7	360,685	39,718	400,403
2007/8	379,314	60,256	439,570
2008/9	393,606	51,764	445,370
2009/10	430,111	55,127	485,238
2010/11	444,185	62,623	506,808
2011/12	513,527	58,554	572,081
2012/13	496,560	71,382	567,942
2013/14	429,926	68,806	502,562

All figures in £000
All figures expressed in real terms (2008=100): inflation figures derived from *United Kingdom National Accounts: The Blue Book* (various years, Basingstoke, Palgrave Macmillan)
Figures calculated from:
Department for Culture, Media and Sport, *Consolidated Resource Accounts* (Various years, London, DCMS)
Department for Culture, Media and Sport, *Annual Report and Accounts* (Various years, London, DCMS)
Arts Council England, *Grants-in-Aid and Lottery Distribution Annual Report and Accounts* (Various years, London, Arts Council England)

have a national status in Scotland, Wales and Northern Ireland, the fact that the national government of the whole of the UK does not directly fund them indicates that they are not seen in the same light as the other (UK-wide) national museums and galleries. Indeed, the funding received by the UK nationals is directly negotiated between the individual museums and galleries concerned and central government, and this is undertaken through mechanisms that the Scottish, Welsh and Northern Irish 'nationals' do not, and legally and constitutionally cannot, take part in. At the very least this adds a degree of peripherality to these latter museums and galleries – with their funding being determined at arm's-length to the centre of national government – and effectively makes their political status for the nation as a whole somewhat tenuous at best, even if they carry real significance and meaning for their own countries.

A second point to note from Table 3.1 is that, in real terms, there is no consistency in terms of the overall allocation of national government money to either the nationals that they have responsibility for, or the

wider museums sector as a whole. Some of this can be accounted for by the small size of this national expenditure in absolute terms: while average annual expenditure of just under £399 million over the period from 2001 to 2014 appears to be a great deal of money it only takes one major piece of expenditure to dramatically skew the overall figures. Given that there have been major redevelopments of the Tate Gallery (costing national government £50 million), the Science Museum and the Natural History Museum (where the development of the new Darwin Centre between 2006 and 2008 cost national government £78 million) in the last 15 years, the variability that there is in overall expenditure can be relatively easily explained with rises and falls in expenditure being directly affected by individual large-scale capital projects. Alongside this, however, there is the clear effect of the economic downturn in Britain in 2008 (matched in many other Western countries) which now appears to be feeding into declining overall support from central government for both the nationals and the wider museums sector. Given the relatively small amounts of money that each of the nationals receives – in 2013/2014 the British Museum, for example, was given direct grant-aid of just under £44 million, and the Geffrye Museum almost £1.8 million (DCMS, 2014, 128) – any loss of income is likely to have important consequences for what they can do and how they can do it. As the national museums are frequently the subject of political encomiums about their importance, not only for the UK but also, in terms of their claimed universal significance, for the entire world, the limited financial support that they receive raises questions about whether this verbal support is merely rhetorical rather than anything more meaningful. This is particularly marked when it is noted that total central government expenditure, in real terms, in the UK in 2007/2008 was a little over £574 *billion* in comparison with museums expenditure in the same year of £439.57 million – 0.00077% of the total amount spent by central government.

Viewed in these crude financial terms the national museums sector in the UK is either remarkably cheap to run or it is not seen to be as worthy of support as many other areas of public expenditure. Given that the latter covers everything from national defence to education to health care to social security this may not be surprising, particularly given the political significance that is attached to these areas of 'high' political status in comparison with the seemingly 'low' status (Bulpitt, 1983) that is attached to the museums sector. Table 3.1 does not, it is fair to say, take account of the expenditure on museums that is undertaken by local authorities, for example, and thus significantly underestimates the *total*

support that is given to the system by public organisations, but in terms of the symbolic role that is assumed to be attached to national museums it would appear that an annual expenditure of around £6.49 per capita a year is a very small amount to pay to maintain them. It is in this light that comparative figures may be revealing given an assumption that there is a certain element of political complacency about the role and importance of museums in the UK as a result of their long established and entrenched legitimacy within the political system as a whole, with this not appearing to be supported by the provision of large-scale financial support for them. A comparison with the figures in Table 3.2 detailing public expenditure that is made by the Scottish Parliament on their own national museums and galleries, and their contribution to the more general museums sectors in Scotland over the same time-period of 2001/2002–2013/2014 can serve to start this comparison.

Table 3.2 Scottish government expenditure on museums in Scotland, 2001/2–2013/14

Year	National Museums	Museum Support	Total
2001/2	12,344	2,318*	14,662*
2002/3	13,772	2,461*	16,233*
2003/4	14,689	2,759	17,448
2004/5	16,858	2,723	19,581
2005/6	20,473	1,754	22,227
2006/7	23,507	1,861	25,368
2007/8	24,927	2,092	27,019
2008/9	27,988	2,104	30,092
2009/10	31,299	2,060	33,359
2010/11	32,932	5,122	38,054
2011/12	29,401	3,562	32,963
2012/13	25,886	3,136*	29,022*
2013/14	27,265	3,303*	30,568*

All figures in £000
*Estimates
All figures expressed in real terms: 2008=100: inflation figures derived from *United Kingdom National Accounts: The Blue Book* (Various years, Basingstoke, Palgrave Macmillan)
Figures calculated from:
National Museums Scotland, *Annual Report and Accounts* (Various years, Edinburgh, National Museums Scotland)
Museums Galleries Scotland, *Directors' Annual Report and Financial Statements* (Various years, Edinburgh, Museums Galleries Scotland)
The Scottish Government, *Draft Budget* (Various years, Edinburgh, The Scottish Government)
The Scottish Government, *The Scottish Budget* (Various years, Edinburgh, The Scottish Government)

While, not surprisingly, the total expenditure in Scotland is considerably smaller than for the UK nationals as a whole the Scottish Government does appear to spend more, in relative terms at least, on their national museums and galleries than the government of the UK spends on the nation's equivalents: 0.0010% of identifiable Scottish public expenditure. This fact could be taken to mean a number of different things – not least that the Scottish Government could be assumed to ascribe a greater importance for the nation to its' national museums than the government of the UK as a whole does. Such a claim, however, is not strictly tenable as the Scottish Government has limited, if any, control over expenditure on social security and defence – which are major component parts of total public expenditure in the UK – and so the comparison is not entirely fair on either party. A more direct comparison of museums expenditure in the two countries can be obtained by comparing the total amounts of money that are spent by national governments purely on the museums sector as a proportion of each other's expenditure. This demonstrates the comparative weighting that is attached to museums expenditure in each case, and can be assessed in terms of the population size of each country: if, for example, Scotland had 10% of the population of the UK as a whole then it might be thought to be appropriate in equity terms if it spent 10% of the amount that the UK spent on the museums sector. In practice, on the basis of the 2011 Census, Scotland has 8.38% of the total population of the UK.

The comparison shown in Tables 3.1 and 3.2 certainly demonstrates how small is the amount that is spent on supporting the rest of the museums sector in both the UK as a whole and in Scotland specifically, and how relatively small absolute changes in expenditure in the English case shift the ratio of support between the two systems quite considerably. The figures in Tables 3.1 and 3.2 could, again, be taken to show that the Scottish system is less generous to its national museums than is true for England and the UK as an entirety, as the average of Scottish expenditure of 6.64% of the English total is considerably smaller than population size might warrant by itself. On the other hand, however, other support by the central state in Scotland to the overall museums sector is running at an average of 7.41% of the English total over the period of 2001–2014 which is less, if not by much, than population size by itself might warrant. Of course, decisions about public expenditure are not made simply in terms of population size – even if national funding support to the Scottish political system is tied to population through the workings of the Barnett formula (Peele, 2004, 63) which provides for 12.5% of UK public expenditure to be undertaken in Scotland, and this is

considerably larger than the actual population share that Scotland has. Using the Barnett formula figure reduces the relative share of expenditure on the national museums and galleries, and the level of general support to the overall museums sector, in the Scottish case as the Barnett expenditure ratio of 12.5% is far from being matched. In general terms it could be argued that the Scottish governments of the recent past have not seen financial support for the museums sector and their own national museums and galleries in as supportive a light as has been the case in England. Apart from such general conclusions, however, it is difficult to say more on the basis of these expenditure figures without having more specific information about how and why states and governments make their decisions about support for museums in comparison with their support for other areas of public expenditure which means that there is something of an analytical black hole in this area which the quantitative information contained in Tables 3.1 and 3.2 deepens rather than resolves.

To return to the original question for this section – are national museums politically important? – the answer must be multiple: it depends upon what is being examined. In terms of expenditure data, for example, they are certainly not over-endowed with resources in comparison with other policy sectors, neither are they central components of debates about levels of public expenditure (quite probably as a result of their relatively small size in comparison with other areas of expenditure). On the other hand, however, museums are persistently held up as being markers of national identity and symbols of national status and are often used as important elements for the exercise of cultural diplomacy (Nisbett, 2013). In each of these it is not that museums are important in themselves but, rather, it is the roles that they are utilised for which provides their importance and significance. In this respect the long-standing concerns about the instrumentalisation of museums and the museums sector as a whole have a firm basis in the realities of the politics of museums, with this concern being a reflection of the multiple uses to which museums can be put and their multi-functional nature rather than anything else. In this respect it is how and why national museums are utilised as they are which becomes important in the context of this chapter.

Politics and the exercise of power

Regardless of whether national museums have any particular political significance for national governments in the grand scheme of things,

the question of whether central political actors are capable of exercising direct and indirect control of what occurs within museums is an important one to consider. This importance derives from the issues that are generated by concentrating on where power lies within national museums. Are the key decisions made by core professional staff operating within the parameters of accepted technical standards where the central concerns are those of the museological community, or are they made externally to the museum on the basis of political rationalities that need not take any account at all of the internal dynamics of museum functions? Certainly the issue of museum funding has implied that political actors make their decisions for a wide range of reasons that need not be, and very often are not, directly related to the interests of museum staff per se or, indeed, to the role that museums fulfil within societies, but these funding decisions are only one part, if a very important one, of the complex relationships between national museums and the people to whom they are ultimately answerable. To examine these relationships simply from the perspective of national museums would be to leave any understanding of why political actors behave as they do in a black box of unknowingness, thus it becomes necessary to also examine what it is that central political actors seek to achieve through their relationships with national museums.

In the first place the symbolic role of national museums in acting as some form of representative statement of what a nation stands for can be of great importance for political actors. The possibility of using museums to tell a story about the nation to the nation raises the questions of what this story is, who is telling the story, and who the story is being told to At this relatively crude level the basic role of museums is to, more or less, act as the bearers of some type of ideological and legitimating message that can serve the purpose of establishing a form of hegemonic statement about how the nation is to be understood, not only by its own inhabitants but also by visitors, tourists and the whole outside world. Actually establishing the conditions in which this sort of ideological message creation can take place depends equally upon political actors being in a position to exercise the appropriate manipulation that will allow their preferred images of the nation to be put in place, and on the external world being in a position where these images can be taken on board (Al-Ragam, 2014). In practice this is rarely something that occurs through the exercise of direct control over museum contents and practices by external political actors – although, as will be seen, this can and does happen – but is, instead, a much more general political process involving the establishment and exercise of national

legitimation through the establishment of principles of validity and propriety (Johnson *et al.*, 2006, 55) in the context of museum practice itself. This implies that external political actors rarely exercise their authority and power entirely independently of internal museum staff. Instead, there is a continual cross-fertilisation between the two sets of actors the outcome of which is the creation of an accepted museum image, because legitimised by both sets of actors, that is presented to the outside world.

The interaction between these actors does not necessarily involve direct conflict: in the presentation of national images through the medium of the museum it is much more the case that the dominant ideological understandings that permeate societies will establish a common framework of understandings that will affect both sets of participants in a similar fashion. The idea of a shared set of understandings between the key players in the political museums game makes clear the extent to which external political actors do not need to directly intervene in museum decision-making processes to get their wishes put into effect. Instead, the over-arching effects of ideology and legitimacy mean that such direct intervention becomes unnecessary as both sets of actors can be assumed to be operating within a shared perspective that forms a version of common sense that does not need to be spelt out. Thus, the common expectation would be that external political actors do not actively need to exercise direct power and control over museums as implicit and indirect means of power and control are already in operation at the level of ideas, and that these ideas are the factors that have the greatest effect on museum content and practice.

In these circumstances a rather nuanced approach needs to be adopted to understand the impact of politics on national museums. It is certainly not the case that external political actors simply impose themselves through a crass imposition of ideological preferences that run counter to the politically neutral professional and technical choices of museums staff. Instead, both sets of actors are part and parcel of the same sets of ideologically legitimating sets of rationalities that establish the framework of museum practice in the first place. At this level everything that occurs in museums is political – although it is possible to differentiate between types of political activity in the museums context that shifts the focus of attention away from the systemic level concerns of ideological representation and towards the more quotidian level of specific political practices. In particular the direct attempt to influence both what museums staff do and how they do it is a central concern here. Equally, the mechanisms that external political actors employ in attempting to exert their influence requires consideration:

there is no point in simply claiming that external influences affect what occurs within museums without demonstrating how this influence is exerted. Thirdly, the motivations that underpin the exercise of external political power require examination to make sense of the interactions between external political actors and internal museums staff. These three approaches – when used in conjunction with the ideological, systemic, view of political agency that has been noted above – to the examination of the specific effects of the exercise of external political power can be applied to the normal workings of national museums at any time and in any country. To demonstrate, however, their full effect the particular circumstances that are generated in conditions of acute change within political systems provide an effective template for the identification of precisely what is involved in their exercise. Examining conditions of acute change may not give an adequate representation of what occurs on a more mundane level of everyday experience but it does serve to make clear how external attempts at political control function, and how effective they can be.

Power and the exercise of control

The key starting-point for this consideration of the exercise of direct political power in the museums context lies in the symbolic representational role of national museums. As implied in the earlier discussion, the manner in which national museums function, and what it is that they are intended to achieve, are important considerations to bear in mind – are they intended to be simply ideological tools for the representation of the preferred beliefs about the nation that political actors wish to establish, or are they intended to be forums where debates about national identity, the representation of national identity, and the meaning of nationality itself can be held? In other words, are they the tools of politically dominant groups of actors within societies who use them for the top-down imposition of personal ideological positions for reasons of societal control, or are they representative of ideas of the public sphere, open to anybody (Barrett, 2011), where ideological positions are established from the bottom-up through processes of reasoned argument and debate? Establishing this as an either/or position is unlikely to be a fair representation of the realities of actual museum practice – as the following will make quite clear – but it does serve to identify how the argument often appears to be phrased. The choice of examples derived from the experience of countries that have been governed under variants of Marxist ideology is equally unlikely to be entirely fair

to the many countries which have not seen the explicit attempts at ideological societal control that were common under Marxist-inspired governments: it does, however, allow for the identification of the overt mechanisms of control that were adopted by these governments and, as a consequence, to establish the extent to which these were effectively dissimilar to the more covert and implicit mechanisms by which ideological meaning is established in other, non-Marxist inspired, political systems. The assumption this rests upon is that museums do contain within them ideological positions – either in what they display, how they display it or why they display it – and this inevitably means that museums are not simply neutral havens for the exercise and application of apolitical, professional, standards but are, inevitably, arenas for the exercise of political and especially ideological power and control.

The establishment or imposition of an ideological component to national museums rests in part on the very nature of these museums as being in some sense or another representative of the nation-state itself, particularly through the role that such museums are commonly assumed to have in the construction of images of national identity for both the inhabitants of the nation-state and for external audiences – who may also be seen and understood as members of the same nation-state, as the status of the Flemish Ijzertoren Memorial Museum in Belgium demonstrates in the context of the linguistically divided country of Belgium (Shelby, 2014). To adequately function in such a representative and identity-forming fashion there needs to be some narrative structure in place that will provide a meaning and under-pinning to the ideas that are meant to be conveyed through the national status that such museums bear. Ideologically aligned beliefs, values and assumptions often assume this role through their contribution to the rationalisation and justification of the national image that is being portrayed. Marxist-inspired governments demonstrate this quite clearly through the iconography that has been a common part of their national museums, as well as the role that these museums were, and are, expected to fulfil in terms of public education, enlightenment and edification. These functions are commonly derived from a particular image of historical development that could be used to establish a clear trajectory for the telling of a story of national development, with the most recent stages of growth being seen to be closely related to the role of the national Communist Party in establishing freedom from the tyranny of the forms of economic, social and cultural structures of control that are seen to be associated with capitalism. In effect there was established 'a single master narrative' (Badica, 2011, 275) that was based on an ideological

construct that denied the specificity of the national in favour of the generality of an inevitable wave of historical change leading to the creation of a set of societies that shared certain characteristics. In particular amongst these shared characteristics is the assumption of the existence of shared values based upon principles of solidarity and the essential unity of the people of the nation-state, alongside a common historical narrative about the nation itself, something that is not restricted to countries under the control of Marxist-inspired governments. To establish an acceptance of these shared values museums would need to demonstrate their importance for creating an understanding of the historical development of the society concerned and this would be done through processes of display and the content of museum exhibitions.

The mechanisms that may be involved in such activities could range from overt state management with, in the case of Cuba (Gonzalez, 2015, 8), this extending to the standardisation of museum architecture and contents (with the latter also true for Romanian displays: see Badica, 2011, 281), to more generalised forms of control that depended upon the production of common narrative structures that fed into the dominant political preferences of the locally and nationally significant political actors within the state. These preferences could be identified through the public and policy statements that these actors made, but putting them into action required, and still requires, the collaboration of museum staff members. These staff members would not just be acting as the translators of externally imposed policy into internal museum practice, they would also provide a legitimacy for the actual contents of displays and exhibits with this being based on their professional status, rather than on their ideological purity. At this point the importance of control becomes evident: just as international agreements need to be implemented at the national (and local) level, and this can create implementation gaps between policy content and policy practice (Hill, 2009, 197), so the demands, requirements and expectations of dominant political actors also need to be translated into practical action and this is not necessarily open to detailed hands-on supervision and management control by those same dominant actors. Allowing implementation to remain in the hands of museum professionals may mean that the outcomes that are produced differ from those that may have been intended, but this also provides a fig-leaf of independence for policy-makers to refer to: if exhibition and display is undertaken by staff who are exercising their independent professional judgement then accusations of direct political control of content can be at least deflected, if not totally denied. Thus the ideological content of national museum exhibitions

becomes, in effect, the output of a collaborative collusion between directly politically active agents and indirectly political professional staff within them.

The extent to which professional staff live up to the ideological expectations of those who are in positions of political control is, of course, something of an open question: do professionals somehow automatically know what will be ideologically acceptable or do they have to learn this? If it is learnt behaviour then how is it learnt? Again, the exercise of control is significant in this: if staff are likely to lose their position or their status if they make the wrong choices about exhibition and display then it is a fair assumption to make that they will be likely to pre-emptively modify their behaviour to avoid such outcomes. Indeed, the changes that have taken place in the national museums landscapes of countries that were previously dominated by Marxist-inspired actors and parties (Kaluza, 2011; Runnel *et al.*, 2011; Sharenkova, 2011) would indicate that this was exactly what took place in Eastern Europe after the fall of the Berlin Wall. Certainly the shift away from a common narrative emphasising the role of national communist parties in the establishment of national freedom from economic, social, political and cultural oppression, towards a story that emphasises national opposition to the Communist Party (Badica, 2011, 284–88) demonstrates a clear break with the ideological suppositions of the recent past, and establishes a new perspective on the national story for museum visitors. In this case museum professionals would need to be seen as actively and directly politically conscious individuals who are capable of walking the proverbial tightrope between the extremes of being the mindless implementers of the ideological preferences of those who held political power within their states, and conscious revolutionaries who seek to subvert the existing order of things.

Regardless of the role that is played by professional museums staff, the status of national museums as the repository of an ideologically defined image of the nation-state raises questions about the extent to which these museums are able to impose such images on societies in the first place. The Marxist-inspired model of museums – as contributors to the education of the population of a country about a particular narrative of historical development – is based on the assumption that there is no effective difference between education and indoctrination, and assumes that there is some form of automatic translation of the messages that national museums convey to the visitors that they have. Such an unreflective transmission model of the effects of museum exhibitions and displays is open to severe questioning, particularly in the context of the

complexity of visitor relationships to the contents of museums (Falk & Dierking, 2013), and implies major weaknesses in the extent to which overt attempts at establishing effective ideological learning through the direct political control of museum content could be achieved. This weakness is amplified when more general models of museum learning and education are considered. In these (for example, Hooper-Greenhill, 2007; Lord, 2007) the museum, by itself, is simply a forum (and one that is implicitly politically neutral) for the development of different forms of educational experience, drawing upon differing student and teacher skills and interests – different, in particular, from those educational opportunities that are provided in more standard classroom environments. For museums to have an effective educational role still depends upon the active engagement of both students and teachers – there is no magic transmission of knowledge and learning taking place. Instead, museums provide opportunities and experiences that are difficult to transfer to other learning environments and how far these are taken advantage of is not straightforwardly apparent. At the very least the implication is that education in and through the museum needs to be actively engaged with, thus casting severe doubts on the simple direct transmission model that underlay the cruder forms of imposed ideological learning that were evident in pre-system change, Marxist-inspired, politicised museums. In terms of a direct imposition of some idea of national identity, similar doubts about the effectiveness of the museum, as an institution, in doing this are raised by Lloyd (2014) who points to the openness of visitors to such messages as being a key variable that needs to be taken into account when assessing the effects that museums have on their visitors. Thus some visitors will accept such identity forming ideas provided they confirm their already adopted identity positions. Other visitors will either not accept these ideas or will be simply oblivious to them. In these cases the automatic transmission view is plainly false.

Pointing out the weaknesses – if not the likelihood of failure – of forms of directly political attempts to use museums for particular educational ends does not mean that museums must therefore be assumed to be ideologically free locations. The dominating assumptions within museum studies that are drawn from the ideas of Foucault (2002), Gramsci (1971) and Habermas (particularly in terms of the idea of the 'public sphere' [Habermas, 1991; Calhoun, 1992]) all accept that there is an inevitable ideological component to museums, not only in terms of their displays and exhibits but also in terms of their dominant discourses, their contribution to supporting particular types of hegemonic

control within societies, and their associated institutional forms. While these approaches vary greatly in terms of how they understand the working of each of these components of social and political action and organisation, they all see an underlying ideological core to patterns of institutionalised life that cannot be escaped from. The normal position that is adopted by all three approaches is that if society is to function effectively without large amounts of social and political conflict then ground-rules for social action need to be established. In addition it is assumed that these ground-rules are, if not actively biased, then at least non-neutral in their effects, with some social groups and actors gaining far more from their operation than do other groups and actors. The consequence is that all social institutions are locations where political conflict takes place and needs to be managed, and an assumed corollary of this is that such conflict management is better undertaken is such a fashion that its existence is not evident: if control is exercised so that it is taken to be simply the application of common sense, rather than being seen as an externally imposed order, then the potential for conflict is assumed to be greatly reduced. In this perspective museums are, regardless of what may be claimed about them, inevitably mechanisms for the imposition of certain forms of knowledge and control. Thus, the universal claims about the museum model that is supported by ICOM – that it is applicable to all museums, in all countries, and all the time – can be restated as the imposition of a model that justifies the plundering of 'third world' countries in the past by their colonial and neo-colonial rulers, and which makes the interests of western museums falsely applicable to museums in other parts of the world. Both these positions can be seen to be valid, but their validity depends upon accepting the underlying ideological claims upon which they are based.

In the case of national museums the consequence of accepting that they have an inherently political dimension means that their role and function within individual societies cannot be simply reduced to their contribution to the establishment of particular notions of national identity – which is itself a deeply political activity – or to providing arenas for learning and individual development. Indeed, the precise manner in which national museums engage with these activities is largely irrelevant to the debate by this stage of proceedings. Instead they require discussion as mechanisms for the active political control of their national populations through their ideological, hegemonic and structural functions within societies rather than in terms of the detailed mechanisms by which these activities take place. Equally, it requires an investigation of how they contribute to the establishment of commonly

accepted ideas about society and social behaviour (as in Bennett, 1995), rather than in terms of exactly what they contain and how this is displayed. This leads to a consideration of the ways in which national museums are utilised by political actors and groups and how these feed into these wider patterns of political organisation and mobilisation. This changes the focus of concern away from the particularities of individual museums towards the more general meanings which can be, and are, attached to (national) museums as a generic structural, institutional, form.

Instrumentalism: The symbolic uses of national museums

National museums can be utilised to fulfil a wide variety of functional roles – of which their ideological, hegemonic and structural roles within society are important ones. Alongside these, however, there are other ways in which museums can be used that have little to do with the precise manner in which museums operate on a day-to-day basis, but, equally, have very little to do with their detailed content. Instead these other ways are concerned with how national museums can be connected to the wider range of interests and concerns espoused by political actors and how this connection affects the inter-relationships between museums and the wider societies within which they are located. The instrumentalisation of national museums that is a part and parcel of the uses to which they are put is not peculiar to the national level: as Chapter 4 will demonstrate, this is equally, if not more so, evident at the local level. There is, however, a significant difference between the national and local levels in terms of the meanings that this instrumentalisation of museum functioning gives rise to. In particular, the status of 'national' museums establishes a symbolic centrality to their existence in terms of their relationship to their own societies (and the wider world) that is not present in the case of local museums, however important the latter may be for their own neighbourhoods and communities. This wider potential significance to national museums means that how they are made use of by political actors has a far greater importance than can be attached to the uses to which local museums are put, as the ramifications of their national status extends beyond simply their role as museums. National museums can be, and are, tied in to a wider realm of international and cultural diplomacy that is as much to do with matters of national prestige and status as it is with whether they can get access to the contents for their next exhibition from other museums in other countries (Nisbett, 2013).

This symbolic dimension to national museums operates both internally to the nation-state itself and externally to the wider community of nation-states – and tourists. Boasting about the unparalleled collections that can be found within national museums has become a common device for selling nation-states to the international traveller, with numerous claims being made about the attraction that these museums have for the sophisticated tourist (Timothy, 2011). The fact that many museums and galleries attract considerable numbers of visitors in an absolute sense (see Table 3.3) contributes to this idea that museums are important tourist destinations in their own right. Whether such a claim is accurate is, of course, another matter: tourists rarely have only

Table 3.3 Most visited museums and galleries

Museum/Gallery	Visitor Numbers
Louvre (Paris)	9,300,000
National Museum of China (Beijing)	7,475,000
National Museum of Natural History (Washington DC)	7,366,700
National Air and Space Museum (Washington DC)	7,300,000
British Museum (London)	6,414,000
Metropolitan Museum of Art (New York)	5,914,600
National Gallery (London)	5,662,200
Vatican Museums (Vatican City)	5,500,000
Natural History Museum (London)	5,115,900
American Museum of Natural History (New York)	5,000,000
Tate Modern (London)	4,948,700
National Palace Museum (Taipei)	4,450,100
National Museum of American History (Washington DC)	4,366,700
National Gallery of Art (Washington DC)	4,322,700
Shanghai Science and Technology Museum	3,590,000
Pompidou Centre (Paris)	3,443,300
National Museum of Natural Science (Taipei)	3,400,000
Musée d'Orsay (Paris)	3,328,500
Science Museum (London)	3,122,300
Museum of Modern Art (New York)	3,098,800
Victoria and Albert Museum (London)	3,073,200
National Museum of Korea (Seoul)	3,060,400

Figures derived from:
http://en.wikipedia.org/wiki/museum#most_visited_museums_in_the_world
(Accessed 18 February 2015)
http://edition.cnn.com/2014/06/16/travel/world-top-museums/
(Accessed 18 February 2015)
http://www.travelandleisure.com/slideshow/worlds_most_visited_museums22
(Accessed 18 February 2015)

a single purpose in mind when they organise their journeys, and visiting a national museum and/or gallery may be no more important than going shopping or to an interesting (because foreign) restaurant. Indeed, museum visiting may simply be a reflection of the old expression 'if you build it, they will come': the fact that the museum is there is as good a reason to go to it as any other may be, and given that most national museums happen to be located in national capitals means that they may simply be another box to be ticked rather than a conscious tourist focus and choice. Regardless of such concerns, however, there is no doubt that the status symbolism of having the home of the national patrimony as being a highly visited destination provides the possibility for making claims about the significance of the national collection in terms of international prestige, if not of more general international relations themselves.

This question of international prestige is, at least in part, tied in with the content of national museums. In this respect the status of national museums as 'universal' museums (Duncan & Wallach, 1980; Prott, 2009) assumes a new significance. Regardless of whether this status is meaningful of anything other than the justification for such museums keeping hold of items in their collections, their contents provide a justification for why they should be considered to be important for humanity as a whole rather than simply for their own national populations, and why the more 'universal' their collections are, the more important their status is held to be. The corollary of this is that the nation-state itself must be considered to be important as it is the preserver and conserver of these collections on the behalf of humanity as a whole. This may be no more than a form of trivial nationalism based upon an idea of an international pecking-order of nation-states, with this being determined by the control of particular types of symbolic resources, but at the symbolic level itself it is much more than this, as it provides an internationally significant status to the nation-state based upon material and tangible forms of cultural capital (Bourdieu, 2010) that are inaccessible to other countries and their museums. The logic associated with this is based upon the idea that these material forms of cultural capital are themselves designators of civilised values (if not of civilisation itself) and, consequently, the more 'universal' the national museum is the more civilised is the country that maintains it. While the syllogistic logic of this argument is decidedly shaky it does identify the underlying meanings that can be attached to the status of national museums for nation-states. In this case the instrumental status of the national museum is concerned with how it can be used to

establish a cultural importance for the nation-state itself, rather than it being considered as simply culturally important in its own right.

This establishment of national status provides the basis for thinking about other ways in which national museums can be converted into instrumental mechanisms for the attainment of policy goals that are not those of the museum itself but, instead, derive from other sets of policy objectives that governments and other political actors either deliberately or indirectly seek to pursue through the means of the national museum itself (Vestheim, 1994; Gray, 2007, 2008). Thus in the above case the policy that is *effectively* being pursued can be claimed to be that of the cultural status of the nation-state, regardless of what governments might like to claim is the 'real' policy intention behind their actions. The means to achieve this status is to be found in the universality of the collections of the national museum. These collections are not seen as being important in themselves but only in so far as they contribute to the broader cultural goals of the nation-state itself, thus turning them into instrumental means to alternative policy goals. This approach depends upon how the policy 'text' is read and understood and is thus as much a product of how analysts apply themself to this 'text' as it is a real product of the policy process itself. To avoid such a position that relies as much upon interpretation as it does anything else, it is possible to refer to actual policy practice where instrumentalism is a quite explicit policy intention of politicians, governments and other policy actors. This then allows an identification of how museums are perceived by this range of policy actors, and whether this perception concerns the museum as a cultural entity in its own right, or whether it is seen as being simply another tool for governments to make use of for their own ulterior motives.

Instrumentalism: The functional uses of national museums

An obvious example of such instrumental intentions can be found in how national museums can be deliberately utilised for reasons of economic and urban regeneration. Cases exemplifying such developmental intentions can be found in, for example, the locating of the Tate Modern in a disused power station in a relatively deprived location on the River Thames in London, or the construction of new national museums in Dubai and Qatar as part of major development projects undertaken in Arab Gulf states – often in conjunction with significant Western museums and galleries, such as the Louvre, the Guggenheim and the British Museum. Needless to say such developments are justified in part,

at least, in terms of the museums themselves and what these developments can offer in terms of exhibition and display, and the creation of new cultural opportunities for cities, regions and countries through the utilisation of museums and their resources. Underlying these cultural and museums benefits, however, are the accompanying economic, social and political benefits that are anticipated to be created as, in economic terms, spill-over effects that arise as a consequence of having national museums located where they are. Teasing out the differing benefits that can be identified as being deliberately instrumental consequences that arise from national museums is difficult when such museums have been established for many years in the same place, and it is easier to identify them when museum locations are changed or new museums and sub-branches are created. It can certainly be said that many local museum developments around the world have been undertaken with an explicit intention to create regenerative benefits for local areas, of which the case of the Bilbao Guggenheim (Sylvester, 2009, 113–36) is a prime example, but the extent to which this is equally as true for developments with national, rather than private, museums remains to be seen.

The sheer cost of establishing new national museums or relocating parts of their collections to new sites within countries, either at home or overseas, almost inevitably means that national governments are likely to have a real interest in how these museums contribute to their own, specific, political agendas, and, in a more general sense, to the 'nation' as a whole. Thus the establishment of the new National Museum of Contemporary Art in South Korea has led to concerns that it has become subservient to the policy and managerial wishes of the state, and is being used to provide support for non-museum concerns, such as those of cultural diplomacy, rather than anything else (Lee, 2011, 382). Such a concern could also be levelled at other international collaborations between national museums in different countries, as with the moves by the Louvre to have parts of their collections exhibited in Arab Gulf state national museums: is the purpose of this concerned with matters of international relations and cultural diplomacy rather than with allowing for a greater and more geographically dispersed display of French national collections? In practice it is a bit of both, although it could be argued that the real beneficiary is the government of France rather than the peoples of any of the countries that are involved in this collections loaning process, as the French government can claim that its decisions contribute to international understanding, to cultural and economic development in the countries to which these loans are extended, and to the enhancement of France's own position and status in world

politics regardless of anything else that these loans may contribute to. Such a view could also be taken to demonstrate that a consequence is that the French government enhances its own position as an important player in the game of international politics and thus contributes to French power in international negotiations, whilst equally legitimising France's international status as an important country to deal with. Whether this claim is true or not would depend upon the ability to measure French international political power and status both before the announcement of these loans and at a later date to establish some sort of longitudinal basis for evaluation. Given that nobody has yet undertaken such measurement means that the claim depends upon the extent to which it makes sense – and, in the absence of effective evaluative qualitative and quantitative data, that depends upon how meaningful the reader finds it be.

Despite this weakness in evaluating the reality of the outcome of instrumentalising policies it is evident that national museums are used for a large number of ancillary policy purposes – even if it can be extremely difficult to identify exactly what the results of these usages are. Indeed, the very establishment of the Louvre as the French national gallery was seen as 'a symbol of Revolutionary achievement and the cultural benefits of liberty' (McClellan, 1994, 92), both of which could then be used to bolster the legitimacy of the newly established revolutionary regime following the overthrow of the monarchy. A distinction can be usefully drawn here between policy instrumentalisation that is intended to have direct effects in terms of providing measureable outcomes, and that which is intended to have indirect effects through the production of symbolic outcomes. The former are largely concerned with explicit statements about what national museums 'should' be providing, while the latter operate through their more intangible effects in terms of ideology and legitimacy. Thus changing the educational role that museums and galleries *can* fulfil into this becoming what museums *are* primarily there to do, and a means to evaluate the effectiveness of national museums, also changes what these museums are meant to be providing, effectively making them extensions of the education system rather than anything else. Such a role can then be evaluated through the contribution that national museums make to educational performance and achievement – even if this is by no means a simple and unambiguous thing to do (Falk & Dierking, 2000, 173–74, 2013, 218–45; Hooper-Greenhill, 2007, 189–201). Regardless of the difficulties of this measurement some concrete evidence can be provided of the actual role that museums fulfil in terms of this instrumental function. With

the more intangible and symbolic effects that museums can produce this becomes more and more difficult. Again, while the methodologies exist to identify the specific effects that museums may have in terms of these outcomes, it is by no means easy to apply them, and the evidence demonstrating these effects is not particularly methodologically strong (Galloway & Stanley, 2004; Jensen, 2013, 146).

These evaluative difficulties could lead to the position where the only meaningful approach to the analysis of museum effects would be to present a series of case-studies that are intended to demonstrate how and why museums are being used for instrumental ends by national political actors. This would shift the focus away from the specifics of national museums per se and towards the manner in which the museums sector as a whole can be used as a political tool for the fulfilment of particular policy objectives. To undertake this would necessarily require a consideration of the comparative policy importance of different arenas of governmental and political activity, and how this importance translates into a form of functional slippage for the museums sector where it is simply seen as being a contributor to, rather than a creator of, the policy requirements that governments are concerned with. At this stage it is apparent that the underlying assumption is that, for this to be relevant, the museums sector must be less important, in both political and policy senses, than are other policy sectors. The political and policy weakness of the museums sector could then be seen as the basic underlying reason for both its susceptibility to instrumentalising tendencies and the comparative ease with which instrumentalisation takes place. The question of the functions that museums fulfil becomes important in this consideration, as so often with questions in the museum sector. Museums are undeniably multi-functional organisations and this multi-functionality provides the opportunity for governments to shift the focus of their attention between functions quite easily: there is nothing about museums that establishes an effective functional hierarchy between their different activities, and thus there is nothing that is sacrosanct about which functions are to be considered significant or important at any given time. This flexibility could be seen as a weakness for museums when confronted with politically and policy-active governments insofar as their views about what are the most important functions for them to undertake can be potentially over-ridden with some ease as a result of the direct democratic legitimacy that governments have and which museums almost always lack. The same flexibility, however, can also be seen as a source of strength for museums as their capability to demonstrate their value to governments across a large number of discrete policy

functions can provide them with a number of strategies to justify their continued existence. The ability of museums staff to show this value could also provide a demonstration of their political nous and management capabilities in being able to switch the arguments that they use to whatever the demands of national political actors may be, thus changing the focus from the structural weakness of the museums sector to the strength of the political agency that can be exercised by museums staff.

In many ways the evident weaknesses of the museums sector are, at least in part, a direct consequence of the multiple claims that come from within the sector about how good museums are at undertaking their functional activities. The claims that are made about the transformative role that museums can play through their direct contributions to education and identity formation are only a part of this, and the instrumentalisation of museums by political actors can be seen to be simply an extension of them. This then becomes a mutually reinforcing process of instrumentalisation and policy attachment (Gray, 2002). Where the focus of political actors is on policy concerns that are peripheral to the museums sector then claims about how museums can help in the fulfilment of these concerns can provide the sector with the finance, political support and legitimation of their existence that they require to ensure their survival. Providing supporting evidence for how good they are at this job – even if such evidence is methodologically dubious or relies simply upon anecdotal claims – can then lead governments to expect museums to be able to contribute to other policy objectives that *they* have, regardless of whether museums claim that they are capable of being able to do so or not. Thus museums can become entangled in a host of activities that do not fit comfortably with their already multi-functional nature but which they need to demonstrate their commitment to in order to continue to benefit from the resources that they have gained from earlier instrumental and attachment activities. This can generate claims that an excessive instrumentalisation of museum activities can shift the focus of what museums do away from their functional 'core' and towards policy concerns that are not those of the museums and their staff but those of other policy actors altogether. At worst this can become an implicit argument that museums should be isolated from the societies of which they are a part as a form of 'art's for art's sake' argument for museums, or that, in some sense at least, museum policy is more important than other policy concerns. Certainly these forms of arguments about the consequences of instrumentalisation are commonly employed: how useful they are is another question given that all policy is instrumental in one form or another

(Gray, 2008), meaning that the whole debate may not be as important as the disputing protagonists may think it is (Gibson, 2008).

Despite this questioning of the significance of the instrumentalisation debate it cannot be denied that it raises a number of important concerns regarding the politics of museums and how these play into the policies that museums are responsible for. Most importantly it raises questions about the political status of museums for governments in a different way to that considered earlier in this chapter. This change of focus moves away from the relative amounts of money that governments spend on the museums sector, or how governments can manipulate and control what occurs in museums and, instead, is concerned with the status of museum policies as a part of public policy as a whole. While national governments can clearly make use of national museums for their symbolic attributes in terms of both their own populations and their role in national identity formation, and in terms of their international status and significance, they can also make use of museums for far more mundane reasons that arise from their overall policy agendas. This can be understood by drawing a distinction between the sectorally specific and 'general' policy intentions of political actors: the former being concerned with the core decisions concerning what the sector is intended to be for, and do, in its own terms, and the latter being concerned with the policy intentions of political actors that are intended to under-pin the totality of their approach towards policy, and which cut across the concerns of individual policy sectors. In the case of the former quite detailed and specific policies concerning individual elements of what make policy sectors distinct would be expected to be produced, while, in the latter, more generalised policy expectations would be expected to be the order of the day, with these being turned into policy actions, objectives and intentions at the sectoral level. In the museums sector the difference would be between those policies that are concerned with the 'core' functions of museums (as seen in pages 3–6) and those which are concerned with, for example, environmental sustainability or anti-discrimination or the support of market competition. The latter policies are intended to apply in all areas of public policy while the former (as, for example, in the case of standards for the conservation of metal-work in museum collections) are strictly limited in their scope.

From the perspective of national political actors all these policies have an identical significance, but they have a quite different importance: they are all intended to be pursued by a variety of organisations and individual policy implementers, but their political meaning is quite distinct. 'Cross-cutting' policies lie at the heart of whatever political project

national politicians seek to fulfil and can be expected to have a greater meaning for these politicians than those which are seen to be only marginally important to their large-scale political intentions. Integrating these marginal policy concerns with the broader policy intentions of governments can be achieved through a variety of devices, ranging from tying financial allocations to the meeting of general policy intentions to direct demands to incorporate these general intentions in sectoral policies.

These variants imply the utilisation of versions of the carrot and the stick to those working within policy sectors in an attempt to get general intentions put into practice, but neither of these can be seen to be straightforward versions of policy instrumentalisation. Instead of making these general intentions the prime focus of the policies that are to be put into practice (which, after all, is the main concern of critics of policy instrumentalisation), they are simply expected to be built into the policy practice that individual sectors will be pursuing. The individual and specific policy concerns of different policy sectors are not therefore being replaced or over-written but are simply being expanded to incorporate newer policy expectations. It may also be true that older policy preferences are subtracted from the current policy stew that exists – on the basis, for example, that they are no longer part of the core government policy agenda – leading to a potential simplification of the policy expectations that museums could be expected to contribute to.

It would be unreasonable to expect that individual policy sectors would be left to simply pursue their own objectives and concerns given that this may well prove to be a recipe for policy confusion, with the potential for the creation of conditions where policies in different policy sectors conflict with each other, and where there is no overall sense of policy direction in existence in the first place. The establishment of general policy objectives and principles allows governments the possibility of assessing how the individual components of overall public policy are being met – or not – and the identification of policy sectors that may require direct intervention to ensure that they are playing their part in the overall aims that governments have established for themselves. There is an element in this argument that assumes that such a rational notion of overall government strategy can be seen to exist – which is an extremely dubious proposition as the garbage can model (Cohen *et al.*, 1972) of policy development forcefully argues – but a less rational picture can also be constructed that is built around ideas and assumptions of relative policy importance. Governments have some reason to intervene in all policy sectors, whatever this reason may be, but while policy sectors are equal, as noted above, in terms of their significance and their

requirement for continuous action and support, they are not equally as politically important as each other. This importance will vary over time and will be affected by a range of social, technological, economic and political factors (an argument dating back to Downs, 1972, and an important part of both punctuated equilibrium (True *et al.*, 2007) and advocacy coalition (Sabatier & Jenkins-Smith, 1999) approaches to policy change). While this opens the possibility that museums can become of real political importance at some times, given the right combination of circumstances and political interest, it is also the case that for most of the time museums are decidedly the poor cousins in terms of any hierarchy of policy importance for most governments. Indeed, the previous discussion in chapter 3 of museums in Eastern Europe, China and Cuba supports this idea as museum importance for their governments depended upon their role in terms of state restructuring or significant societal change rather than it being dependent upon their own intrinsic role as museums. The contribution of museums in periods of major turmoil is always of a secondary form – instead of being in the vanguard of change and change mechanisms they are always in a position of minor players: never Hamlet, much more the gravedigger. Thus museums are not seen to be key actors in policy terms by most national political actors except in their role as contributors towards the larger and, as far as central political actors are concerned, more important political objectives that they have.

This conclusion raises, again, the relationship of the museums sector and individual museums to the national political environment within which museums operate. It also, however, raises the question of how museums and their staff react to this seemingly permanent position of political unimportance. The national politics of museums cannot be only understood by looking at them from the top down: their own actions need to be taken into account to balance this picture. Are museums as powerless as versions of instrumentalism may lead one to believe, or are they able to intervene at the national level in ways that extend far beyond the view of them as simple contributing cogs in policy machinery that is dominated by national political actors? The final section of this chapter answers these questions by examining the relationship between national policies and museum politics.

National politics and museum practices

It would be very easy to begin this section by starting from the position that museums are more or less limited in what they can do in terms

of national politics as a consequence of their lack of political impor-
tance. This, however, would be to seriously underestimate the extent to
which museums of all sorts can not only contribute to the fulfilment of
the goals of national political actors but can also act as the creators of
policies and the makers of political choices that have national polit-
ical consequences and implications of their own. What is evident is
that direct, hands-on political control of museums by national politi-
cal actors is remarkably infrequent in global terms. Even when – as is
often the case with governments showing varieties of authoritarian ten-
dencies – there are clear expectations of what museums are meant to
be providing, particularly with regime-legitimating propaganda, this is
rarely enforced through direct managerial control of the choices and
decisions that are made inside individual museums. Instead, a form of
anticipated reaction often comes into play where museums' staff appear
to internalise the messages that they are expected to provide because
they are fully aware of the consequences that could, or would, follow if
they failed to provide them. This might be expected to lead to forms of
ideological and party political conformity, where museums become pas-
sive mechanisms through which a standardised set of beliefs and values
are transmitted – and there are certainly cases where such conformity
can be found, as when museums exercise forms of display isomorphism
within a relatively short period of time in response to what are seen to
be the key issues to be addressed at that instance. Examples of this can
be found in the increasing emphasis on displays concerning ethnic and
cultural diversity in the museums of many Western countries (Message,
2006 (*passim*), 2014; Lockyer, 2008; Dewdney *et al.*, 2012), as well as in
East Asian countries (Varutti, 2014), or in displays concerning the role
of opponents of the regime in most post-Soviet museums (Badica, 2011;
Kaluza, 2011). In each case new interpretations are overlaid on parts
of museums' existing collections and new display lay-outs are created,
which are informed by the latest issues and concerns that are perceived
to be of societal and political (and moral and ethical) importance for
the country concerned. In each set of examples, however, this process of
reinterpretation is internally led by museum directors, curators and edu-
cationalists – it is not directly imposed on museums by external political
actors, however much they may wish to claim the perceived benefit that
is associated with the new displays that are produced.

National politics has the effect of opening new opportunities for
museum actors to exercise their own judgements about how these
opportunities are to be dealt with in the museum environment. In the
same way museums effectively contribute to the national political

debate through the messages and stories that they create and present to the public, with the added expectation that these messages and stories will be subject to interpretation by the public itself. This line of argument is itself a direct result of parts of the 'new museology' arguments of the last 40 years (Vergo, 1989; Harrison, 1993; Stam, 1993), where the status of curators and other museums staff as the presenters of an unimpeachably 'correct' account of their displays and collections became increasingly questioned and criticised. Even though the new museology has not been as uninhibitedly adopted within museums (certainly not in the UK at any rate – see McCall & Gray, 2014) as some of the museums rhetoric might lead one to anticipate, it is certainly the case that new, and often self-reflexive, approaches to visitor-museum interactions have been developed that seek to encourage more participative roles for visitors and less didactic roles in education and display techniques on the behalf of museum staff (Dewdney *et al.*, 2013). These developments have been part of a continuing process of political negotiation between national political actors and national and local museums over at least the last 40 years and concern the even longer-lasting clashes between the top-down demands and expectations of the former and the bottom-up practices and choices of the latter. The nature of the conflict between the two sets of actors is particularly acute as a consequence of the low level of political importance that is traditionally attached to the museums sector. The instrumentalisation of museums discussed above is one of the direct consequences of this – with museums becoming dealt with as a means to an end rather than as an end in their own right – but it extends beyond this to issues of what museums are expected to do in the first place. In this case the outward-facing dimension of museums becomes a central arena in which top-down demands and bottom-up practices meet and generate a great deal of heat and noise if not outright conflict.

The working-through of these conflicts is affected by a variety of factors, as might be anticipated, but central to these are the clashes that are generated between the political legitimacy of national political actors and the professional legitimacy that underpins the actions and choices of museum actors. Rather than these forms of legitimacy establishing sets of arguments that are incapable of resolution, more usually forms of compromise between them are constructed to allow for the development of workable solutions to sources of contention where these solutions can be at least lived with by each set of actors, even if they are not entirely satisfactory for any of the parties involved (Boltanski & Thevenot, 2006, 277–335). Museums have always been conscious of the

need to encourage appropriate relationships between themselves and the outside world, even if the nature of these relationships has changed and developed over time. The fact that the 'typical' museum visitor is normally drawn from particularly privileged population groups (usually being more highly educated and better paid in socio-economic terms, and with 'higher' levels of cultural capital in socio-cultural terms than is the case for the general population) has been a particular concern within the museums world for many years and contributed to the development of the new museology as, in part, a response to the perceived social exclusiveness of museum visitors. While long being recognised as an issue in the museums world (the research on museum visitors reported by Bourdieu & Darbel (1997 [1969], 117–18) was undertaken in 1964–1965, for example), and while serious attempts were developed by museums staff to broaden the public reach of museums from the first part of the twentieth century onwards (Black, 2005; Alexander & Alexander, 2008, 282–85), it was only some time later that it became a subject for serious debate at the level of national political actors. Indeed, it could be realistically argued that it was the willingness of museum professionals to transform their own practices that led the way to asking questions about who the audience for museums consisted of, and who it might consist of, rather than museums simply responding to top-down demands for change and development (Janes, 2009).

The evidence would appear to support the idea that museums only become a part of national debates in politics when they impinge on other issues and concerns that national politicians are concerned with. The relatively self-contained world of museums rarely, if ever, generates enough political momentum in terms of what are generally seen to be the 'big' issues in society for it to be at the forefront of political debate in its own right. Instead it is how museums contribute to debates that have been generated from other concerns and issues that has tended to form the route into the national forum that museums have followed. This can be seen in both the manner in which national governments have changed their perceptions of the roles that museums can play in fulfilling their broader political commitments (as with the civil rights agenda in the United States in the 1960s and 1970s – see Message, 2014; or the social inclusion agenda in the UK from the late 1990s/early 2000s – see Newman & McLean, 1998, 2002, 2004; West & Smith, 2005), thus bringing museums into the national political arena, and in the attachment strategies (Gray, 2002) that museums adopt as a means to both justify continued state support and to give them access to the wider range of resources that are necessary for them to undertake

their 'normal' museum role separately from their role of an agent for the delivery of national political objectives. Museums are thus in the position of being both policy active in the pursuit of their own goals, and policy reactive in being expected to contribute to political strategies and objectives that extend far beyond the doors of the museum itself.

Such a Janus-faced position for museums to occupy is no different to the position that all policy sectors find themselves in – none of them can operate entirely independently of the national political, economic and social contexts that they find themselves in. The consequence of this is that there is an inevitable politicisation of what museums are and what they do and it can often be difficult to draw a clear distinction between independent museum policy choices and those choices that are responsive to the demands of national political actors. Where museums can, however, exercise clearly independent choice is in the process of policy implementation. The arm's-length nature of the usual relationship between national political actors and museums leaves a great deal of scope for museum staff to manage the process of turning national policies into museum practice. Thus, as was the case with the international dimension of museum politics, the lack of direct control over technical matters – or what are claimed to be 'technical' matters at least – that are subject to high levels of professional control leaves national political actors at a distinct disadvantage in comparison with those who are located in museums on a day-to-day basis. This can provide museums with an important means for maintaining their control of policy as the direct imposition of nationally determined policies can be held up as an example of invalid politicisation: 'invalid' as the boundaries between national politicians and technically adept museums staff can be claimed to have been improperly crossed. While this argument is effectively incorrect – as museums are always and inescapably political entities – it still carries a great deal of rhetorical weight and can be used to defend the freedom of museum staff to make their own choices independently of exogenous pressures.

National politicians, however, are not simply an exogenous source of pressure: their access to key resources allows them the possibility of exercising effective control without the need to direct the operations of museum staff in a hands-on fashion. The resources involved here are both the general political resources of power, legitimacy and ideology, and the more specific ones of appointment and money. The political legitimacy that politicians have is generally accepted as being the key factor underpinning their exercise of power (Beetham, 1991, 15–25), providing the means by which their decisions can be accepted

as being appropriate for all society. This generality of legitimacy extends further than the specific legitimacy for decisions that are made on the basis of professional expertise and knowledge. Technical legitimacy is really only appropriate in these professional realms whereas political legitimacy covers all areas of society. As such, political legitimacy rather trumps professional, technical, legitimacy as its scope is very much wider than that which professionals could possibly lay claim to. The consequence of this is that determined national politicians can always over-rule museum professionals in policy terms – particularly as doing so is unlikely to lead to a direct loss of life as might well be the case if they tried to overrule structural or nuclear engineers in the exercise of their technical functions, for example.

Establishing an effective ideological framework that can contribute to justifying political legitimacy extends the means by which national politicians can exercise effective operational control of public (and private) organisations. This can be achieved through not only winning the ideological argument but also by ensuring that ideological preferences get put into practice through controlling who runs these organisations. Thus appointing the 'right' people to be the Director of a national museum or to be members of Boards of Governors or Trustees can reduce the need for the direct exercise of political muscle by ensuring that those in charge of these organisations share the same sorts of ideological belief and policy preferences as national politicians do. Given that 'virtually all political systems have some level at which appointments are quite clearly political' (Peters, 2010, 84) it would be safe to assume that the directly political appointment of senior members of the teams that run national museums is not unheard of, not only in relatively non-liberal democratic, if not downright authoritarian, political systems but also in liberal democracies. Regardless of the relatively low political importance that museums have for most national governments for most of the time it would be surprising if such key appointments within the system were to be made purely and simply in terms of technical and professional merit. The other extreme of appointing people to run national museums who have absolutely no technical legitimacy, simply because of their political trustworthiness, would, however, be equally as surprising: national political actors would be unlikely to want to appoint somebody to such a prestigious position if they could be embarrassed by the decisions or statements that they then made.

In circumstances such as these, where considerations of legitimacy and ideology can be managed through the processes of political appointment, such mundane means of control as holding the purse-strings

become much less significant than may have been anticipated. After all, if political ideologies and policy preferences are shared then how much money will be made available becomes a distinctly secondary consideration. Allied to this is the idea that public debate about what is occurring within national museums – let alone local or private museums – is not necessarily something that national political actors would particularly wish to encourage. Why, after all, would they wish to become embroiled in arguments that are matters of 'low' rather than 'high' politics (Bulpitt, 1983)? Even, or even *especially*, in periods of acute political turmoil museums are not central concerns to most political actors. The consequence of this is that there is a strong tendency to accept a high level of overt depoliticisation of museums at the national level as this will avoid politicians becoming involved in diversions from what they perceive to be the 'serious' political issues of the day. The result of this is usually that explicitly political decisions about membership and management are relatively infrequently made, just as the exercise of direct control over museums and their activities is infrequent. Instead the 'experts' are given the scope to exercise their technical judgement in conditions of relative freedom – provided, of course, that they do not scare the political horses. The extent to which technical rationality is allowed free rein is thus affected by the nature of the opportunity structures that national political actors find themselves confronted with (as discussed in the 'policy streams' literature: see Zahariadis, 2007; Cairney, 2012, 232–42). The more routine these structures are, where politics is dealing with standard issues in standard ways, the more likely it is that museums will be given the freedom to operate according to professional standards and practices. Conversely, the more extreme the political circumstances that museums and political actors find themselves within the more likely it is that political, social or economic rationalities will assume importance, and the more likely it is that professional and technical claims to policy control will be either over-ridden or simply ignored, and the more likely it is that changes in key personnel will be made.

Conclusions

The lack of centrality of museums to the exercise of political power at the national level does not mean that museums are therefore simply politically unimportant. The role of national museums in contributing to ideas and images of national identity can be clearly identified in the post-colonial literature (Harrison & Hughes, 2010, 238) how political actors make use of these museums as tools for the exercise of cultural

diplomacy (Nisbett, 2013) or to lay claim to a symbolic significance for the nation-state through the collections that are held within them are all matters of national political significance. Indeed, the instrumental use of museums – in terms of using them for political reasons that have little if anything to do with them as museums – at the level of national political activity can sometimes appear to be the entire basis upon which their continued existence is predicated. Given that all policy is instrumental in one form or another (it is always intended to fulfil *some* policy objective, whatever it may be) museums are simply open to involvement with multiple forms of instrumental demand ranging from the symbolic to the social to the political to the economic and even, sometimes, to the museum-determined. The consequence of this is that museums are subject to a range of endogenously *and* exogenously created policy pressures, all of which place demands upon their resources. The choices that are then made within museums serve as an indicator of which sets of demands are perceived to be the most important and, thus, where power effectively lies within the museums sector.

Not surprisingly these power distributions vary across political systems leading to very different roles and expectations for museums to fulfil across the globe. Thus the overtly propagandistic role that museums are expected to play within the Chinese political system (Varutti, 2014) is not to be found in, for example, the French museums system (Poulot, 2009): even though such a role is certainly present within the French system it operates much more implicitly through ideological means concerning the legitimation of the French political and socioeconomic system rather than through explicit state-determined and managed direction and control. There is, therefore, a specificity to how the national politics of the museums sector operates that is dependent not upon the internal mechanics of the sector itself but, instead, on the political contexts, beliefs and expectations within the wider political system itself. As with the international level of museum politics, while there are common themes that can be identified across countries and political systems the precise mechanisms and underlying logics that underpin them, and which provide them with sense and meaning, varies widely across the world. To see these mechanisms and logics at work within the museums sector requires a shift of focus from the general to the particular and how museum politics function at the level of the individual museum. Thus, Chapter 4 undertakes this shift to examine the complex interplay of political expectations and demands at the local level.

4

The Local Politics of Museums

Introduction

While there are numerous pressures at work on museums that arise
from both the international and the national levels of action, they all
require managing at the local level of the individual museum. Despite
the fact that many of these pressures operate at a level of generality that
is far removed from everyday museum practice, and despite the fact
that national and international political actors generally have little in
the way of direct, hands-on, control over what occurs within individual
museums, these external pressures cannot be simply ignored or wished
away by museums staff. Instead, they establish a set of exogenously
determined structural constraints that surround the decision opportuni-
ties available to museums staff. How these pressures are managed within
museums forms the focus of this chapter which examines the nature
of the interplay between specifically local matters affecting museums –
ranging from patterns of accountability and control within individual
museums, to the hierarchical and professional structure of the museum
work force, to the functional roles that local museums are expected to
fulfil – and the exogenous constraints within which these local matters
are played out. The role of power within and over museums, the legit-
imation strategies that are made use of by different political actors and
the ideological understandings that underpin political activity at the
level of the individual museum provide the framework for making sense
of how these complex relationships affect what occurs at the level of the
everyday museum practices that the public is confronted with in their
relationships with museums – whether as visitors or not.

While it would be entirely feasible to undertake this examination of
museums simply on the basis of case-studies and examples drawn from

the wider museums literature – as Chapters 2 and 3 have already done – this chapter also draws upon original and detailed empirical evidence from the experience of publically funded museums in England between 2011 and 2013 (see also Gray, 2014). The limited geographical basis for this evidence means that the fine detail of museum practice will not necessarily, if at all, be the same as that which could be found in any other country and must be recognised as a potential limit to the validity of the conclusions that are drawn. Equally, however, that focus of the empirical study on subjects that are common across international borders – such as the role and status of different professional groups within museums, the impact of exogenous policies on museum practice, and the differences between formal and informal power distributions within museums – allows for the provision of findings that have both a general validity in their own right and which can be picked up on for comparative purposes in further studies based on the experience of other countries. While the English example is *sui generis* the range of policy issues and concerns that are dealt with inside these museums share much, if not all, of the same ground as is confronted in the politics of museums around the world, regardless of their specific location, and thus provides an effective basis for the examination of how the politics of museums operate at the local level. It would, of course, be foolish to expect that the limited research study that will be made use of would provide all the answers to all the questions that could have been asked about the local politics of museums and a number of other empirical sources are also made use of (as, for example, Lawley, 2003; West & Smith, 2005; Janes, 2013; McCall & Gray, 2014) to justify the conclusions that are reached at different places within this chapter.

What will become evident through the use of this empirical evidence is that the relationships between individual museums and the communities that they serve are subject to a complex set of variables. Some of these are under the direct control of, and subject to the direct choices of, museums staff, but many more of them are governed by the exigencies of the realities of organisational structure, the formal distribution of power between multiple actors within the system, the nature of management within individual museums and the willingness of museums staff to integrate external actors into their decision- and policy-making activities. Each of these produces different implications for the ways in which power and control will be exercised within individual museums, and each is directly related to the justifications and rationalities that are employed in museums to establish their legitimacy in the eyes of the publics that they are serving. Uncovering the specific impact that

each of these has on museum practice is, therefore, an important element in explaining not only the ways in which the politics of museums plays out in practice but also why differences exist between individual museums and what the consequences of these differences are, and how sense can be made of the general principles that underlie the answers to the questions posed in Chapter 1. This chapter starts by considering the importance of differentiating between power and control in the context of museums and then examines and explains why and how these operate as they do in practice.

Power, control and the museum

Chapters 2 and 3 have stressed the limited ability of international and national political actors to exercise any real effective operational control over what takes place within individual museums as a consequence of their limited capacity to manage the implementation of their policy desires, and their almost non-existent control of everyday managerial practice. Thus, even if these actors have quite clear policy intentions they are normally constrained by the need to get local actors to do what is wanted and expected of them – not that this stops them from trying and, occasionally, succeeding, as Message (2014, 16) demonstrates when a Presidential Commission 'requested' that the Smithsonian produce an exhibition on human rights in 1968 and one was duly provided later that year – even though this success depended upon the willingness of museums staff to accept that such an exhibition was appropriate and timely. Museums' general lack of political centrality, however, means that there is rarely sufficient impetus to ensure that detailed national or international political control is perceived as being either necessary or desirable in the museums sector, particularly at the local level. When allied with the fact that the predominance of professional expertise lies within the sector and not with national or international actors, a great deal of room for manoeuvre exists for local actors to take control of, and to manage (or manipulate) the intentions and wishes of external actors. At best the anticipation would be that national and international political actors could, and would, exercise some sort of control through their ability to establish patterns of ideologically determined expectations – about what museums might be anticipated to provide for societies and the wider political system – and patterns of legitimation that would then provide the justifications for policy choices and actions. In both cases, however, it is not as simple as a straightforward, top-down imposition of international and national views and choices. Instead, there is

a complex meeting of competing and conflicting views and choices that creates the conditions for the development of an active field of political engagement over precisely what museums will do and how they will do it. This will be the case regardless of whether or not the usual lack of political engagement by national and international actors is in place and derives, again, from clashes between the forms of legitimation that exist at the level of the individual museum and those that predominate in the broader political environment within which museums are functioning.

To see the divisions between levels within the political system as being determined simply by legitimacy issues – or even by ideological concerns – is to underestimate the importance of the everyday practice of working within museums. The 'new institutionalist' literature (March & Olsen, 2006; Peters, 2012), for example, discusses the importance of a variety of structural influences for the organisation of political action, with these influences ranging from formal institutions (such as the British Museum [Wilson, 2002]) to informal institutions (such as professional networks [DiMaggio, 1981] or 'standard operating procedures' and other organisational arrangements [Janes, 2013]). In the case of the former, the very nature of the individual museum concerned will influence the patterns of behaviour that are undertaken within them – for example, national museums are expected to operate differently from local, university and specialist museums (such as the host of medical museums around the world [Alberti & Hallam, 2013]), with each being directed at different audiences and expected to have differing emphases upon which museum functions are seen as being the most central for their activities. The importance of informal institutions can be seen in the range of ideas of 'good' management practice for museums that can be found in a variety of textbooks and collections of essays (as in, for example, Moore, 1994; Fahy, 1995; Fopp, 1997; Ambrose & Paine, 2012) where perceptions of museum effectiveness and efficiency depend upon playing by the rules of established 'good practice', with this being determined by certain managerial standards and nostrums that are generated exogenously to the individual museum itself. From this perspective the specificity of each museum has important consequences for how the museum will operate, and this specificity cannot be effectively controlled by political actors who are operating at either arm's-length or at even remoter levels of control, as they are subject to the specific choices and actions of museum staff and have their effect through the operational choices that they make. Thus, to understand the manner in which power and control are exercised within the museum sector as a whole it is important to focus on the actual practice of those who are

working within the sector, rather than relying simply on generalisations that are based on normative preferences about how museums 'should' be functioning. Of course, these preferences will have an effect upon expectations about how power and control are to be exercised within individual museums and it would be unhelpful to ignore entirely this source of ideas when examining everyday museum practice.

Power is distributed within the museums sector in different ways depending upon the type of power that is being examined – whether it be 'to', 'over' or 'for' – and which group of political actors are being examined – whether these are elected or appointed politicians, the different staff groupings that operate within museums, or the broader aggregations of political actors operating outside of the particular museum environment, but whose actions and decisions can affect museums in both specific and general ways – with these being made up of pressure groups of various sorts, community and other forms of interest group, political parties, funding agencies and philanthropists, as well as the relatively disorganised mass of the general citizenry. In every case this distribution of power is overlaid with societal patterns of power distribution – whether the society concerned can be identified as pluralist, neo-pluralist, neo-elitist or corporatist, for example, in terms of how widely spread power is; and whether the exercise of power is determined by, amongst many other variants, plutocracy (the rule of the rich), theocracy (the rule of the religious), democracy (the rule of the people) or kleptocracy (the rule of the thieves), in terms of who has access to effective power.

The same considerations apply to the examination of the exercise of political *control* over the local level of museum activity. As will be seen, while there are overlaps between the exercise of power and the exercise of control they do not always coincide, and, as a consequence, it is useful to differentiate between the two – not least because of the importance of particular events, demands and circumstances in terms of how they will affect museums and museum practice in their own right. Control is particularly tied in with how the legitimation of the exercise of power and museum practice are undertaken, as well as the underlying principles and justifications that are utilised by political actors in support of these legitimating tactics. In a hierarchical sense there is also a clear distinction between bottom-up and top-down systems of both power and control and this is important for explaining why the differences between power and control have the particular effects that they do, both individually and in combination with each other, in the context of the local museum.

Power and management in the museum

There is, to a certain extent at least, a clear relationship between museum functions and the distribution of power within museums. Depending upon which set or sets of functions are seen as being the most central to the work of the museum then, not surprisingly, this affects which sets of actors are seen as being the most significant for what the museum is intended to do. In practice no group of employees within an organisation are entirely without some power but this power is always tied in to the requirement of making the museum function effectively in terms of what it is intended to achieve in the first place. Thus, collections management will usually have a rather central importance for those museums that rely upon material and tangible cultural expressions, as these concrete components of the collection require consistent, if not actually continual, maintenance and upkeep if they are to serve their purpose (Ambrose & Paine, 2012). Most museums are fully multi-functional in that no single element of their work dominates all others, and no function is entirely neglected, meaning that there is inevitably a dispersed pattern of power – although not necessarily a wide one – within museums. Such a dispersal will also change over time as museums reconsider what it is they are trying to achieve – and, consequently, which functional activities are the most central to this changed environment – and as external political actors change their demands upon and their ideas about museums. Thus Parry (2007) notes the increasing significance that digital technology has for how different activities are undertaken within museums, and Dewdney *et al.* (2013) discuss the effects that increased awareness of, and concern with responding to, cultural diversity can have for inter-relationships between different functional groupings inside museums, both of which have effects upon where effective power resides in the museum, and which groups – both internal and external to the museum – are important in its exercise. Peacock (2008, 347), for example, argues that the introduction of IT systems can transfer the exercise of power from senior managers, operating in a top-down fashion, to the general staff of museums as it is they who have effective control of the uses to which technologies contribute. This is, again, an illustration of the expected implementation gap between what managers may want and what they actually end up getting, in this case determined by the control of working practices.

What is important, however, is the *balance* between sets of museum functions and how this affects the internal distribution of power

between groups of actors. A common perspective on museums from both the management and the museums literature (see, for example, Abraham *et al.*, 1999; Holmes & Hatton, 2008) is that these institutions are examples of professional bureaucracies, functioning through a standardisation of skills, horizontal job specialization and a high degree of decentralization (Mintzberg, 1979, 348, 1983, 189). At best the idea that museums are full-blown examples of professional bureaucracies is something of a simplification: instead of there being a single core professional basis to museums based around, for example, the 'curator' their multi-functionalism leads to a much more complex mixture of core competencies which contributes to the decentralised autonomy of professional action but which runs directly counter to the idea of a standardisation of skills and is an example of vertical rather than horizontal specialization. The result is that organisational fragmentation is much more common within museums than the 'professional bureaucracy' label might imply.

The 'new museology' was, in part at least, intended to change the central role that was believed to be played by 'curators' in favour of what were seen to be less considered professional roles, such as those of education or community engagement, and while there has been considerable development since the 1960s in this direction it is still the case that in many museums the 'curator' is either in a position of centrality in terms of managing the museum and its activities, or is perceived to be the key actor in this role (Cuno, 2011; McCall & Gray, 2014) not least by other museum staff, but by distinguishing between different occupational roles within museums a pecking-order of significance can be identified that will allow for an appreciation of how widely spread power actually is across the entirety of the museums spectrum. Thus, the English example shows that 'curators' are still central in some museums, whilst in others education and outreach work are seen as being the most important activities that the museum is engaged in. Why this is the case is not necessarily the result of an internal power-struggle between distinct professional groupings that are only concerned with fighting some sort of turf warfare with each other. Instead it largely results from changes in internal expectations of what it is that the museum is to provide to their local audiences (for 'universal' museums the 'local' may actually be seen as the international community rather than anything more geographically 'local' to the physical museum itself), with this arising from changes in professional ideologies rather than from anything else. It also stems from changes in the broader political, social and economic environment within which museums are operating, with control

over general policy passing from 'museum' professionals to a more general breed of professional 'managers' operating on the basis of generic management principles. Thus museum professionals may still be of central importance in some cases but in others these sector-specific actors are not the only ones who will have an effect upon how museums are run and what it is that museums will provide.

Changes in professional status within museums may also arise from changes at the managerial level where the replacement of key personnel can be matched by changes in the perspective that is adopted to the work of the museum itself and how this could, and should, be undertaken. Morgan (2006), for example, argues that the ways in which organisations are imagined can have considerable effects on views of how they should be structured and managed to maximise particular forms of organisational efficiency and effectiveness. Many of the clashes over museum management, for example, derive from opposing images of how organisations can be understood. The consequences of these clashes can be seen through the examination of specific museum histories where changes in senior management have frequently led to considerable changes in how these museums operated. A comparison of the examples discussed in MacLeod (2013) on the Walker Art Gallery in Liverpool; Message (2014) on the National Museum of American History in Washington DC; Sherman (1989) and Hill (2005) on local museums in France and Britain in the nineteenth and early twentieth century; and Wilson (2002) on the British Museum demonstrates how important such changes can be for the organisation and functioning of museums, regardless of time or specific place. In addition to such internal managerial changes, imposed changes arising from the choices of external political actors in deciding how museums should function, and what the focus of their activities should be, will have equal effects but, in this case, arising from decisions that have little, if anything, to do with what internal museum actors would prefer, depending much more on external normative preferences. Gilmore & Rentschler (2002, 751), for example, point to the way in which shifts in emphasis in museum management can lead to an over-riding of professional values, and their replacement with more general managerial requirements as core components of how museums should function, with these deriving from entirely non-professional considerations. This possibility was recognised relatively early on in the development of more managerially focused museums (Kovach, 1989), and still underpins many of the perceived tensions that currently exist in museum management where clashes between museums specialists and general managers are often

seen as generating conflicts about the role of museums and how they 'should' be operating (Hatton, 2012).

Each of these sources of change – internal conflict, professional ideology, external imposition, internal managers and changes in managerial practice – will have different implications not only for how power is distributed within museums but also for the extent to which political turmoil and disagreement will become associated with them. The expectation would normally be that professionally dominated and internally controlled change will be more consensual than would be that which is simply externally imposed, and that, as the label implies, internal conflict will always be a source of organisational dissensus. Second-order changes arising from the effects of management and managerial change could potentially be the source of either turmoil or acceptance, largely dependent upon how well the process of change is actually managed by all the actors concerned and how these changes are justified to them. This, however, would be something of a simplification of what is actually a much more complex picture of what is normally a matter of negotiation, discussion and compromise rather than being a simple, direct, exercise of power from either the top-down or the bottom-up. Considering the exercise of power in isolation from the resources that each of the actors in the process of managing change has access to contributes to this simplification: power is not exercised in the abstract but in concrete circumstances and the more that is known about the context within which it is being wielded, the better the prospect of understanding where the variations in its exercise derive from.

Power, rationality and legitimacy in the museum

Clashes between rationalities and legitimacies contribute to these power variations, particularly when the participants in the exercise of power include both internal and external actors. If a museum is undergoing a process of internal renegotiation of roles and practices then debate will centre around both rationality and legitimacy but in circumstances where there is already some accepted framework that incorporates each of them (Boltanski & Thevenot, 2006). In such a case the creation of an acceptable compromise between the demands of different groups of actors can take place in the context of an already existing acceptance of difference – thus reducing the potential for overt conflict between actors. It may also, however, take place in circumstances where the ruling framework of rationality and legitimacy is itself subject to disagreement, in which case conflict can be widened to incorporate a

much larger range of issues and concerns than the immediate issue of organisational change entails. In such a position the establishment and acceptance of a new dominant set of ideological positions can become a central component of effective change management (Thornhill *et al.*, 2000, 69–81; Garud & Van de Ven, 2002, 212–13 [where it is pointed out that not all approaches to management change see ideological change as being important]; Lovell, 1994: see also Cunningham & Harney, 2012, 353–64 for a more recent view). This in turn leads to changes in the perceived relevance of long-established views of the importance of particular sets of rationalities and legitimacies in terms of how museums could and should be managed, with this then leading to shifts in the perceived centrality of different groups for the attainment of effectiveness and efficiency within the museum – and in their possibility to exercise power over others. In effect, just because a particular group of actors has always been functionally and politically important for what happens in museums does not mean that they will always continue to be so.

The differentiation of museum staff in terms of their functional role is one reason why conflict may develop within particular institutions. Equally, however, a differentiation in terms of location within the organisational hierarchy can also be a root cause of potential conflict. While the former is largely symptomatic of differences in professional status, the latter reflects differences in managerial status and operates in a quite different fashion. In the case of functional differentiation there are major differences between individual museums that are reflective of such obvious issues as the sheer size of the museum in the first place, with the smaller the museum the more likely it is that qualified professionals (either in educational or training terms) will have a technical advantage over unqualified staff, and this translates into a clear position of power and authority in determining what the museum will be doing and how it will be doing it. In larger museums, the interdependencies between multiple actors can become reinforced by a recognition that all these actors are required if the museum is going to be effective at what it is seeking to do – potentially leading to the development of less directive and more co-operative forms of management, a position supported by the English evidence.

The question of an imbalance in power between different functional groups need not lead to an assumption that conflict will be endemic within museums between competing groups with their own sets of interests to protect and advance. While this assumption may be common in the rational choice literature (Hindmoor, 2006), and would certainly not surprise the realist school in international relations (Frankel, 1996;

Roskin & Berry, 2015, 22–6), the reality is that overt conflict on functional lines is relatively uncommon in museums – at least to the public eye. In part this is the local equivalent of the silo mentality that occurs at both the national and organisational levels of policy – each functional grouping either operates in isolation from all other functional groups thus making conflict unnecessary on the daily basis of getting things done, or combined working is a consequence of the specific needs of particular circumstances (as in the example documented by Macdonald [2002, 60–3] of the reorganisation of the Science Museum in London) and this is not necessarily, and certainly not usually, how museums operate on an everyday basis. Given the different types of expertise that are required for the fulfilment of the wide-ranging activities that take place within museums it is not surprising that siloification occurs, even if this can also serve to generate a lack of knowledge (and even interest) across functional groupings about what each group is actually doing. It is at this point that hierarchical differentiation becomes significant for museum practice. While the reality of silos may be most evident at the level of everyday practice, at higher organisational levels within museums these boundaries become less important: senior managers are rarely solely concerned with what is occurring within their own fiefdom (although this is still important) as the necessity to work with other functional specialisations becomes increasingly apparent and relevant when developing strategies for the entirety of the museum rather than for only a part of the whole.

Hierarchical differentiation adds a new complexity to the practice of managing museums: the focus shifts away from the particular interests and demands of individual functional specialisations towards a much more general institutional focus. The responsibility of managers not only lies in a downwards direction towards the individual component parts of the museum that they have responsibility for but also in an upwards direction for reasons of managerial accountability. There are multiple forms of accountability that can be identified in museums: accountability for the efficient and effective working of each part of the museum workforce; accountability to the law on which museum functioning depends (Brown, 2014); accountability to those who hold the purse-strings – from boards of governors and/or trustees, to national and local governments and their elected representatives – and accountability to the communities and interests for whom the museum exists in the first place, with each of these being concerned with issues of transparency, liability, controllability, responsibility and responsiveness (Koppell, 2005).

These multiple forms of accountability in turn have their own effects on museum practice, potentially pulling the focus of museums in divergent and, sometimes, competing directions. The English example shows that one of the central consequences of these accountability concerns is that there are a variety of expectations about what the role of museum managers should be and what purpose there is to their activities (see also McCall & Gray, 2014). Thus managers are often seen by frontline staff as undertaking a type of buffer role between the demands, requirements and expectations of external actors and the actual job that is being undertaken by museum staff. At the same time they are also seen to be acting as either defenders of the museum through making the case to those to whom accountability is owed about how well the museum is performing, or as contributors to the making of the overall strategies and policies that museum staff will have to implement. In this respect museum managers are seen as being rather Janus-faced, in so far as they need to take responsibility for both internal and external demands and expectations about performance, in ways that front-line service delivery staff are not usually expected to be – provided, of course, that their performance provides what senior management expects will be delivered.

This points in the direction of another dimension to museum work that adds to the complexity of understanding the role of power within the museums sector: the fact that this work is taking place not simply in the context of the particular specialisation that museum staff are associated with – and this extends beyond the 'core' functions of curation, conservation and education to incorporate such activities as security, catering and cleaning as well – but also in the context of the museum as an organised institution in its own right. As such, demands for forms of performance reporting, for example, may often be seen as an unnecessary imposition on the integrity of professional autonomy but, in organisational terms it is a *sine qua non* for understanding how service delivery might be improved. This, again, demonstrates a clash between different forms of legitimacy and rationality within the museum – between technical and managerial forms of expertise in this case – with the outcome of this clash depending upon where power resides. Thus, if power is concentrated within the museum as an independent organisation (that is, it is not part of any larger organisation such as a local authority or a government department) then there is more opportunity for internal professional expertise to trump externally generated managerial requirements, as the latter are not as central to the museum as an institution, even if they can never be entirely evaded.

Equally, the greater the external political pressure on museums – as was seen in the case of national museums as the creator and/or defender of images of the nation-state and its peoples – then the more likely it is that externally derived management expectations will be in a position to over-ride technical demands and expert knowledge. Examples of each of these possibilities can be found in the case of individual museums. Whitehead (2009), for example points to the important role that was played by museums in the nineteenth century in defining the fields of art and archaeology, and how 'good practice' in either case could be identified, demonstrating the strength of forms of professional judgement in affecting the external world. Conn (1998), on the other hand, points to how there was a shifting in how disciplines and disciplinary knowledge were to be understood in the United States that was fought out between museums and universities with the latter largely prevailing by the early twentieth century, demonstrating the dominance of the external world over museums. Given that the museums sector as a whole is not central to the exercise of state political power it is likely to be the case that individual museums will be able to exercise autonomy over their own practices for most of the time and for their own purposes, however, the demands of the external world can never be completely ignored and these can act as powerful pressures in the exercise of arm's-length forms of control over museum practice.

The mediation of external demands through senior levels of museum managers and through the requirements of technical expertise can be used to explain why museums are rarely objects of complaint and action within the broader political sphere, largely on the basis that museum managers are not, in the main, stupid people – whatever their internal and external critics may think. The ability of senior museum managers to balance out and, at times, manipulate the cross-cutting demands that are placed upon them by their own staff and by those to whom external accountability is owed, extends the view of them away from being simply a buffer between internal and external demands towards a much more politically active role as a positive agent for the exercise of power. In this guise managerial staff within museums are just as capable of managing the expectations and demands of external actors as they are those of their own staff. In the English case, for example, senior managers in local authority museums were clearly adroit at ensuring that the key elected representatives who they dealt with were kept on side and supportive of their museums. This was done not only through managing the formal reporting mechanisms that local authorities had in place but also through ensuring, for example, that these representatives

could get their photographs in the local paper whenever there was a positive story being reported about the local museum. A casual trawl through local newspaper stories about local authority museums in other countries demonstrates that this is by no means simply an English phenomenon but appears to be an almost universal constant in local museum reporting around the world.

The view of museum managers as actively engaged participants in the exercise of power within their domains, and capable of walking the organisational tightrope between being the creatures of external forces and the puppets of internal ones is important when considering how the major issue of internal management change is dealt with in the museum context. As seen above, the tension between technical/professional and managerial rationalities and requirements can easily be presented as being an either/or case: museums are either subject to the former or to the latter. The reality is, however, nowhere near as straightforward as this dichotomy would suggest. Instead, both are continuously present and it is more a matter of the demands of particular circumstances and issues that determines which is of greater significance at any given time. Thus, the changes in managerial ideology in public sector organisations around the world that originated in the 1970s (although developing from a much longer tradition of public management reform: see Lynn, 2005) placed an increasing emphasis on the demands of external requirements in terms of management reporting and practice as well as on changes in organisational structures. These demands and requirements shifted attention away from the long-established models and methods of undertaking functions and roles within museums that depended upon internal professional autonomy, towards new approaches deriving from external, and highly generic, management ideas. With the latter the fact that management was taking place inside a museum was largely irrelevant: instead, general, if not universal, managerial principles were imported into the sector that were believed to be appropriate for management purposes regardless of whether the organisation being affected was a museum, a chemical plant or an insurance company. In practice such generic perspectives were not made much use of in public sector reforms in most countries where a much more discriminatory approach to managerial reform was developed instead, leading to multiple patterns of change (Pollitt & Bouckaert, 2011, 75–125). They were, however, common currency, and provided a common language for discussing change, across the private, voluntary, non-governmental and charity sectors and museums operating within them, and did have some effect on many public sector

museums around the world as well, particularly in terms of providing justifications and legitimations for the changes that were introduced, with these resting on what was claimed to be an ideologically neutral exercise in technical improvement.

Needless to say, these changes led to a simmering tension in many cases between internal professional groups who felt that their role and status was being undermined, and external actors who were concerned with a more efficient use of organisational resources than they believed were commonly to be found within museums (Gray, 2011). The resolution of the organisational impasses that this clash gave rise to depended upon how the importation of the new managerial regime was undertaken and who was undertaking it. Leaving the implementation of the new managerial ideas to staff within museums allowed the precise manner in which change took place, and the shape of the changes that were introduced, to be controlled by those who were potentially somewhat sceptical about the value of the reform process in the first place. As a consequence, the outcome was that supposedly universal principles became managed through the lenses of professional pairs of glasses, meaning that reform could be manipulated into those forms of structure and practice that could be matched with existing professional standards and expectations rather than being implemented in a 'pure' form. This manipulation of external expectations and demands has been a staple of the implementation literature for many years now (reaching back to the early ideas and arguments of Pressman & Wildavsky, 1973) and should, therefore, not be a surprise. Allowing such internal control of managerial reform certainly makes the imposition of some form of change without the outbreak of intense inter- and intra-organisational conflict possible: whether it succeeds in making the intended changes effectively part of organisational practice is, however, another matter altogether and the English example demonstrates that in many cases professionalism still trumps managerialism.

The alternative to handing control over to internal actors – that of imposing change from without – may make the attainment of the desired changes in the preferred form more possible, but the risk associated with this is that opposition to the changes may equally become entrenched, potentially leading to outright implementation failure. It may equally lead to the creation of resentment against the imposers of change which could create further difficulties at a later date when other externally desired changes are demanded. Neither of these are likely to make for easy inter-relationships between internal and external actors in museums and nor are they likely to lead to simple successes

in getting managerial change accepted. As discussed above, the size of the organisation concerned is an important variable when considering how managerial change can be put into effective practice – and so is the national context within which reform is being undertaken. Just as with the significance of functional differentiation in museums for how power is distributed, with this being related to organisational size, so with the introduction of management change: it is much easier for externally demanded changes to be introduced into smaller museums as these usually lack the necessary political, legitimacy and technical resources that would allow for the development of effective opposition to imposed change. In a different fashion the imposition of management change does not necessarily lead to the same difficulties in 'less-developed' countries where the meaning of change can be different (Peters, 2010, 324), and the level of professionalisation may be considerably lower, making opposition to change either irrelevant or ineffective.

This discussion of power in the museum has demonstrated the importance of legitimacy, professionalisation and hierarchy for how power can, and will, be used by museum staff. While a certain amount of emphasis has been placed on the conditions that can lead to the establishment of opposition within the museum, and the outbreak of conflict between different groups of actors with an interest in what happens within museums, it must be recognised that serious conflict over museums and how they are run is relatively uncommon. This is not to say that conflict does not exist – it clearly does (Fortey, 2008) – only that the mechanisms for managing it are quite effective at doing the job of keeping it within acceptable bounds. A lot of this is to do with the relatively small size of most museums and museum systems: for every Smithsonian, 'made up of 19 museums, 9 research centres and more than 140 affiliate museums' (Message, 2014, 6) there are very many more community and local museums that depend upon the good will of volunteers to keep themselves open and which cannot call upon the financial resources of the United States government to help them pay their way, with this making them vulnerable to external pressures that they do not have the resources to resist. Equally, however, the professional backbone of many museums, particularly larger ones, even if divided amongst many functional specialisations, provides a source of legitimation for independence and autonomy of action, as a result of the technical competences that museum staff possess and which external actors rarely do, which can be used as a key mechanism for resisting what can be claimed to be, and often are, inappropriate demands for changes in museum practice.

The power of museums

The discussion so far has largely been dealing with where the staff in museums derive their power from, and the ways in which this power is used to maintain their position as key actors within individual museums. A shift of focus to what this power is used to do, and what it is used for (other than simply maintaining existing systems of power and control that is) can serve to develop some of the arguments that were presented in Chapter 3 about ideological expression and identity formation *through* museums and the instrumentalisation *of* museums by external actors operating at the national level. An examination of how these activities are understood and put into practice by museum staff at the level of the individual museum can clarify their capabilities and limitations, and how these may feed into political, societal and economic effects over and above those associated simply with the sheer fact of the existence of the museum itself. In effect, the focus shifts from the operation of power within museums to the consequences of these internal uses of power for the wider communities that museums serve. As might be anticipated this develops into a way to identify how museums are not only 'sites of contention' (Message, 2014, 22) in themselves but also how they contribute to, and are affected by, the results of their actions. This requires some examination of the relationships between individual museums and the communities and societies that they function within.

Museum staff as a whole are responsible for a multitude of individual functional activities from cleaning the toilets to conserving the collection, and from designing exhibitions to evaluating their outcomes, even though each of these functions may also be contracted out to external agencies. In many cases, central activities that need to be undertaken to allow the museum to function at all are not actually undertaken inside the walls of the museum but are carried out either by the larger organisations of which the museum is a part (as with local authority museums which have their payroll activities undertaken on their behalf by the local authority itself), or by external agents operating on the behalf of the museum (as with the use of a variety of external actors and agents when negotiating for the return of stolen museum items – see, for example, Middlemas, 1975; Nairne, 2011). This fact shifts the focus of much of the concern about what individual museums do to the core functions of curation, education and conservation as it is these that museums everywhere are expected to have direct responsibility for and control over (ICOM, 2013). Unfortunately such a focus also leads to the position where the effects of museum activity are usually left

to the individual museum to identify. While accountability necessarily requires forms of reporting about organisational performance there is something of a division in what gets reported to whom. Thus, external accountability is normally addressed in terms of the issues and questions that external actors require answers to – whether this concerns reporting on the number of days taken as sick leave by individual staff members or how many people have gone through the doors of the museum is not really the point: it is a question of who is demanding the information and for which purposes they want it. Once again, the difference between the needs and requirements of external and internal actors assume an importance in this: there can be, and usually is, a clear distinction between the performance information that is required by each set of actors, and the reasons for why this information is required, but the practice of information collection and organisation is weighted heavily in favour of the museums, giving rise to numerous opportunities for forms of games-playing to develop where the information concerned is 'managed' in ways that favour the museums rather than their external reference points (Hood, 2006; Radnor, 2008).

This simple difference provides the basis for developing forms of conflict between museums and their external communities of interest. At one level this can be at the relatively simple level of managing the external demands that are made on museums for information. The English example, for instance, shows that while there is little concern with the demands for information that are placed on museums – it being accepted that there are legitimate organisational and political reasons for needing this information on the behalf of both external and internal actors – it was commonly questioned as to whether this information was ever made real use of by external actors. This could have given rise to the argument that if this information was not made use of then what was the point of asking for it, and why should staff waste their time gathering it, but this, however, was not made. At the front-line level it was commonly seen that even if the use of this organisational information was not directly apparent it was contributing to the overall needs of those who were requesting it – that is, that requesting information about its collection and how it was managed was a legitimate activity for museum staff to be involved in. For more senior managers, however, there was a much clearer image of how the information fed into external concerns, even if there were limited, if any, direct consequences for the museum itself. In this context external demands became a source of occasional grumbling rather than anything more overt, but they also provided the opportunity for the development of forms of inter- and

intra-organisational political manipulation that could be, and are, used in support of the concerns of both internal and external actors.

An alternate example, however, can show how the responses of museums to the demands of external actors can contribute to much larger patterns of political agitation and debate, with museum staff ending up as directly engaged political participants in matters of central importance for particular communities. Questions of intangible cultural heritage, for example, can cast museum staff in the position of being active agents in the protection of minority rights, or, alternatively, as agents of forms of neo-imperialism and neo-colonialism (Smith, 2004, 2006) through the imposition of the dead hand of, what can be seen to be, Western images of heritage that are concerned with the preservation of an idealised past, and the failure to accept that cultural change is a continuous phenomenon that should not be stuck with an unchanging set of meanings and practices. Protection and exploitation in this case can be attached to the same sets of organisational practices, and which one becomes accepted as the official story will have consequences for how museums and heritage practitioners become labelled as either heroes or villains by the communities with which they are interacting. It is simply not the case that museums are always representative of forms of neo-colonialism and neo-imperialism that, explicitly or implicitly, are displayed in the very nature of the museum itself or in the ways in which the collections of museums are managed, displayed and exhibited. Instead there is a much more complicated set of positions that develop from the inter-relationships between museums and their communities, the intentions of museums staff, and the ideological underpinnings that affect how these staff do their jobs (Crooke, 2007; Bhatti, 2012).

In these cases of organisational games-playing and the management of community relationships, the role of museum staff as active agents in the making of decisions and choices places them in the centre of the local politics of museums and, as such, the manner in which they exercise this centrality – and whether they are able to exercise it in the first place – are important issues when considering the manner by which the power of museums is actually undertaken. Clearly the legitimation that is derived from forms of technical and expert knowledge allows museum staff the ability to stake their claim to positions of authority, with this receiving support and justification from the underlying professionalised ideologies that have developed in the museums world concerning how museums *should* be run, what they *should* be doing, and who they *should* be answerable to. Each of these normative imperatives

depends upon accepting as legitimate the role of technical experts in managing the competing demands and pressures that are to be found in individual museums and the museums sector in general. Provided that other actors cannot find other legitimating mechanisms that can outweigh these professional claims the position of museums staff as the effective controllers of the system is unlikely to be subject to externally imposed changes, even if it is subject to a large number of external challenges.

In this respect a distinction needs to be drawn between *technical* knowledge in the sense of physical science – with this underpinning the authority of conservators, for example – as well as more *craft* concerns such as the most appropriate way in which to hang a painting of a given size and weight, and *operational* knowledge concerning what can be done with the museum collection (whether tangible or intangible), and how effects may be generated from this – with this dealing with the more everyday *practical* concerns of curators and education staff, for example. The manner in which museums are expected to be accountable to external actors has a considerable effect upon the internal practices that develop within them – Thompson (2003, 236–38), for example, argues that an increasing standardisation of museum practice in the United Kingdom, in comparison with New Zealand, is a direct consequence of the manner in which their museums sectors are organised, and the forms of management inspection that they are subject to. These external sources of pressure are far less effective in influencing the activities that are undertaken within museums in the more strictly 'technical' sense as the competence of elected or appointed politicians to argue on 'technical' grounds tends to be extremely limited. These technical issues are far more likely, therefore, to be determined by the technocrats themselves, operating through such organisations as professional associations and international organisations such as ICOM (see Chapter 2). This differentiation between the types of knowledge that underpin museum practice can be applied to both what power is used for and what power is used to do within the confines of the museum as an institutional form. The relative freedoms that staff within museums have to undertake their functional activities depends upon their ability to control both their own legitimacy and the ideologies that justify the exercise of their roles. All staff within museums are actively engaged with these processes and practices and, as a consequence, a focus on simply one set of actors within museums (as in the case of 'curatorial activism' – see Message, 2014, 1 and *passim*) can seriously underestimate the inevitability and extensiveness of political activity within museums,

as well as the fact that curators are not the only practicing politicians within museums or with a concern for them.

By extending the focus of political analysis away from the central role that curators often have within museums it is possible to identify a range of political effects that museums staff can generate, with many of these being functionally specific, but all of which contribute to the range of social, economic and political impacts that museums can have on a number of distinct communities of interest – whether these are local, regional, national or international. The interest here is in the deliberately chosen roles that museums staff adopt, and how these roles are utilised to manage what it is intended that museums should be doing, rather than in the often unintended consequences that arise from museum practice. The use of national museums, for example, as a means for the creation of national identities is not always what it is intended that these museums should be doing, even if it is what they contribute to (see Chapter 3), and it may be extremely misleading to imagine that staff within these museums are consciously intending to undertake this role through their choices and actions. Instead this identity formation role is often a spin-off of quite other concerns that museums staff have, or it is an imposed reading of what museums are doing that is as much based upon assumptions about national museums as institutions as it is on actual museum practice. By concentrating on the consciously intentional roles that museums staff are fulfilling in their everyday practices it is possible to assess the extent to which some of the dominant assumptions about museums are actively lived up to.

The ways in which museums display their power is through the choices and activities of their staff – 'museums' by themselves have a symbolic role and contain within them a conglomeration of meanings and symbols, but these rely upon those who have responsibility for them for this to be made evident through what is displayed, how it is displayed, why it is displayed and who it is displayed for. While these choices may generate a large number of unintended consequences for the museums themselves, as well as for their staff and visitors, there is always a clear rationale behind them, even if 'museums have not been and are still not organized exclusively around the production of exhibitions' (Lord, 2014, 9). While this simply recognises the multi-functional nature of museums – with display and exhibition being only a part of the entirety of the museum enterprise – it is still the case that for the majority of people what matters about museums is not the quality of the research that is generated from within them, the standard of the educational experience that they offer, the legibility of the display

information on the walls, or the standard of the cakes in the museum tea-rooms but, instead, what is actually on display within them. Not surprisingly there is a flourishing literature about the mounting of exhibitions (see, for example, Hughes, 2010; Bedford, 2014), as well as about the political messages that exhibitions contain (Macdonald, 1998; Luke, 2002). It has certainly been the case that following the development of the new museology there has been a heightened awareness of the political dimension of what museums choose to display and exhibit, with this being reflected in the choice of exhibition themes, the participation of community members in exhibition choices and forms of display, and the ways in which things are explained to the visitors themselves. Taking these processes apart clarifies the ways in which museum staff exercise their power, as well as the ways in which this exercise of power produces particular consequences for all the participants in the process, whether as active producers or as the recipients of the exhibitions and displays that are created.

Mobilising the power of museums

It is something of a truism that sure-fire mechanisms to attract a range of visitors to museums and museum exhibitions and displays involve mounting events that involve dinosaurs, ancient Egypt and/or gold (with the ideal exhibition, of course, being one that displays a golden Egyptian dinosaur). This gross simplification hides, however, an accepted fact of museum life that there are certain themes and components that are expected to lead to the attraction of large numbers of visitors with the expected result of not only providing large amounts of money to the museum's coffers but also of attracting infrequent visitors or non-visitors through the doors of the museum. This latter is important for a variety of reasons, of which the economic motive is only one (although often an extremely important one). Adding new visitors is economically of most relevance in museum systems that rely upon box-office receipts for their funding: attracting new visitors and providing displays that will encourage them to return will contribute to the long-term economic sustainability of the individual museum concerned. Alongside this there might also be the added revenue to be gained from visitors making use of museum drinking and dining facilities, or spending money on exhibition catalogues or other things that are available in museum shops – where, that is, either of these opportunities exist, which is by no means certain in the smallest museums.

Alongside these material benefits for museums, however, there are also a variety of social consequences that the attraction of both old and new visitors can give rise to, ranging from increasing participation from social groups that are not traditional museum visitors (quite often this means working-class, less highly educated, or ethnic minority groups), to the potential to generate positive health benefits through engagement with the museum's collections (Newman, 2013; Chatterjee & Noble, 2013) and, running alongside these, are the obvious benefits for visitors in informal learning and formal education (Hooper-Greenhill, 2007; Falk & Dierking, 2013). Indeed, in many countries there has been an increasing demand placed upon museums to demonstrate the social benefits that they produce, and to actively pursue these benefits in their practices through forms of museum instrumentalisation. A consequence of this at the local level is a display of themes and practices in museums that explicitly relate to the local communities that they are serving, usually through using gallery space to 'tell the story' of the history of the local area, quite often through some combination of geological and social history displays, or by mounting special exhibitions that are of particular interest to parts of the local community. The point behind this is that 'the local' has become an increasingly common focus of new exhibition trends in ways that have not been so evident since, in some cases at least, the nineteenth century when the 'local' nature of museums was particularly prized (Murray, 1996 [1904]): instead of pointing towards general issues that are associated with wide-ranging ideas of universal relevance and importance, the tendency has been to move towards a specific localness to museum practice with an explicit intention to create an 'engaging museum' (Black, 2005) for local communities.

Alongside this localisation of exhibition and display, in many parts of the world there has been a development towards an active role for local communities in curating museum exhibitions and displays, which, in turn, has contributed to changes in how museums are organised and function (Crooke, 2007; Simpson, 2007). Again, there is a political content to this shift in museum practice, with this arising, in the main, from the different meanings that are attached to the perceived function of the museum in displaying aspects of community existence: whether the museum is seen to be acting as a repository of the material objects that are a part and parcel of the way of life of a particular community or whether it is seen to be the narrator of the intangible stories that make the community what it is, these lead to very different roles that the museum is expected to undertake, calling on

different forms of technical expertise and demanding different relationships between the museum and the relevant communities that are involved. This is not concerned with any moves towards overthrowing the expertise and technical knowledge of museum professionals (although see Watson, 2015, 235) but, instead, making use of these to create a more personalised form of museum arrangement that stems from inside the local community rather than being imposed upon it.

These newer community-based forms of museum arrangement can be created through either the active encouragement of museum staff – usually through forms of curatorial activism – or through bottom-up demands for control of how local communities are to be represented within the confines of the museum exhibition, with this having an added impact on professional developments amongst museum staff through the introduction of new skills and practices (Witcomb, 2003, 67–101).

These bottom-up shifts are themselves quite often the result of new tendencies towards more general ideas of community development and empowerment that just happen to intersect with the opportunities that museums, as an institutional form, can give rise to. As such the museum functions as a transmission and translation device that establishes the forum within which community development and empowerment can be organised: it is not directly a political mechanism but it provides the location within which political action can take place. In this respect the museum could be simply seen as a neutral entity that acts as a part of the wider public sphere of communication and interaction (Habermas, 1991; Barrett, 2011) for communities to participate within. Such a view, however, would be to seriously underestimate the ways in which the establishment of such a public sphere involves a deeply political set of practices and beliefs about the values that are to be expressed. In this case the 'reading of the text' of the museum that is commonly found in the museums studies literature provides a valuable set of arguments about precisely where this political dimension to the museum is to be found, and the processes by which it is maintained through the organisation of museum contents, exhibitions and displays.

The core position is that museums are both the creators and the displayers of meaning through the whole range of their activities: in the case of museum collections, both tangible and intangible, for example, what is collected is assigned with significance through the simple fact that somebody believes it is worth preserving for public display or simply as a memento of the past or the present (for a much more detailed examination of this subject rather than this rather gross generalisation

see: Elsner and Cardinal [1994]; Pearce [1994]); Martin [1999]). This assignment of significance can then be justified (or not) through the creation, for example, of a set of Foucauldian (1977) discourses that locate it within broader patterns of value and meaning within society. As an alternative to this view, significance carries with it a weight of ideological messages that legitimise preservation and/or memorialisation as distinct forms of social practices. Both arguments end at the same position that collection is itself a political act or, at the very least, an act that conveys a variety of political meanings and messages within it. To develop this idea a return to the core political theme of power is necessary, not so much in terms of the ways in which power is used but more in terms of the structural and behavioural dimensions of power within the museums context. In this case structural power is concerned with how museums can be seen to demonstrate (or at least reflect) the distribution of power within societies in terms of what is deemed to be worthy of collection, how this is then displayed, and in whose interests these activities are undertaken. The behavioural dimension is concerned with who makes the decisions, the basis upon which these decisions rest, and how these decisions are put into practice. These matters are, of course, intimately related to the type of power – to/over/for – that is being employed in any given case and both form part of this discussion.

Structurally the content of the overwhelming majority of museum collections so obviously reflect the beliefs and values of the dominant members of society that it hardly needs to be noted. This is normally simply a reflection of the class-based nature of museums as institutions – it was usually the powerful within society who had the resources to establish museums in the first place, with this taking place for a variety of reasons, as shown in the context of the establishment of museums in the British colonies (MacKenzie, 2009), or of new city museums in more recent times (Jones *et al.*, 2008). More recent museum developments show, however, that they need not be the simple expression of class-power, as in the case of China (Varutti, 2014), where it is the dominant Communist Party that has access to the resources that new museums require to pay for both their physical construction and the development of the collections that will be housed within them (although it could be argued [as the Party would probably prefer it to be seen] that the Party is simply operating as the legitimate representative of the organised power of the Chinese proletariat and peasant classes). Equally the development of community and neighbourhood museums depend upon having the financial resources to establish them and this can lead to their gradual (or sudden) collapse, or the passing over of

them to those who can fund them (Crooke, 2007), but who need not share the same community-based rationale to justify their involvement. Collections that are based upon the personal interests of passionately concerned individuals equally require access to the necessary resources – not simply financial ones but also political, legitimating, organisational, technical and managerial ones as well – that will allow for their collections to continue to exist en masse into the future. The examples of the foundations of the British Museum (Wilson, 2002), the National Gallery in London (Conlin, 2006) and the National Galleries of Art in Washington (covering what are now the National Gallery of Art *and* the various Smithsonian Galleries) (Fink, 2007) all demonstrate that personal collections can survive the death of their founders – or even the wishes of their founders – but only if a whole range of resources alongside those of the collection itself can be mobilised in their support.

These latter examples also demonstrate how value gets assigned to the material objects that form the basis of the national collections that are deemed worthy of preservation for the people of a given nation-state: particular classes of material or art were effectively seen to be important enough that the nation-state felt compelled to take them on, usually after some bitter resistance to having to do so. The reasons for this compulsion were tied in with the perceived quality of the material that was included in the collections concerned, with this perception being guided by the opinions and beliefs of particular individuals and groups who were in a position to exert effective influence, if not direct power and control, over national policy-makers. Certainly there was no widespread national enthusiasm (or even interest) in adopting any of these collections, but there was a high level of oligarchical support that allowed particular opinions and beliefs to become transformed into a taken-for-granted acceptance that the nation 'needed' to take these collections into their care to preserve them for future generations. This transformation process can take many forms but it usually depends upon an underlying consensus that the values concerned are, indeed, appropriate ones for the nation-state to provide support for.

This same principle underlies the establishment of local museums and galleries – some expression of the necessity to establish such an institution depends upon there being particular sets of values, opinions and beliefs that a museum would be able to represent on the behalf of particular constituencies of interest in the local sphere. This could take the form of telling the historical and natural history 'story' of a locality or town or city to both the people who live there and visitors to the area; it could also relate to popular stories and myths that

are associated with the area – as, for example, the use of the story of Lady Godiva in Coventry's Herbert Museum; and it can also relate to the image that the local area would like the rest of the world to have of itself, with this being common in many of the newly developed city museums around the world (Jones *et al.*, 2008). Each of these is undertaken through the making of particular choices about which parts of the existing collections will fulfil the function of local representation and through the choices that are made about how to display these elements of the collection in particular forms and in particular ways.

The development of the new museology contributed to ideas about what could and should be shown in museum galleries, with an increasing emphasis on representing the voices of the previously over-looked or deliberately ignored. This was particularly important for local museums as they could make new choices about what would be on display and, more importantly in this context, how this material would be presented. The deliberate intention behind a great deal of this activity was to encourage a much more active engagement with those members of the local community who were, at best, infrequent visitors to museums. This approach to social inclusivity was based on clear political assumptions concerning the nature of the collections that were on display. These collections could be simply dismissed as being irrelevant to much of the local population as they embodied the old values of groups and individuals who were not representative of new, local, generations. This shift away from what had been seen as universal values that were relevant for all people, in all places and at all times towards a more particularistic set of values required the development of new arguments, justifications and legitimacies for museums to make use of. Such changes in the underlying principles and values that museums make use of should not be assumed to be simply a recent development, there has always been an element of re-making the museum for changing times and changing circumstances – the effect of the new museology was simply more politically aware of what it was seeking to change, and why change was necessary, than had been the case where forms of evolutionary and incremental changes in policy and practice were in place, based on the common-sense necessity to take account of change within the museum.

The behavioural dimension in this process of change depends upon the concrete decisions and choices that are made by museum participants and how these are translated into action. There are surprisingly few detailed examinations of the decision-making process in museums and galleries, particularly in terms of exhibition and display (although

see MacDonald, 2002; Message, 2014) with most 'how to' books being based on assertion and detached theory rather than on specific evidence (Ambrose, 1993). Despite this, however, it is possible to identify sufficient evidence to clarify the manner in which decision and policy-making in museums affects what takes place in terms of collections and collections management. In the first instance the professional autonomy of museum staff is a key component in this. Again, the values and ideologies that inform the justifications that are employed in making particular choices from the many that could have been chosen are important in this process: the ideas of path dependency from forms of historical institutionalism (Peters, 2012, 70–4), and incrementalism (Lindblom, 1959) would imply that past decisions severely constrain the possibility of moving rapidly to new policy positions (although neither denies that rapid change could occur in the right circumstances), and the reliance on standard operating procedures that are determined by professional standards and values are generally seen as a key component of this constraining role of the past on the future (DiMaggio, 1981). In this context the idea that museums staff are consistent advocates for activist and interventionist roles for themselves and their museums is perhaps over-optimistic about the role of museum actors as 'change agents' of the first order, as the development of such roles takes place over a period of time in the face of resistance, if not downright opposition, from fellow members of the professional communities concerned who may see such changes as being contrary to existing patterns of 'best practice'.

Indeed, it is not only the potentially constraining role of professional standards and values that may limit the potential for large-scale (or even small-scale) change in museum practices, policies and decisions: museums staff are operating within the larger institutional and organisational contexts that are established by their working conditions, and each of these could also affect the potential for change. At the local level the functional and hierarchical location of particular members of museum staff can limit their room for manoeuvre, as can the fact that they are not simply individuals making their own choices but, more normally, are members of a variety of work- and task-based groups of actors with a subsequent necessity to operate inter-actively and, usually, co-operatively rather than individually. The discussion of how choices about exhibition contents and formats are made in the context of organised groups of museum staff is covered in both MacDonald (2002) and Message (2014), where the importance of compromise and the existence of inter- and intra-group conflict, negotiation and bargaining through

processes of neo-pluralism that require managing by museum staff are seen as being important components of the decision-making process. In this context the shift of focus from the role of the individual professional to the members of a larger collective environment of decision- and policy-making makes the idea of short-term change in response to short-term pressures and demands as being a common characteristic of museum activities a rather questionable one. The English example provides evidence that routine patterns of decision- and policy-making in larger museums establish patterns of interaction that shift the attention of museum staff away from simply their own functional and professional concerns towards a wider appreciation of what is involved in making the museum effective in its operations, even if this is by no means as apparent in smaller museums.

The fact, however, that change does take place needs, once again, to be placed in the context of the longer term. Making major changes in the short term may be difficult but the achievement of effective policy change over a longer time-span may be a more realistic image of how change occurs. It is not necessarily the impact of the individual choices that are being made that is important but, rather, the combined impact of many choices that leads to overall change. In the context of museum collections this could be thought of as being a question of museum practice: the issue is not what museums have in their collections but what they do with them. Changing the content of museum collections as a whole is a decidedly long term, and, these days, expensive project: changing the ways in which the collection is used is something that can be undertaken over much shorter time-scales and would require much less divergent group involvement in the process, particularly when wide engagement could raise the potential for creating overt political conflict between the demands of competing professionals and groups of exogenous actors. The English example of building 'social inclusion' into the core of what museums were doing, and how it was being done demonstrates that changing museum practice is considerably easier if different museum groups do not see the changes as threatening their own professional autonomy (Lawley, 2003; Newman & McLean, 2004; West & Smith, 2005; Tlili, 2008; McCall, 2009). In this case it was also evident that the majority of professional groups already saw the inclusion principle as being an important part of what they were doing anyway, particularly amongst members of museum education and outreach teams, making the introduction of the principle much less politically fraught than it might have been if a more contentious issue had been involved.

In terms of getting changed policies put into practice without the creation of sizeable implementation gaps along the way, functional and hierarchical differentiation can be either an asset or a potential danger, with this, again, being dependent upon the size of the museum. The limited extent of either of these forms of differentiation in small museums can make the process of implementation relatively straightforward as there will be far fewer 'decision points' (Dorey, 2014, 247) – where active co-operation and engagement is required if implementation success is to be achieved – both horizontally and vertically, that could limit or actively prevent the successful introduction of new ways of operating. Conversely, both forms of differentiation will be more problematic in larger organisations where there are many more actors and groups with a potential interest in the subject, if not an active engagement with it, but who do not necessarily share the same views about what could or should be done in any given set of circumstances. In this context an examination of the practice of implementation can be extremely informative about both the distribution of effective power within museums and museum sectors across political systems, and the core values, ideologies and justifications that are used within each. This is particularly the case when the focus of attention shifts to the multi-organisational context within which most, if not all, museums are operating. The accountability of museums staff to independent funders – whether as individual philanthropists, or national or local governments, for example – inevitably leads to the requirement to undertake certain activities that may be seen by museum staff to be either an unnecessary burden, as a result of their demands on staff time and other resources, or as an interference in their autonomy. In the case of the latter, the demand by philanthropists that their donations of art works to museums and galleries be displayed all together (and usually in one room) can be very effective in showing the extent of the donation that has been made, but need not make much sense in terms of the overall collection that the museum or gallery already has, or may acquire in the future, or in terms of changing professional ideas about effective display techniques. The perceived instrumentalising pressures that museums and galleries find themselves confronting (Gray, 2008, 2011) is a further example of the requirement to respond to external actors which requires forms of management that depend upon the extent to which staff are capable of acting independently or not, with this usually being achievable in both large and small museums: in the former through the weight and wealth of expertise that is contained within them, and in the latter through their general lack of visibility and significance in the eyes of external actors.

If the power of museums resides in both their institutional status within societies and in their collections then how this power is expressed is just as important as who it is expressed by. The development of groups of museum actors with specialisms in a range of technical skills from marketing to exhibition lighting and design to visitor evaluation has been a continuous process from the early days of the museum enterprise with each group contributing their own element to the overall museum experience. Each, equally, undertakes their role through a range of techniques and devices that have their impact through their combined effect rather than as a discrete set of independent particles. Establishing the structure of these elements and particles, and how they are expected to produce the desired outcome for museums, through effective inter- and intra-organisational management means that there is an inevitable potential for conflict and dissensus between divergent values and practices across the museum. What is displayed in museums and galleries is rarely, if ever, the result of the decisions of individual actors and is more usually the outcome of the collaborative effort of people from both inside and outside the individual museums concerned – even if this collaboration can be the consequential result of the resolution of tension and argument just as much as it can be the deliberate result of consensus and agreement. The precise detail of what is displayed in museums, then, is not necessarily the real issue to be addressed as this display rests on how it is produced through the interplay of sets of political interests operating at the local level of both the museum and the geographical area that it is located within.

Museums and the exercise of control

There is no doubt that museums are involved in the exercise of control in a number of distinct ways. Not only do they regularly exercise control over the content and presentation of exhibitions and displays, as discussed above, and over the specific policies that they more generally pursue, but they also serve an important role as gate-keepers to both knowledge and access to the museum in the first place. Such a distinction points to the well-established proposition that museums exercise control both internally and externally (Hooper-Greenhill, 1992; Bennett, 1995), affecting both the practical detail of what it is that they are doing, the presentation of themselves to their particular communities of interest and their presentation to the wider world as a whole. The ways in which these types of control are undertaken vary considerably and involve the development of ideological and policy responses to

the demands that the actual and perceived need for control place upon them. The fact that museums are in a position where they are expected to, and in fact do, exercise control in such a diversity of ways indicates that museums have real power as social institutions over and above that which resides in their professional and technical expertise.

This social power derives as much from the symbolic role that museums can be seen to play within and for societies and specific local communities as it does from their direct contribution to the public realm of debate, information and communication. At the local level museums are not necessarily representative of national identity or flag-bearers of some form of nationalist political message, instead they more often act as contributors to a particular sense of local identity and community which carries a very different set of meanings within it. This sense of 'localness' can be built upon by museums as a potentially helpful device to escape from the external pressures that may be exerted over them from the regional, provincial or national level: an appeal to the needs and wishes of local communities can be a real political trump-card for museums to play, particularly if there are already considerable tensions between the different levels of political authority within nation-states. By acting as the effective flag-bearers of ideas of 'the local' through their collection of objects, with these being seen to embody some idea of a sense of place, and how this 'localness' is displayed, museums can exercise a powerful role in controlling what these ideas of the local will be seen as, thus establishing a political function in the process of doing so. This has been long-recognised as an important role for local museums to undertake, with arguments on this being developed all the way from, for example, Greenwood (1888 [1996]), to Ross (1960). The representation of the local is not simply, therefore, a symbolic role: it also produces significant political effects for both local communities and local museums alike.

Museums' broader social power derives from their functional activities, particularly the outward-facing ones of education and community engagement where the exercise of control is, perhaps, most obviously apparent. In these cases social power is quite clearly derived from the utilisation of the resources that museums contain, and operates in much the same way that national museums undertake their roles of engaging with visitor communities (Dewdney *et al.*, 2013). In both cases, however, the key point is that 'the museum', as an institutional form, carries with it a great deal of ideological baggage that allows it to exercise control: of particular importance in this is the perception that museums act as repositories of knowledge and meaning that establish criteria of value

and significance for society. Such a traditional image of museums carries with it an implicit view that museums must, therefore, be rather conservative institutions seeking to maintain the accepted wisdom of the past rather than being actively engaged in the creation of new forms of knowledge and new forms of meaning for the changing societies within which they are to be found. Not surprisingly, this view bears little relationship to the reality that those working within museums would accept. Museums can, of course, be deeply conservative in terms of what they do and how they do it but they can also be highly engaged active agents in the process of responding to social change. Their ability to do so, however, depends upon how, and whether, their roles and abilities as agents of change are accepted as being appropriate ones to pursue by both external communities and internal actors.

Museums are therefore not simply neutral mechanisms that are affected by every wind of social and political change that blows through them. The ability of museum staff to manage the numerous demands that are made of them, from both internal and external groups and pressures, and those that are both explicit and implicit in nature, is a key factor in these sets of local relationships, and it is here that effective control becomes significant. In their position as gate-keepers, in both the physical and intellectual sense, museums are in an extremely strong position when dealing with the heterogeneous demands that are placed upon them. Firstly, their control of technical expertise provides forms of legitimacy and a range of arguments and practical capabilities that are difficult for non-professional groups to counter or replace. Secondly, the prestige of 'the museum' as an institutional form carries such a weight that outsiders may seek to overthrow it by replacing one set of assumptions and practices with another, but this, as with all revolutionary demands, is difficult to achieve or establish in the short term and largely depends upon the willingness of museum staff to go along with demands for change. Thirdly, museums are in the position where they can pick and choose who they deal with. In this respect the classic distinction between 'insider' and 'outsider' groups (Grant, 2000, 19–35) assumes significance.

While the distinction between groups on the basis of their centrality to policy-making may be something of a simplification of a much messier reality it does allow a means by which to understand how museums exercise effective choice and control over the multitude of demanders that they are persistently and consistently confronted with. 'Insider' groups have close relationships with power-holders and core policy-makers and are accepted as legitimate participants in policy

processes. They know who to approach, how to approach them, and how to make their case in an 'acceptable' fashion, and they accept the outcomes of the policy-making process, whether they agree with them or not. This willingness to accept defeat does not mean that they will simply stop trying to change the existing, or new, patterns of activity that are generated by the policy process, or that they will simply stop playing the game of pressure-group politics. Instead, it shows that they accept the rules of the game and can therefore be trusted to participate in later rounds of policy-making where they may end up getting whatever it is that they want. This acceptance allows groups to be labelled as both acceptable and legitimate and establishes a measure of trust that museums will then attach to them. This then reinforces their insider status and can make them important links between museums and their communities by allowing them to be seen as effective representatives of different sets of community opinion and feeling. Groups representing volunteers or 'friends of the museum' are often in this position of being trusted by power-holders in museums – even if, as the English evidence shows, they can sometimes be seen as more of a problem than an aid to the effective running of the museum as, for example, when their demands are seen as obstructive to, or destructive of, what museum professionals are seeking to achieve.

'Outsider' groups, on the other hand do not have such a comfortable relationship with museums and their staff. Such groups may not, indeed, wish to have such close relationships with the organisations that they are seeking to change, feeling that this could diminish their own integrity as independent actors and limit their ability to freely state whatever it is that they wish to argue for. Such groups are often highly critical of what they see as cosy sets of relationships between the holders of power and the groups that they affectively authorise to speak on behalf of local groups and communities. Not surprisingly their lack of desire to conform to what are seen by museums as appropriate ways and means to make their case reinforces their outsider status by locking them into a cycle of opposition and closed doors. In practice many groups that start as outsiders find that they are more likely to be effective in making their case and achieving their goals by breaking this cycle and developing closer links with the holders of power, even at the cost of their own perceived independence from the system of control that they are dealing with. This demonstrates how much control museums can exercise in their dealings with external groups and demands: not only do museums establish the rules of the game that external groups are expected to play by, but they also control what the game consists of, as

in the exercise of Lukes' (2005) second dimension of power. Thus, some topics and subjects will be opened to groups to participate in whilst others are made off-limits for discussion and debate: some subjects will be open for some groups but closed to others at the same time. Establishing the parameters of debate can serve to close down the extent of meaningful participation that external groups can have and this reinforces the power that key actors within museums and the museum sector as a whole have access to.

In this context museums are caught in the proverbial cleft stick: if they open up access to the system to everybody they may find themselves having to deal with strident demands from multiple actors that cannot be reconciled with each other, creating a climate of mutual dissatisfaction, if not one of open warfare between antagonistic groups. On the other hand, if they exercise firm control over access they can be criticised for censoring valid objections to what they are doing, or for simply ignoring community opinions and voices that they are not comfortable with, or ignoring minority voices that do not or cannot, or do not wish to, shout loudly enough to get heard. Each of these positions is likely to be a deeply uncomfortable one for museums, particularly given the prevailing ideological position that they should be open institutions that establish a form of public sphere for discussion and debate. In what is a fairly clear demonstration of the difference between 'is' and 'ought', museums are put in the position where the expected vision of what they should be doing runs into the reality of what they in practice do, with no way of resolving this potential clash except by appeal to either normative value-judgements or to what are normally seen as crude, everyday, practicalities. Given that both of these positions are open to questioning museums will always find themselves as objects of political dissatisfaction from parts of local communities, even if for quite divergent reasons. Escaping from this position would require significant changes to the underlying ideological and normative claim to openness that museums are working with. Given that this openness is a source of legitimacy for what museums do and how they do it, it is unlikely that the tensions that are generated by these debates will be capable of easy resolution.

Thus, the exercise of control within and by museums will always generate the potential, even if not the actual practice, for the expression of dissent about what they are doing and how they are doing it. Given the difficulties that there are of arriving at a definitive solution to the problems that are generated by the competing demands that are placed upon museums, the question must shift to how they can effectively manage

their relationships with the multiple communities with which they are dealing. The fact that museums are not simply dealing with immediately local communities and groups but are also tied in with regional, provincial, national and international arenas can certainly be taken as marking a limit to the extent to which the insider/outsider group metaphor can be carried, but it also implies that museums require a variety of strategies for coping with the external world. Certainly, the relationship of local museums to ICOM, for example, leads to very different patterns of relationship to those that are required for managing relationships with the diversity of local groups that museums deal with. These differences are exacerbated by the specific contexts within which individual museums are operating: thus well-funded and professionally staffed private museums in the United States are not in the same position as small community museums in Melanesia or Central America which often have limited numbers, if any, of professional staff, and little in the way of financial resources to call on. The fact that these very different museums will also be dealing with very different sets of community and other external actors, with these being able to call on different sets of resources in support of their own positions, means that it is difficult to draw conclusions about how museums will control the demands that are being made of them except by making generalisations, and this caveat should be borne in mind in the discussion which follows.

The solution to many of the demands that are made of museums are to either retreat behind the barrier of technical expertise, thus closing off the issue to debate, or to more positively use such expertise to find ways of meeting these demands. While the former may well smack of 'blinding them with science' it is an extremely effective device to use given the often monopoly control of such expertise that museums and their staff possess. The latter may, however, be more effective in the long term as it demonstrates a willingness to respond to external voices in such a way that these voices are more likely to develop a positive attitude towards museum staff, and this can then be appealed to at a later date when other issues are involved. At this level this is a case of establishing the conditions within which future issues can be dealt with in conditions of mutual trust – in other words establishing insider status for the core groups that the museum is dealing with. As there is no limit to how many groups can acquire insider status it is possible for museums to juggle competing demands in such a way that outright dissent gets capped – even if this leaves museums open to extreme pressure if the juggling-act fails. As part of this the development of consultative forums or other forms of regular communication and discussion,

both formal and informal, with outside interests can establish recognised channels for the airing of grievances and the management of expectations that can serve museum staff well – although not always (Watson, 2007, 2015).

At the level of the individual museum these general claims about how to manage the external world are normally tied up with the broader issue of the exercise of control. While 'management' and 'control' are not the same thing, the former usually implies the latter in one form or another: 'managing' the external world almost always includes an assumption that the 'managers' are capable of exercising effective control over the situation which confronts them. This then returns the discussion to the core features of power, legitimacy and ideology with particular emphasis on who the key actors are in exercising these in any given case. The normal assumption, particularly in the 'new museology', is that the more explanation of the aims and intentions of the museum that is given to local communities of interest, the more likely it is that museums will be able to establish the conditions of trust that underpin effective community engagement and working. This depends, however, not only on the museum and its staff but on the wider networks of power and control that these museums are working within: thus, national museums must pay due regard to national politicians and governments, local authority museums to their elected councillors, and private museums to their executive boards. All must also have regard to the economic balance-sheet at some level which has other ramifications for what museums can, and cannot, do in practice: McGuigan (2005), for example, sees the entire field of cultural policy – of which museums are only a part – as being severely constrained by the logic of the existing form of economic system within which it is being carried out. As a consequence of this community engagement cannot be meaningfully separated from the demands and controls that museums are already tied into and from which they have limited independence. This lack of control over their operating environment is exacerbated by the general lack of political centrality that museums as a whole, and individual museums in particular, have. The generally small size of most museums exacerbates the difficulties that arise from this: limited financial and staff resources, for example, will severely constrain the ability of museums to be proactive in relation to their local communities and the tendency will be to fall back on much more reactive forms of community engagement than the staff might prefer. The consequence of these problems for museums – their lack of independent control over their operating environment, and their lack of political centrality – is that *real* control, control that

is exercised by museums and their staff on their own terms and in ways that are determined by them, can be extremely limited. This actual control is normally seen to exist in precisely those areas of organisational functioning that are dominated by the professional and expert classes that have already been identified as the core power-holders within museums systems around the world. In this reading of the distribution of power within the museums sector it is the case that the centrality of museums professionals is as much a function of their lack of control over the external world as it is a matter of their vice-like grip over the key functional resources that allow museums to undertake their everyday institutional activities.

Ideology and legitimation strategies in the local museum

Limitations on the degree of control museums can exercise over their external environments can therefore act as a source of reinforcement for the dominant professional groupings within the museums sector. The choices that these sets of actors make at the local level about the content of museum exhibitions and displays, and how they engage with external actors, are both clearly important in terms of how these activities contribute to the development of representations of particular views of local communities, with these having both ideological and legitimating roles to play for museums. In this context museum professionals have a political role to play that extends far beyond the manipulation of resources which allows them to undertake the multiple functions that they are engaged in. As well as these practical matters of concern that contain their own political meanings for both museums and their visitors – not least as an indicator of which functions are seen to be the most important for the museum – the less explicit processes of ideological reinforcement and questioning, and the establishment of a legitimating background to this, are equally as political and may, in practice, carry even more political significance for individual museums than what they contain and how this is displayed.

The use of museums for symbolic reasons – and the association of this role with exhibition content and exhibit labelling, as well as with what museum staff choose not to display – can be quite clearly propagandistic and explicitly designed to reinforce particular stories about localities and processes of national development, but they can also be more subtle representations about core values and beliefs that are seen to be important for the expression of some sort of national *zeitgeist*. The acceptance of the idea that these are a part and parcel of the role

of museums has already been noted in the claims that museums have both a symbolic and functional role to play in terms of their local communities with much of this resting upon the collections that they have access to. Inevitably this has led to many local museums displaying artefacts that have a close connection to their local area, either as the direct source of the material concerned or through some local connection to the donor: thus many local museums in Europe that have Egyptian relics on display received these as donations from their local universities who were partly funded by their local museums to undertake the excavations that uncovered them. The ideological component that is associated with these collections derives from the use that is made of them, just as is the case with national museums. For local museums this most often takes the form of establishing the relevance, significance and importance of local differentiation from other areas – which can be perceived to be particularly important when there are major local or regional rivalries at play. In these cases it is not only establishing a local identity that is important but also marking the local off from other areas and identities. In this context the role of the collection in serving this differentiation process can be as important as the display of material objects, and it is this that contributes to the legitimation of the museum as a key actor in the establishment of local identities. To extend this argument a closer examination of how local museums fulfil these twin functions of ideological production and legitimation establishment is required.

The extent to which local museums can function as contributors to ideological establishment, reinforcement and questioning depends to a large extent on whether they are seen to operate as a valid source for such activity – in other words, not only whether they are perceived to be both legitimate institutions in their own right but also as locations that can provide legitimacy to communities. The status of the local museum as a central forum for public learning and discussion depends upon an acceptance that the museum, as an institution, is a valid location for such activities to take place within. In this respect the local nature of the museum assumes importance – if the local museum is seen as being the central repository of the material artefacts that contain the history and the stories of the locality then it is in a position of real strength: no other local institution carries the same relationships between the material and the immaterial within it to as large an extent as the museum does. While other institutional forms (such as law courts) carry a great deal of symbolic weight this is quite often divorced from the full panoply of material objects that museums are home to, and these other institutions are normally not specifically local ones in the

same ways that local museums are. It is through this that local museums derive their legitimation as a valid mechanism for the expression of a local identity. In this way it is not a matter for concern whether local museums are visited or not so long as they actually exist: the legitimacy of the local museum spills over into the ideological role that it may then undertake, but it is the former that gives meaning to the latter rather than the reverse being the case.

The establishment of legitimacy *in* local museums can be undertaken through a variety of means, depending upon whom legitimacy is required from, and this can be quite a different matter to the establishment of legitimacy *of* or *for* local museums. For national governments, for example, the legitimacy *of* local museums could be derived from their legal status – are they directly creatures *of* statute, for example, as local authority museums are; are they simply covered *by* statute, as private museums with charitable status will be covered by charity laws: or is their legitimacy derived from their role in fulfilling the policy requirements that national governments have in other areas – as in the instrumentalisation of museums. In this last case the role of local museums in providing educational or social benefits that national governments wish to see provided might become the basis upon which they receive public funding, as their success in such provision will have demonstrated the validity of their role as providers of public policy benefits, with their legitimacy resting on this policy role. Such a position is quite different to the establishment of legitimacy *for* and *in* local museums. The former largely depends upon establishing the validity of museums as an institutional form, particularly for the local communities that they are located within. This process is determined by those inside the museum world itself: it depends upon the ability of museum actors to demonstrate that they *are* the sources of unimpeachable local knowledge and benefit that they are popularly believed to be. This role is largely undertaken through forms of advocacy work that will show the range of benefits that local museums provide for their communities, ranging from positive stories in the local media, to the provision of a range of public events (such as object identification sessions in the museum) that will illustrate the knowledge that the museum contains. It can also be undertaken through the actions of professional organisations and associations that serve the museum community as a whole, with these serving to both back up local actors through the provision of specialist expertise that is not locally available, or to provide the 'official' position on issues affecting local museums. This last starts to spill over into legitimacy *in* local museums, with this being bound up with the

technical expertise and professional skills that the museum can bring to bear on particular subjects with, once again, museum size affecting this. Smaller museums, having a more limited range of technical capabilities available to them than larger museums, will find it more difficult to establish their independence from external demands and pressures. This is also concerned with how local communities grant legitimacy to their local museums, and this is not just a matter of professionalism and expertise. Local community-run museums, for example, are often markedly short of these skills and techniques but acquire their legitimacy as the voice of their communities through the active engagement of community members in establishing and managing 'their' museum, and in their establishment of a communal resource for the continuation and preservation of local memories (see the example of the District Six Museum in Cape Town in Crooke [2007], 119–24).

Each of these forms of legitimation – of, for and in – has a separate role to play in the creation of a status for local museums that allows them to assume a form of leadership role in the establishment of forms of local validity for whatever it is that they do and provide. This has been particularly important in the development of museums that cater for minority community groups or which are providing forms of representation, provision and display for particular sets of interests that were previously unavailable (see, for examples of these at work, the essays in Goodnow and Akman [2008] on Scandinavia and Basa [2010] on India). In these instances the legitimacy of the museum institution underwrites the validity of new forms of representation for local groups and communities and thus provides moral and political support for these developments. Thus local museums provide an opportunity for the entrenchment of particular sets of community-derived values and beliefs by providing an institutional setting that already carries within it sets of ideological baggage to justify this role (Duncan, 1995). In effect there is a mutual reinforcement of ideology and legitimacy at work in the case of local museums that can serve to underwrite powerful political claims on the behalf of local communities, and which certainly serve to act as a line of demarcation between and within them (Branche, 1996). As long as local communities accept the validity of the existing arrangements then these legitimating and ideological functions will continue in place: a change in either, however, will necessitate a reappraisal of both what local museums are doing, and the justifications upon which these actions rest (see, for example, the relationship of the Smithsonian museums with Native American groups in the 1970s as discussed in Message [2014], 124–53). Practice has shown that such changes rarely, if ever,

originate from inside the museum and, instead, are much more commonly externally driven. This implies that museums are largely reactive to external socio-economic and political pressures and that they have little active agency in themselves. Such a view equally implies an ability to draw a clear distinction between museums and their local communities, with each affecting the process of change independently of the other. This perspective would, however, be largely fallacious: the reality in both cases is much more one of mutual inter-dependence between internal and external demands and expectations than it is one of simple uni-directional pressures or compulsions to change. This interdependence between groups and museums creates a position where the standard processes of bargaining, negotiation, competition, conflict, consensus building, compromise, blackmail and threats that are part and parcel of neo-pluralist and neo-elitist forms of group inter-action and engagement enter the picture. In the case of museums no single actor is in a position of such strength, or has access to such sources of power, that they can simply over-ride the interests and concerns of other actors. The balance and control of power and ideological and legitimating resources may well be heavily weighted in favour of one set of actors – particularly museum professionals – rather than another, but the lack of a monopoly over any of these resources will mean that museums will always have to take some account of the outside world, even if the outside world can quite happily ignore whatever is happening inside museums for much of the time.

The role of museums in this process of group inter-action is determined by the specific issues that are at stake and how the role of the museum is understood by the participants involved. Thus, at times the museum can, indeed, serve as the focus for forms of activism that make them central actors in the particular issue at stake. At others, however, the roles of museums and their staff can be largely an irrelevance in terms of dealing with what is concerned, with the 'real' debate taking place elsewhere and between different sets of actors. In effect, local museums are victims of the general lack of political interest that is shown in 'culture' in general (Gray, 2009) and museums in particular. Regardless of the central role that museums can play in matters of real political significance, and regardless of their inherently political role within societies, they are not generally seen as being political institutions by most people within society. This is, in part at least, a consequence of the ideologically constructed view of museums as the repositories of knowledge and meaning for communities with the importance of this knowledge and meaning being independent of

matters of ideology such that 'politics' has no place within the walls of the museum. The depoliticisation of the museum inherent in this ideological position may serve to devalue the evident political role that museums play in societies, but it also contributes to the legitimacy that they make use of. Indeed, part of the legitimation argument that museums depend upon rests on the notion that they are independent of the waves of political fortune that wash through societies and derive their authority from other sources than the 'merely' political. By being able to claim forms of legitimacy that are not dependent on electoral fortune or claims to ideological acceptability museums can exempt themselves from the messy world of everyday politics and present themselves as 'truly' independent organisations and institutions, regardless of the validity of such an exercise.

The consequence of this independent stance is that involvement with local groups' attempts to affect what their local museums are doing weights the balance of the argument in favour of the latter by denying the *political* relevance of the particular sets of community interest that these external groups are aligned with. The focus of the argument becomes one where group engagement with, and involvement in, local museums becomes converted into one concerning museum practice, rather than being one of museum ideology and meaning. Debates about what can and should be displayed in museums, and how such displays are to be undertaken, can become simply a series of technical discussions about signing, lighting, conservation, education and learning opportunities, outreach and matters of access – all of which are important matters for museums and their communities, but all of which deny that matters of power and ideology have any real significance for what takes place inside the museum. For much of the time matters of legitimacy are also seen as being largely irrelevant to the museum, although the increasing demands for the repatriation of human remains and cultural artefacts to their countries of origin (Greenfield, 2007) have started to have some effect on this. As a broad generalization, much of this debate has centred on matters of identity formation (Watson, 2007) and the moral right to ownership of museum property, and has taken it as read that principles of community empowerment are as important as questions of technical expertise and competence when making decisions about these. Despite that fact that these principles are themselves deeply political in nature the idea that politics forms a key component of how museums function is often seen as being something that causes problems, at the very least, and which should be kept as far away from the museum as an institution as it can be (Message, 2006, 108).

Conclusions

While the academic world of museum studies, and many of those working within museums, are only too aware of the political dimension of what occurs within these organisations, it is not necessarily the case that the wider ideologies and legitimating claims that exist within, and are made about, the sector are as well recognised in the wider societies within which museums function. The depoliticisation of museums that is associated with this lack of recognition serves to direct attention towards certain sets of understanding about what museums are doing and how they are doing it which adopts a vision of politics that is a largely superficial one. The tendency to treat politics as an exogenous phenomenon which is foisted on the neutral and authoritative museum to meet the goals of elected and appointed politicians, and the fact that these goals are quite distinct from those of the museums concerned, creates a false dichotomy of the political and the museological that denies the importance of the former for the latter (and vice versa). As is evident, local museums are just as political as their national counterparts and are affected by the same underlying issues of power, legitimacy and ideology.

The fact that these issues take different forms from those which are in operation at the national and international levels of the museums world should not be taken to mean that they are not relevant in the context of the local museum. Indeed, it could be argued that the importance of local museums to their communities makes their political content and status of even greater importance than it is for those museums operating at the national level, or which make claims for international, rather than simply national, significance. The sense of place and accessibility that surrounds most local museums gives them an immediacy that national museums, located in geographically remote places to much of the population of a country, usually lack. One consequence of this is that the ideological component of local museums is usually not as recognised as it is for national museums – the creation of a national identity is normally, after all, seen to be of far greater significance for the people living within a nation-state than is the creation of forms of local identity, even if the latter may have a significantly greater importance for individuals living in remote and rural areas, as well as for those living in divided societies, than the national dimension is.

The lack of ideological importance for local museums that this implies is then reinforced by the depoliticisation of other aspects of museums

that have become associated with it. Forms of political intervention by both elected or appointed politicians – often seen as forms of illegitimate 'intervention' in museum affairs – and by community groups that are seen to have their own particularistic agendas to pursue, are normally seen as being illegitimate invasions of public arenas which detract from the museum's neutral role in representing the local to itself. Given the imbalance in technical and professional forms of expertise within localities between museum staff and the communities within which they are located, this view provides local museums with their own legitimacy which denies the relevance not only of direct political claims to control by politicians and groups but also a whole range of other forms of rationality that could serve as an alternative basis for making decisions about both museums as institutions and their operations (Diesing, 1962). Thus the manner in which ideology and legitimacy interact in the case of local museums provides a firm basis for entrenching the power of these museums as central actors in the establishment and reinforcement of particular ideas about both what the locality means, and why museums should be trusted to undertake the role of creating what this sense of the 'local' is.

The combined effect of these complicated sets of self-reinforcing attitudes and beliefs is that the local museum is not only a deeply political institution but is also one where the operative form of politics that matters has little to do with precisely what the museum *does* but is much more concerned with what the museum *is*. The significance of the local museum is built around the symbolic role that it is seen to be associated with, acting as a form of public sphere (Barrett, 2011) for the consideration of matters of local concern free from the exercise of control by particular groups and individuals, and where all may find their own independent means of expression. The fact that the local politics of museums clearly shows the lack of accuracy of this view is not necessarily the point: what matters is the extent to which it is *believed* to be not only accurate but also relevant and important for the functioning of local museums. If this view is accepted, the removal of museums from the humdrum world of the everyday exercise of power and authority becomes justified. And, if this happens, the current imbalance of power between local communities and local museums and their staff ceases to be a matter to be questioned and simply becomes the reality of the situation. The lack of political significance that is attached to the museums sector contributes to the state of acquiescence that surrounds the world of the local museum and provides the basis for the continued maintenance of a distribution of political power that serves the interests of

the museums sector as much, if not more than, it serves the interests of local communities. Whether it is appropriate to accept such a depoliticised view of individual museums is another matter altogether, but it has a clear effect on how and why museums are understood in most societies today.

5
Museums as Political Institutions

Introduction

The previous chapters have demonstrated that museums not only have a political dimension but that they are inescapably political. It is difficult, if not actually impossible, to deny the impact that forms of political engagement and activity have for the ways in which museums function, what they are both expected to do and actually undertake, what they provide for the various groups and individuals that are associated with them, and what the consequences of their existence are for the societies within which they are located. Each of these concerns is intimately connected to key political concepts of power, legitimacy and ideology and are worked through via mechanisms of political rationality and justification. It is also the case that the role played by these concepts takes different forms and involves different sets of actors according to which geographical perspective is adopted, with the international, national and local politics of museums operating in quite distinct fashions from each other. This final chapter brings together the arguments that have been earlier developed to establish a series of general conclusions that assess the ways in which these central political concepts can be used to make sense of the questions concerning the 'who', 'which', 'how' and 'why' of museum politics.

Who are the key actors?

It cannot be doubted that the most central actors in the museums field are to be found in the professional groups and associations that are connected with the fulfilment of museum functions. While some of these groups are not directly 'museum' ones – with education being the key

counter-example, even if the sub-discipline of museum education has a long established basis – their centrality to making museums function at all, let alone efficiently and effectively, is apparent at each level of concern. The source of their centrality lies, in the main, with their technical and professional competence and expertise, but it is not restricted to this factor. These core groups of actors have become entrenched in positions of organisational and managerial control over museums as institutions and this then reinforces the technical importance with which they are imbued. The historical development of the museums sector has ensured that this functional centrality has morphed into institutional dependency to such an extent that it is difficult to conceive of circumstances where professional skills and competencies could be entirely ignored in the running of museums. In practice it *is* perfectly possible to run museums without the necessity for having control being ceded to such professionally competent sets of actors, as many community museums have demonstrated, but at the level of *perceptions* of what makes a museum a 'good' one the ideological control that museum professionals have been responsible for constructing ensures that they are the central actors in determining how museums should be understood and in defining the standards of what makes for 'good' museum practice.

The central role that museum professionals have in the construction of the governing ideologies surrounding their institutions feeds in to the role that these ideologies play in both providing the legitimacy that is required to give power to these actors as well as in providing the justifications that can be used to allow them to continue to dominate museum practice and the sector as a whole. Such a reinforcement process is certainly not unheard of in other policy sectors, with health and education professionals being seen to be just as associated with these legitimations and justifications as engineers and lawyers ever were. This view of professional groups is based upon the forms of occupational control that these professional groups have over their employment (Lipsky, 1980), and this is often associated with particular characteristics that provide a form of status in the workplace and which differentiate them from other groups of workers (Friedson, 2001, 180). Even though such a position for understanding professionals and professionalism was severely criticised many years ago (Johnson, 1972), there is still a tendency to continue to see the power and control that professionals exercise through these same lenses. In the case of museums, however, a strong tradition of criticism of this professionally based status was brought to a head in the new museology arguments that emerged from the 1950s onwards. This critical stance on museum professions can be seen as part of a much

wider challenge to the status of professionals that was concerned with the social consequences of having power concentrated in the hands of actors who might not be as committed to the greater public good as they claimed to be. This wider, and early, criticism of professionals ranged from the potentially 'disabling' role that they played with regard to individuals (Illich *et al.*, 1977), to their role in maintaining the dominance of patriarchy in society (Witz, 1992) and served to reinforce George Bernard Shaw's (1911 [1946], 115) claim that 'all professions are a conspiracy against the laity'. While the content and nature of this critical literature on professions and professionalism has developed and changed over time, particularly with the public choice analysis of the vested interests that organised professional groups are seen to represent, a line of argument that can be traced from the economic analysis of organisational behaviour in Downs (1957), Tullock (1965) and Niskanen (1971) through to more recent rational choice arguments (Hindmoor, 2006), it has left an indelible mark on the way in which museum professionals are seen.

The tendency to see museum professionals as exercising particular skills that require certain forms of technical competence associated with professional training and education is often divorced from the question of what these professionals *do* with these competences and skills. At the international level these museum professionals are clearly associated with the establishment of particular sets of standards and agreements that are meant to be equally applicable at any place and at any time. This universalistic position must also, however, deal with the specific characteristics of individual museums where such standards and agreements need not necessarily be applicable or, even, appropriate. This can be particularly the case when the museums concerned are established and function on the basis of different expectations of what the purpose of a museum actually is. The tensions that can be generated between top-down and bottom-up sets of attitudes, opinions, ideologies and legitimations can then create the conditions for serious disagreements about museum contents and collections, and their exhibition and display. This has been most obviously seen in the context of the demands for the return of human remains where a lack of enthusiasm on the behalf of museums to engage in this was marked in the early period of repatriation practice (Pickering, 2007, 251), but this particular case hides the more important political question of whose museum it is anyway. This is tied in with the central questions of organisational and behavioural legitimacy (Beetham, 1991; Johnson *et al.*, 2006), and the ability of museum professionals to control this should not be

underestimated. The international level is clearly dominated by professionally controlled resources and claims to expertise, allowing for the establishment of, for example, the ICOM-approved sets of museum standards (Ambrose & Paine, 2012) and it is normally anticipated that the implementation of these standards will require forms of professional training and oversight to allow them to be applied in an effective manner. Thus, examples of the establishment of community museums that are informed by detailed involvement of local groups and communities are almost entirely undertaken in the context of either arm's-length or direct professional control (Crooke, 2007; Simpson, 2007; Watson, 2007; Message, 2014).

Clearly, then, museum professionals are a core set of actors – but they are not the only ones. Local groups, whether pressure, interest or community, can also have an impact on museum practice and organisation and their role in these areas needs to be considered in terms of the inter-relationships that are present between the different actors who are involved. Thus in terms of everyday museum practice, groups of volunteers, who are normally overwhelmingly made up of local participants, can be both a blessing and a curse to museum professionals: they can provide extremely effective and helpful support to these professionals as they undertake their functions, but they can also be seen as potential usurpers of professional autonomy and control by making what are seen as unhelpful, if not positively damaging, demands (Watson, 2015), as well as calling for large amounts of training and oversight that can easily eat into a professional's time. In this context it is helpful to consider what function groups, of whichever sort, are playing in terms of museums: are their intentions to provide practical support in the provision of museum services (as is the case with most volunteer groups), or are they concerned with the museum as a general institution? In the former case the expertise and knowledge of the professional museum staff is likely to provide them with a powerful status in the game of group politics in comparison with other groups. In the latter case, on the other hand, professionals become simply one group amongst the many which have an interest in the museum. The status and power of professionals in this instance depends upon the relationships they have generated with the wide variety of local groups and the extent to which their legitimacy is seen to provide them with an advantage. Their power is not, therefore, automatically guaranteed because of their knowledge or expertise but, instead, is dependent upon how they are perceived by other participants in the process.

This position, where professionals need to establish their own legitimacy and develop the relationships with other groups that will reinforce this legitimacy, will be affected by the focus on the role that museums play at different levels within the global museum environment. At the international level, for example, the focus placed on museums is the universalist one that derives from the particular vision of museums as carriers of certain functional necessities – the core ICOM (2013) (see also Desvallées & Mairesse, 2010; Ambrose & Paine, 2012) functions that all institutions are expected to undertake if they wish to claim the label of being a museum. This position means that the weight of competence required for participation in international negotiations more or less requires a position of professional competence and knowledge in the first instance, while more generalist concerns that are not explicitly orientated towards museums become considered as being of secondary status and concern. At the national level, and particularly in the case of national museums, a focus on the symbolic role of museums in terms of nation building and the creation and maintenance of national identities (Knell *et al.*, 2011) requires the integration of the museum with groups that share such a national focus, such as political parties in the case of both liberal democratic and one-party systems, alongside groups that have a national rather than an international or local organisational basis. Lastly, local museums that have a narrative focus (in so far as they are concerned with telling the story of the locality in which they are located, rather than anything else) will be drawing equally upon local and community-based groups as the key participants with whom the museum must interact. This fairly simple division in terms of the central focus to the work of the museum provides a largely structural account of how and why different sets of group interests become associated with the museums sector. In effect each type of group is seen to be fulfilling a particular sort of functional role for the museums sector, leading to a picture of the sector as producing a functionally disaggregated set of actors in each case. This position has some similarities with the idea of a form of societal corporatism as the basis for group integration in the political process, where the special contribution that each group makes to the achievement of sectoral objectives determines their access to the system. In this respect community groups are not just a conglomeration of local interests, they are necessary for the museum to fulfil its functional remit.

The discussion so far has been based on a position where the museums sector is the prime focus of concern, dealing with the actors who are directly involved with it. Alongside these particular groups, however, are

the very much larger number of groups which can intersect the museums sector for more general reasons. This is particularly to be seen, for example, in those cases where museums are being used in an instrumental fashion by policy actors at the international (as in the example of cultural diplomacy [Nisbett, 2013]), national (as with social inclusion [West & Smith, 2005; Tlili, 2008]) and local (as with urban regeneration [Lorente, 1996]) levels of action. In each of these cases the interests that become involved with museums are operating according to quite different rules, and are involved for quite different reasons from those that are concerned with museums per se. In these circumstances it becomes evident that museum professionals have a very much weaker position than might be anticipated from their centrality to the internal operations of the sector itself. Given the stress that has been placed on the relative political weakness of the museums sector, however, this is not surprising. The inability of the museums sector to establish a clear political role for itself has left it in the position that it is not really taken very seriously by political actors whose policy concerns are seen to be of far greater significance than are those of museums: 'the more peripheral an issue and the more limited the range of interests affected, the greater is the capacity of a network to run its own affairs without politicization' (Adam & Kriesi, 2007, 142). While such a depoliticisation of the museums sector provides certain advantages – it rarely becomes a focus for national political concern, for example, and it can gain legitimacy for itself as being above the everyday concerns of here today, gone tomorrow political actors (at least in political systems where some turnover of power-holders is common) – it also carries a number of political risks. Not least amongst these is the possibility that the sector will always be at a disadvantage in comparison with actors from other policy sectors which are seen to be more politically important in particular instances, and who will thus carry more weight when intersectoral clashes occur.

In effect a division arises from the relatively neo-elitist operations of the internal working of the museums sector, with power and control being highly concentrated in the hands of technically and professionally qualified and organised groups, and the workings of the wider political environment within which the sector functions, where power and control are more widely distributed. This could be taken to show that this wider environment operates via a form of neo-pluralism, where the organised interests that carry the day will continually vary, where no one group has a dominance in the political process and where power is dispersed amongst a variety of interests (Gray, 1994, 94–119). Given, however, that the museums sector can also be seen to be organised

alongside some variant of corporatist arrangements for the integration of group interests, an alternative line of analysis might clarify what is actually taking place in terms of the museums sector as a whole. The policy networks literature, for example, differentiates between arenas of policy activity on the basis of different patterns of group integration and involvement in the creation of particular policy choices (Adam & Kriesi, 2007), with each policy sector having a dominant organisational and behavioural pattern that can be used to identify and explain what is occurring within it. In this case the museums sector is really rather *sui generis* since its specific characteristics do not fit with any of the major patterns of policy network that have been identified. The rigidity of the network approach rests primarily in its focus on sectoral level policy-making. As the discussion has shown, however, activity in the museums sector is only rarely undertaken at this sort of meta-level, and where it does take place (primarily at the international level) it is largely dominated by professional interests. A shift in focus to the national and local level of museums activity, however, demonstrates that these professional and technical interests are not the only ones involved, and in the case of instrumental policies they are often something of an irrelevance to the policies that are produced. In effect the variation in policy activity in the museums sector produces the conditions where there is no single model that applies to all cases at all times. Instead, there are a variety of forms of group engagement in place which explains why the same policy sector can be seen to be representative of neo-pluralist, neo-elitist and corporatist arrangements at the same time.

The attempt to establish single descriptions of who is involved in the politics of museums, whether as particular types of network arrangements or not, can also be questioned on the basis of the endemic changes to patterns of group engagement that have been taking place across the world in different political systems. The increasing involvement of a wide range of civil society organisations has been a common phenomenon in recent years, and the developing focus on museum engagement with community groups is certainly not unusual in this respect. The consequence of this has been that policy networks have also been subject to pressures for change, leading to the increasing porosity and decreasing stability of networks. The particular reasons for this vary between policy sectors, but in the case of the museums sector clear influences can be seen as arising from the development of the new museology (McCall & Gray, 2014); the bottom-up pressures from communities over subjects such as collections repatriation (Greenfield, 2007); changing understandings of the heritage field (Smith, 2006;

Harrison, 2013); and the increasing managerialisation and instrumentalisation of the sector (Rentschler & Hede, 2007; Gray, 2008; Hatton, 2012). These, alongside other influences discussed in previous chapters, have contributed to the creation of a fragmented and flexible policy sector where the contributing actors could be characterised as forming disaggregated sets of participants (see Figure 5.1).

In this pattern the focus lies on the centrality of various sets of potential participants to the actual business of having and running a functioning museum. Regardless of their perceived limitations, museum professionals – from curators to education officers to conservators – form a real *core* through their provision of meaning to the international

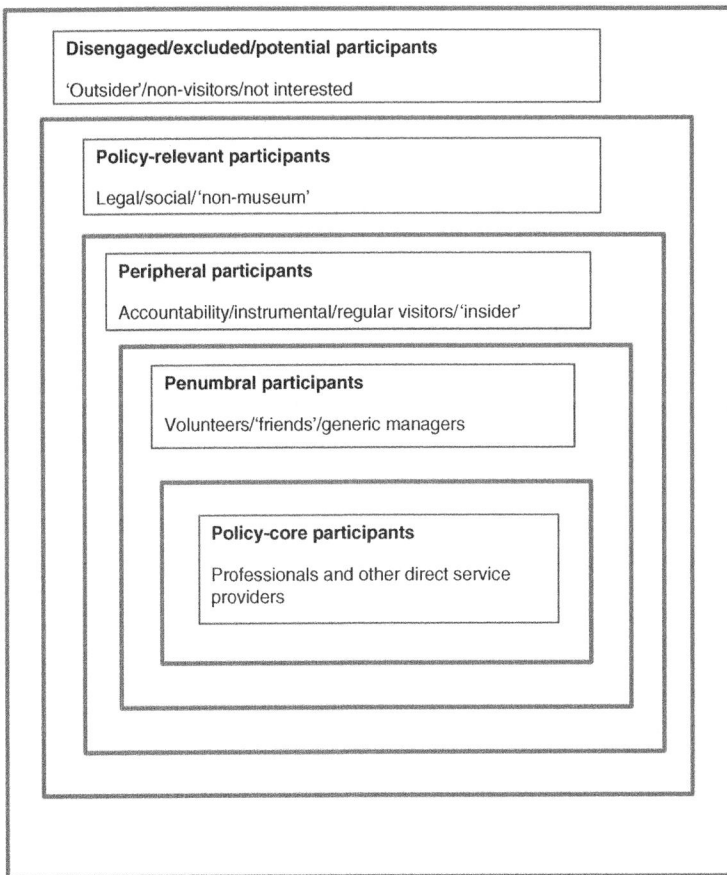

Disengaged/excluded/potential participants

'Outsider'/non-visitors/not interested

Policy-relevant participants

Legal/social/'non-museum'

Peripheral participants

Accountability/instrumental/regular visitors/'insider'

Penumbral participants

Volunteers/'friends'/generic managers

Policy-core participants

Professionals and other direct service providers

Figure 5.1 Participants in museum politics

museum world and their control of what are seen to be the necessities for the provision of effective and efficient museum services to the outside world. Alongside these are the service providing ancillary staff within museums (such as cleaners, security and box-office staff) without whom the museum could not function. In effect, this core is made up of all those who are formally employed by the museum to provide museum services. At one remove from this core are the secondary, *penumbral*, groups of actors who contribute to service provision without being a part of the functional core. This includes not only service providing volunteers and various 'friends' groups, but also the museum managers who act as a buffer between forces external to the museum and the core itself (and who sometimes do not have a particular museums background themselves but do possess forms of generic management knowledge). The third set of actors is made up of a *periphery* that consists of those to whom museums are accountable (ranging from national and local governments to the management and Trustee Boards that have an oversight function for charitable, community and private museums), and those external groups with which museums regularly interact (largely made up of various 'community' and visitor groups and forums, as well as other groups which have an instrumental interest in museums, such as mental health charities [Chatterjee & Noble, 2013]). Such groups are rarely, if ever, involved in the direct making of individual museum policies, although they may often be part of the wider realm of 'the consulted' which museums make use of for their own policy purposes. Fourthly, there are the large group of organisations and actors which interact with the museums sector for *policy* reasons that are not directly those of the museums sector but which museums need to co-operate with. These groups can cover a wide range of interests from those of tax and building inspectors to equal opportunities groups to charities and individuals who provide financial (and other) support to museums, and which may affect the operating practices of individual museums through their application of non-museum policy demands. Finally, there is the very much larger group of those who either have no contact with museums or whom museums actively seek not to engage with – largely on the grounds that there are so many of them that museums do not have the resources to become actively involved with them. These groups, such as national trades unions and orchestras, and local environmental groups, could, however, became engaged if circumstances or the particular issues that concern them change. In practical terms these individuals and groups form what is effectively a realm of *disengaged*, *excluded* but *potential* participants.

Which are the key organisations?

While it is evident that there are a large number of participants taking part in the politics of museums, and these actors have a larger or smaller access to effective power according to which issue is being looked at, and what level – international, national or local – of museum activity is being examined, it is also the case that effective involvement in museum politics depends upon some sense of organisation. This organisation need not be in the shape of formal institutions, although it often is, but can also be in the shape of ideological and legitimating forms that structure the relationships between individuals and between individuals and formal institutions. As pointed out many years ago, the organisation of social life has wide implications for the exercise of political power and the consequences that can then arise from this (Schattschneider, 1960) and the museums sector is no exception. Thus 'organisation' in both senses requires examination to see how it affects political activity in the museums sector.

At the simple, and highly descriptive, level of formal organisation it is relatively easy to point to particular examples of key organisations: at the international level ICOM is of central importance (not least for the role that it plays in giving formal embodiment to the ideological and legitimating organisation of the sector across the world), while UNESCO can also be usefully appealed to for particular (and, again, usually ideological and legitimating) reasons. At the national level not only are nationally organised governments of real significance for the sector, particularly when they directly fund the sector and individual museums, but so also are the range of political parties, professional organisations and pressure and interest groups that represent particular sets of actors who have an interest in museums and which have both a national presence and a nationally mobilised organisational existence. Likewise, at the level of the individual museum or gallery, particular management boards, Trust organisations, local authorities, volunteer organisations and a much larger realm of other formally organised community interests can be identified in particular places and particular times as being of real importance for what takes place at the local level. Indeed, it should not be forgotten that in this context the individual museum or gallery is itself an example of an organised interest.

Such a listing may serve to identify the wide range of organisations that are concerned with the museums sector, and it implies that there are a variety of reasons why people within these organisations may wish to be involved in museum activities, but it does not go much further

than this. Clearly the identification of certain of these organisations as having a central role to play in the operation of museum politics depends upon how this centrality is understood – which is, once again, tied in with how power is distributed within the sector as a whole. It is hardly surprising, for example, to recognise that the formal organisations already noted here have been identified as being associated with particular forms of power which can be employed to advance or defend the particular interests that they represent or embody. It would, however, be hard to claim that the potential power of these organisations is actually exercised by them: to reify the exercise of power in this way would be to confuse how the actors within these organised contexts use the power that is available to them through their organisational location with some more general structural sense of 'organisational power' (Elder-Vass, 2010, 13–39). In effect, 'organisation' is better employed as a metaphor for the control of particular resources and authoritative positions, how these are used, and what the consequences of their use are, rather than as a descriptive label. Much of the new institutionalism literature (Peters, 2012), for example, is more concerned with how people within formal organisations manage a range of informal resources to produce a policy result, with the emphasis being firmly on the role of human agency. So what are the resources that these organisations offer which affect their opportunity to exercise effective power over, and for, the museums sector?

Clearly, a central factor in identifying the key organisations in the museums sector concerns the role that museums play in establishing the structural frameworks within which individual and group choices and actions are made. In particular their role in establishing legitimacy for the choices that are made, and the ideologies that can be used to make sense of these choices, are both important for establishing these frameworks. Thus the central role of ICOM, and the secondary role of UNESCO, can both be traced back to the fact that these organisations are able to claim a global framework of decision that is linked with the representation of national views and opinions. As such, the decisions that are made within these organisations can claim to be made on the basis of a very much larger community of interest than can be reached at the level of individual nations, regions, provinces and localities: if everyone in the world thinks like this then how can you not share this position? In practice, of course, many individual countries do not play this game, particularly in the case of what UNESCO produces, but given that there is a distinct lack of effective enforcement capabilities available to UNESCO this claim for a supranational legitimacy is possible in ways

that refusing to implement national laws is usually not. The importance of these international organisations thus depends upon the willingness of individual countries to be bound by their decisions. While ICOM, equally, does not have effective enforcement capabilities its position as the internationally accepted voice of the museums sector provides it with a large amount of symbolic weight. A failure to be seen to be meeting ICOM standards, for example, can serve as a powerful tool to be employed by individual museums in the effort to gain resources from national and local governments, not least for reasons of national prestige in being able to claim parity of status with the 'best' museums in other parts of the world.

At a more mundane level, the emphasis that has been placed on the importance of professional and technical staff resources for making sense of museum politics would indicate that recognition of the role played by the organisations that affect the working practices of these people would be worthwhile. Such a recognition would need to take account of both the detailed effect of these organisations on everyday working practices as well as the general implications of the ideological component of their existence. At the very least there is a general tendency for such organisations to either claim a monopoly control of technical and professional expertise, controlling access to positions of authority within their area of concern and serving as *the* voice which needs to be consulted by governments, other professionals and the general public when dealing with their core subject-matter, or they attempt to become a representative museum voice (alongside others) that *should* be taken into account when decisions are being made. Which position is adopted will be affected by the precise nature of the issue that is the subject of concern, and the more that these issues extend beyond the museums sector itself the less likely it is that claims to monopoly status will be tenable. In effect the depoliticisation of the museums sector reinforces professional and technical dominance over affairs that are self-contained within it but equally serves to limit the extent to which this dominance is transferable to wider policy and political debates.

A secondary element inherent in professional and technical organisations is their role in supporting the dominant ideological positions that inform the functioning of the sector as a whole. While these positions are effectively maintained at the international level they are underpinned through their acceptance by national (and local) organisations which support their principles and beliefs. Given that such organisations are intimately involved in the construction of these ideological positions in the first place, particularly through their contributions to

ICOM, it is hardly surprising that they act as supporting mechanisms to ensure that international standards of museum competence, efficiency and effectiveness are maintained and supported within their own national contexts. This can become a means to politicise the museums sector at the national level since an appeal to international standards can serve to support campaigns to maintain and/or improve national standards in the face of governmental reluctance to invest in their own museums and staff resources. In this context professional organisations are important not only for their role as active participants in political debates and the development of policies that directly affect museums, but also for their role in helping to establish the nature of the debate that is appropriate for museums in the first place. Again, establishing the nature of the debate is most effective when discussion takes place simply in terms of the museums sector and becomes decreasingly effective when the concerns and interests of other policy areas start to impinge on the debate, particularly given the museums sector's weak political status.

This point effectively reinforces the importance that other organisations can have for the politics of the museums sector. This is not purely in terms of national or local political settings where governments and governmental agencies are actively involved, but it also covers the range of other organisations that can affect the functioning of the sector. Thus in countries where the tradition is one of a reliance on non-state resources to support individual museums – largely through private philanthropy and charitable donations in most cases (see O'Hagan, 1998, 163–95) – these sources can become centrally important for the individual museums and galleries concerned with concomitant concerns about the implications of this, largely financial, dependence for the autonomy of museum staff and museums when making their decisions (Janes, 2007). This direct impact on the sector can be extended to the rather more arm's-length effects that can be generated by the host of penumbral actors, peripheral and policy-relevant actors (see Figure 5.1) who operate through formal organised means to have an impact. At this level the overlap between individual actors and organised interests starts to turn into a picture of such complexity that separating the one from the other becomes difficult, if not impossible.

How are interests represented in the museum?

The sheer number of potential participants that are apparent from looking at the key actors and organisations within the sector raises questions

about how and why some of these become incorporated into the system and others do not. From the perspective of political science these are rather trivial questions that can be answered by reference to, for example, group and individual resources; the nature of the issue concerned; the confluence of problems, policies and politics (Kingdon, 1984) in existence at any given time; the strength of feeling that exists around the issue; the open-ness of access within the policy system involved; the way that the issue is structured (both formally and linguistically) (Zittoun, 2014); and the particular interests that are involved in any individual case. A simple listing of this sort could allow for the establishment of the exact conditions that govern group access in any particular example but it does not allow for easy generalisations to be drawn about the politics of the museums sector as a whole.

An alternative starting-point can be found by considering the question of when the representation of interests makes sense, rather than that of what interests need to do to make themselves heard, particularly in contexts where museums themselves – and governments – wish to exercise tight control over group involvement in the life of museums. Such a starting-point once again depends upon the precise nature of the issue that is involved, and assumes that access to the system is controlled in something of a top-down manner. From the perspective of all the potential participants at any given time, the museum becomes an arena for action, with actual involvement being subject to gatekeeping activities by a variety of specific actors. The core museum participants of professionals and amateur staff, boards of governors or directors, elected politicians (in the case of national, regional and local museums) are central to this as a consequence of the legitimacy that is formally vested in their position and which makes them responsible for what occurs within the museum on a continuous basis, and their involvement will therefore be equally as continuous. From this formal position the involvement of certain groups in discussions about the museum makes sense: the penumbral groups (Figure 5.1) which have an active role in the museum may need to be informed or actively consulted, but they cannot simply be ignored unless the museum is willing to run the risk of losing their support or creating problems for themselves. Whether such groups are engaged or actively involved is dependent on how the policy and functional core of the museum wishes to engage with them. For peripheral groups (Figure 5.1) their involvement is much more issue-dependent. The policy core is likely to invite such groups into discussions, negotiations and bargaining sessions if their active support is needed, or if they are seen as being the appropriate groups for the provision of advice and

ideas. None of them, however, has a right of access into the negotiating system, although insider groups will, inevitably, find this easier to achieve.

The top-down control of these forms of access inevitably puts power into the hands of the core group participants. For outsider groups, or groups which have not developed routines of engagement with core groups, obtaining access into the system can be much more difficult. Apart from having resources that the museum may require – such as forms of legitimacy that are directly derived from the interests that are being represented – some sense of shared terrain in terms of how the game of involvement is to be played, and a tolerance for the views that are being advanced by each party are both central to the process of gaining access. These issues of legitimacy and tolerance return to the question of what interests need to control or to represent to make their acceptance into the policy arena a valid choice for museum power-holders to make – and how these can be presented in such a way that they can and will be integrated into decision-making processes and not merely ignored. While in some instances groups can effectively be seen to be pushing at an open door, where their involvement will be greeted with open arms by people inside museums, in other cases there can be a great deal of resistance to the demands that external interests make of museums. Achieving success in such circumstances may be more difficult than would be the case in a fully pluralistic political system where all interests have access to the system, and all arguments are given equal credence; but it is not impossible. Certainly the examples of source communities retrieving material (both human and symbolic) from museums demonstrate the ability of such groups to attain their ends, often in the face of intense opposition. These examples also point to the fact that success need not only be a matter of resources but also of how the argument is mounted by the participants involved. By making restitution a matter of morality the shape and nature of the discussions that museums became involved in shifted from the forms of technical and professional justification that had previously been used to justify the retention of such otherwise retrievable material. For external groups, being able to control the terms of the debate provides an extremely powerful tool to counter the weight of top-down control within the museums sector. In this respect the integration of groups into the museum depends as much upon the forms of legitimacy and rationality that are made use of the participants involved (Diesing, 1962), and the justifications that they employ in support of their positions (Boltanski & Thevenot, 2006), as it does upon anything else.

In this respect the policy approaches adopted by the multiple actors who are involved in the museums sector becomes important for understanding how politics in the sector functions. While the balance of power – whether 'to', 'over' or 'for' – certainly rests with the functional and policy core of the system (Figure 5.1) these actors do not retain a monopoly over it. Involvement in the process of agenda-setting and agenda-management can provide an effective means to regulate not only what will be talked about but also how it will be talked about, who will be doing the talking and who will be listened to. Establishing the terms of the debate that will be taking place about museums, as both institutions and as sets of practices, provides a mechanism by which the relatively excluded can reach a position of real strength and control within the sector. As arguments about colonialism, post-colonialism and the museum have demonstrated, however, the debate requires that all potential participants accept that this is a valid issue of concern for the museum to deal with: just because a claim is made does not mean that it will simply be accepted as setting the agenda for everyone. New groups, as is the case in all policy sectors, need to establish their credentials before they can have a real effect, and while this is possible it is by no means easy, which helps to explain why the functional core of the sector continues to be so significant for explaining what occurs it.

Are museums important?

At a trivial level museums *must* be seen as being important – governments, private corporations, charities and communities all spend time and money on establishing, running and maintaining these institutions: if they were not important, why would these people bother with them? This does not answer the question of 'why' museums are important, but the underlying assumption would be that they do, or provide, something that each of these groups believe needs to supported. What this basis of support might be will inevitably vary from case to case, but a common factor is that museums are seen to contain within them particular values that are given expression through not only what museums do but what they contribute to in broader social, economic and political terms to societies as a whole, local communities, groups of people and individual members of society. This view of museums can, and does, extend far beyond the rather mundane functional definition of museums provided by ICOM to include a whole range of symbolic values (such as contributing to particular notions of national, regional and/or

local identity [Anico, 2009], or providing an open forum analogous to the idea of the public sphere [Barrett, 2011]).

In practice it may be the case that the importance of museums in this symbolic sense would be far more noticeable if museums did not exist. If it is accepted that this symbolic dimension of social life is important in contributing to a sense of 'culture' (however this might be defined), then museums clearly do undertake an important role in establishing and maintaining these symbols, and symbolic forms, of presentation, action and interaction, even if their role in this is not as directly evident to political actors – such as elected or appointed politicians, political parties and pressure and interest groups – as it might be. The very nature of symbolism, however, means that it is largely an undiscussed, and often unrecognised, part of social life, acting as a form of unconsciously and implicitly accepted set of orientations and beliefs about societies and the dynamics of social life. As a repository for the corporeal and material representations of this world the museum provides one of the central devices for locating how societies view and understand themselves. The decisions that are made within museums about what to collect, how to store collections and how to display them all contribute to this and thus provide an important component of the creative activity of recognition and location. This role is potentially given greater contemporary meaning through the role of museums in managing forms of intangible heritage (UNESCO, 2003; Alivizatou, 2012), particularly where this is subject to very different national understandings of what the term actually means and what is involved in these management processes (Bortolotto, 2012). Given the variations that exist in forms of intangible heritage, and the role that museums play in supporting the expression of cultural diversity, their function in contributing to the recording of not only existing forms of this heritage but also the processes of change that heritage is subject to can make them central resources in this area.

Each of these arguments indicates that museums, as an institutional form, fulfil functions and provide arenas for the expression of particular sets of understanding and practice that are of real importance for the societies of which they are a part. At the same time, however, it cannot be denied that in terms of the role that museums actually play within societies, in ways that are distinct from their symbolic role, they are consistently – if not always – seen by core political actors as not having any real importance or significance. This gap between what museums do and how they are understood within political systems is of central importance for making sense of the politics of museums, particularly in terms of where this fissure stems from. Certainly museums have been

seen to be important tools for the establishment and maintenance of core political values in some countries and at some times (as the examples provided by Knell *et al.*, 2011, and Varutti, 2014 demonstrate). What is also evident, however, is that this political centrality is most obviously recognised in conditions of acute political change, such as in the establishment of new nation-states, or when there is a clear and overt ideological position that is expected to be either established or maintained by, for, and on the behalf of core political actors. In more 'normal' times, however, museums are more or less accepted as part of the scenery, and usually the background scenery at that, rather than as being direct political actors in their own right. It is for this reason that museums can be fairly easily subjected to forms of instrumentalisation (Gray, 2008), or can allow themselves to exercise forms of policy attachment (Gray, 2002). In each case there is an acceptance that museums and museum policy are less important than are other policy issues and sectors and that museums need to develop links (whether through imposition in the case of instrumentalisation, or through deliberate choice in the case of attachment strategies) with this larger policy environment.

Inevitably, a part of the explanation for this lies in museums' relatively high level of depoliticisation. As pointed out elsewhere in this volume, this status carries both benefits and disadvantages for individual museums and the entire museums sector. While it can normally allow for the establishment of forms of organisation and practice that can be informed by technocratically established and accepted standards of good practice, and which are, therefore, free from the imposition of externally derived and 'politically' motivated demands and expectations (where 'politics' is seen to be an invalid basis for determining 'technical' matters), it also means that there has been an underdevelopment of other bases upon which museum independence can rest. As a consequence it is very difficult for museums to establish a wider range of justifications and legitimations to support their relative freedom from political 'interference' than is provided by professional and technical expertise and knowledge. For much of the time this is not necessarily a problem, but when there are clashes between the political and the museums spheres the former is normally in a position of real dominance over the latter as it can call on a much wider range of resources than are normally available to museums. Apart from the democratic legitimacy that all political systems lay claim to, regardless of the validity of this claim in many instances, political actors usually have a much greater control of the financial, legal and hierarchical resources, amongst many others,

upon which museums depend. Attempts to establish and maintain a sphere of depoliticised and professionally bureaucratic (Mintzberg, 1979, 1983) organisations effectively makes museums subjects rather than active agents in the calculations of political actors: they become seen as instruments that exist to fulfil particular sets of functional, service-delivery roles and their wider contributions to cultural and social (*and* political) life become devalued or largely ignored. This is not to say that museums actually *are* politically unimportant (Message, 2014, 23), only that directly and centrally involved actors within political systems who are in positions of political authority, and who have high levels of political legitimacy, do not necessarily see them or treat them as if they were politically important. A direct consequence of this is that political actors tend to see museums as a peripheral subject for concern, and have done so for many years (Conn, 1998, 261).

Thus the question of whether museums are important depends upon how 'importance' is to be considered. At the level of their broad contribution to cultural life museums are extremely important mechanisms for establishing and maintaining the parameters of a range of ideological positions within societies. These can involve each of the social, cultural, political and economic dimensions that are found in everyday life – although whether this role is a real one itself, where museums are seen as central locations that directly contribute to this ideological activity, and which the mass of the population are intimately involved with, or whether they form a back-cloth that provides a much more symbolic role for societies and which most people quite happily fail to visit, is another matter altogether. Again, a distinction between the institutional role of museums and the actual lived experience of individual museums can be informative. To return to the start of this section, the simple fact that museums exist provides evidence that their symbolic function is perceived to be important for societies and whether people visit them or not is not particularly important. On the other side of the equation, however, the role that museums are capable of playing depends upon an active use being made of their facilities, their collections and the opportunities that they provide for not only direct and indirect learning but also for purposes of entertainment and general amusement. The former position assumes that museums will have their effect through a form of social osmosis and the precise means by which museums have their effects are not necessarily a matter of concern – a clear example of a form of 'ritual' rationality (Royseng, 2008). The latter, however, depends upon the establishment of clear causal linkages between what museums provide and the effects that they would like to, and actually do, produce.

In this respect the importance of museums is to be found in how they are managed and what it is that they are providing. While this might emphasise the instrumental role that museums can play within societies it also lays stress on the fact that museums are as much concerned with the concrete processes of service delivery as they are with the abstract diffusion of values and ideas. Museums do both these things and to emphasise one at the expense of the other is to underestimate how and why museums are as important as they currently are.

Conclusions

Understanding the politics of museums leads discussion into a wide range of subjects from identity formation to lighting arrangements, and from management practices to accountability concerns. To make sense of this array, this book has applied key concepts from the field of political analysis – power, ideology, rationality and legitimacy – to the policies and practices of museums from around the world. This has made it possible to explain why some groups of actors are more important than are others in affecting both the shape of the museums sector as a whole and the internal policies and practices that individual museums employ in the pursuit of particular sets of objectives, whether these have been determined by themselves or have been imposed upon them from outside. These key concepts have also served to identify how and why some organisations in the museums sector embody particular forms of power that are central in making and allowing museums to function as they do. This, in turn, allows for the identification of how and why particular sets of interests are incorporated into, or excluded from, detailed involvement in the making of policies and choices and the establishment of everyday working practices at both the sectoral and individual institutional levels. All three of these sets of concern can be seen to be relevant to making sense of these actions and actors at the international and national levels of concern, as well as at the level of the individual museum itself. Between them they can be used to explain why museums are both centrally important, in social, political and cultural terms, to the societies that they exist within, and why, at the same time, they are usually seen as being unimportant to political movers and shakers for most of the time. The significance of museums, not only for the functional roles that they carry out but also for their symbolic meanings for societies, demonstrates that such a lack of political centrality is a matter of wilful neglect rather than being anything inherent in museums themselves.

What is evident is that, while museums are usually politically weak in terms of exercising effective power outside their own doors, their ideological and legitimating roles and functions provide a degree of political meaning for societies that operates at a different level, and in a different way, from the results that are generated from the direct and indirect exercise of political power, and it is in these ideological and legitimating activities that the real political significance of museums is to be found. The relative lack of political centrality that museums, and the entire museums sector, have is, in part at least, a direct consequence of the depoliticisation of the sector that has arisen from the importance attached to the range of technical and professional assumptions and practices that are seen to be central to their ability to exercise their functional roles. This depoliticisation allows museums and their staff to exercise their ideological and legitimating roles in relative isolation, even if more recent changes in the museums world that have emphasised a more open environment for the exercise of exogenous influences have started to affect this. Despite these intimations of the development of a potentially more politicised world for museums to function within it is still the case, however, that the balance of power within the sector remains concentrated in the hands of what is effectively a technocratic policy elite.

The emphasis that is laid in this explanation on the importance of the ideological component of museum practice is part and parcel of the more general argument that in cultural policy questions of meaning have a real significance that is not as evident in other policy sectors (Gray, 2009). Explaining how the politics of the museums sector functions calls for a similar treatment of ideas and that these can be just as, if not more, important than the roles that are performed by the other concepts of rationality, legitimacy and power with which this book has been concerned.

Bibliography

Abraham, M., D. Griffin & J. Crawford (1999), 'Organisation Change and Management Decision in Museums', *Management Decision*, 37, 736–51.

Adam, S. & H. Kriesi (2007), 'The Network Approach', 129–54 in P. Sabatier (ed.), *Theories of the Policy Process*, 2nd edn (Cambridge, MA, Westview).

Adamson, W. (1980), *Hegemony and Revolution* (Berkeley, University of California Press).

Alberti, S. & E. Hallam (2013), *Medical Museums: Past, Present, Future* (London, Royal College of Surgeons).

Alexander, E. & M. Alexander (2008), *Museums in Motion: An Introduction to the History and Functions of Museums* (Lanham, MD, AltaMira Press).

Alexander, V. & M. Rueschemeyer (2005), *Arts and the State: The Visual Arts in Comparative Perspective* (Basingstoke, Palgrave Macmillan).

Alivizatou, M. (2012), *Intangible Heritage and the Museum: New Perspectives on Cultural Preservation* (Walnut Creek, CA, Left Coast Press).

Allison, L. (1986), 'Sport and Politics', 1–26 in L. Allison (ed.), *The Politics of Sport* (Manchester, Manchester University Press).

Al-Ragam, A. (2014), 'The Politics of Representation: The Kuwait National Museum and Processes of Cultural Production', *International Journal of Heritage Studies*, 20, 663–74.

Ambrose, T. (1993), *Managing New Museums: A Guide to Good Practice* (Edinburgh, Scottish Museums Council).

Ambrose, T. & C. Paine (2006), *Museum Basics*, 2nd edn (Abingdon, Routledge).

Ambrose, T. & C. Paine (2012), *Museum Basics*, 3rd edn (Abingdon, Routledge).

Anderson, B. (2006 [1983]), *Imagined Communities: Reflections on the Origin and Spread of Nationalism*, revised edn (London, Verso).

Anico, M. (2009), *Heritage and Identity: Engagement and Demission in the Contemporary World* (Abingdon, Routledge).

Arnoldi, M. (1992), 'A Distorted Mirror: The Exhibition of the Herbert Ward Collection of Africana', 428–57 in I. Karp, C. Kreamer & S. Lavine (eds), *Museums and Communities: The Politics of Public Cultures* (Washington, Smithsonian Institution Press).

Aronsson, P. (2011), 'Explaining National Museums: Exploring Comparative Approaches to the Study of National Museums', 29–54 in S. Knell et al. (eds), *National Museums: New Studies from around the World* (Abingdon, Routledge).

Bachman, K. (ed.), (1992), *Conservation Concerns: A Guide for Collectors and Curators* (Washington, Smithsonian Institution Press).

Badica, S. (2011), 'Same Exhibitions, Different Labels? Romanian National Museums and the Fall of Communism', 272–89 in S. Knell et al. (eds), *National Museums: New Studies from around the World* (Abingdon, Routledge).

Basa, K. (ed.) (2010), *Multiple Heritage: Role of Specialised Museums in India* (Bhopal, Indira Gandhi Rashtriya Manav Sangrahalaya).

Barrett, J. (2011), *Museums and the Public Sphere* (Chichester, Wiley-Blackwell).

Bedford, L. (2014), *The Art of Museum Exhibitions: How Story and Imagination Create Aesthetic Experiences* (Walnut Creek, CA, Left Coast Press).

Beetham, D. (1991), *The Legitimation of Power* (Basingstoke, Macmillan).

Benedikter, R. (2004), 'Privatisation of Italian Cultural Heritage', *International Journal of Heritage Studies*, 10, 369–89.

Bennett, T. (1995), *The Birth of the Museum: History, Theory, Politics* (London, Routledge).

Bennett, T. (1998), *Culture: A Reformer's Science* (London, Sage).

Bevir, M. (2012), *Governance: A Very Short Introduction* (Oxford, Oxford University Press).

Bhatti, S. (2012), *Translating Museums: A Counterhistory of South Asian Museology* (Walnut Creek, CA, Left Coast Press).

Black, G. (2005), *The Engaging Museum: Developing Museums for Visitor Involvement* (Abingdon, Routledge).

Black, G. (2012), *Transforming Museums in the Twenty-First Century* (Abingdon, Routledge).

Bocock, R. (1986), *Hegemony* (Chichester/London, Ellis Horwood/Tavistock).

Boggs, C. (2000), *The End of Politics: Corporate Power and the Decline of the Public Sphere* (New York, Guilford Press).

Boltanski, L. & L. Thevenot (2006), *On Justification: Economies of Worth* (Princeton, NJ, Princeton University Press).

Bortolotto, C. (2012), 'Globalising Intangible Cultural Heritage? Between International Arenas and Local Appropriations', 97–114 in S. Labadi & C. Long (eds.), *Heritage and Globalisation* (Abingdon, Routledge).

Bourdieu, P. (2010), *Distinction: A Social Critique of the Judgement of Taste* (London, Routledge Classics).

Bourdieu, P. & A. Darbel (1997 [1969]), *The Love of Art: European Art Museums and Their Public* (Cambridge, Polity).

Branche, W. (1996), 'Indigenes in Charge: Are Museums Ready?', 119–31 in Canadian Museum of Civilization/Commonwealth Association of Museums/University of Victoria, *Curatorship: Indigenous Perspectives in Post-Colonial Societies* (Quebec/Alberta, Canadian Museum of Civilization, University of Victoria, Commonwealth Association of Museums).

Brown, A. (2014), 'The Challenges of Accountability in a National Museum', *Museum Management and Curatorship*, 29, 311–26.

Bulpitt, J. (1983), *Territory and Power in the United Kingdom: An Interpretation* (Manchester, Manchester University Press).

Cairney, P. (2012), *Understanding Public Policy: Theories and Issues* (Basingstoke, Palgrave Macmillan).

Calhoun, C. (ed.) (1992), *Habermas and the Public Sphere* (Cambridge, MA, MIT Press).

Carswell, D. (2012), *The End of Politics and the Birth of iDemocracy* (London, Biteback).

Cerny, P. (2010), *Rethinking World Politics: A Theory of Transnational Neopluralism* (Oxford, Oxford University Press).

Chalmers, A. (1999), *What Is This Thing Called Science?* 3rd edn (Buckingham, Open University Press).

Chatterjee, H. & G. Noble (2013), *Museums, Health and Well-Being* (Farnham, Ashgate).

Cohen, M., J. March & J. Olsen (1972), 'A Garbage Can Model of Organizational Choice', *Administrative Science Quarterly*, 17, 1–25

Conlin, J. (2006), *The Nation's Mantelpiece: A History of the National Gallery* (London, Pallas Athene).

Conn, S. (1998), *Museums and American Intellectual Life, 1876–1926* (Chicago, University of Chicago Press).

Crooke, E. (2007), *Museums and Community: Ideas, Issues and Challenges* (Abingdon, Routledge).

Cunningham, J. & B. Harney (2012), *Strategy and Strategists* (Oxford, Oxford University Press).

Cuno, J. (2011), *Museums Matter: In Praise of the Encyclopedic Museum* (Chicago, University of Chicago Press).

Dahl, R. (1998), *On Democracy* (New Haven, CT, Yale University Press).

DCMS (2014), *Annual Report and Accounts, 2013–14* (London, Department for Culture, Media and Sport).

Desvallées, A. & F. Mairesse (eds) (2010), *Key Concepts of Museology* (Paris, Armand Colin).

Dewdney, A., D. Dibosa & V. Walsh (2012), 'Cultural Diversity: Politics, Policy and Practices. The Case of Tate Encounters', 114–24 in R. Sandell & E. Nightingale (eds), *Museums, Equality and Social Justice* (Abingdon, Routledge).

Dewdney, A., D. Dibosa & V. Walsh (2013), *Post-Critical Museology: Theory and Practice in the Art Museum* (Abingdon, Routledge).

Diakhate, L. (2011), 'Museum Ethics, Missing Voices and the Case of the Tropical Houses', *Museum Management and Curatorship*, 26, 177–95.

Diesing, P. (1962), *Reason in Society: Five Types of Decision and Their Social Conditions* (Urbana, University of Illinois Press).

DiMaggio, P. (1981), 'Constructing an Organizational Field as a Professional Project: U.S. Art Museums, 1920–1940', 267–92 in W. Powell & P. DiMaggio (eds), *The New Institutionalism in Organizational Analysis* (Chicago, University of Chicago Press).

DiMaggio, P. & W. Powell (1991), 'The Iron Cage Revisited: Institutional Isomorphism and Collective Rationality in Organizational Fields', *American Sociological Review*, 48, 147–60.

Dorey, P. (2014), *Policy Making in Britain: An Introduction*, 2nd edn (London, Sage).

Downs, A. (1957), *An Economic Theory of Democracy* (New York, Harper & Row).

Downs, A. (1972), 'Up and Down with Ecology – The Issue Attention Cycle', *Public Interest*, 28, 38–50.

Duncan, C. (1995), *Civilizing Rituals: Inside Public Art Museums* (London, Routledge).

Duncan, C. & A. Wallach (1980), 'The Universal Survey Museum', *Art History*, 3, 448–69.

Easton, D. (1953), *The Political System* (New York, Knopf).

Easton, D. (1965), *A Systems Analysis of Political Life* (New York, John Wiley & Sons).

Ekman, M. (2012), 'Architecture for the Nation's Memory: History, Art, and the Halls of Norway's National Gallery', 144–56 in S. MacLeod, L. Hanks & J. Hale (eds), *Museum Making: Narratives, Architectures, Exhibitions* (Abingdon, Routledge).

Elder-Vass, D. (2010), *The Causal Power of Social Structures: Emergence, Structure and Agency* (Cambridge, Cambridge University Press).

Eling, K. (1999), *The Politics of Cultural Policy in France* (Basingstoke, Macmillan).

Elsner, J. & R. Cardinal (eds) (1994), *The Cultures of Collecting* (London, Reaktion Books).

Fahy, A. (ed.) (1995), *Collections Management* (London, Routledge).

Falk, J. & L. Dierking (2000), *Learning from Museums: Visitor Experiences and the Making of Meaning* (Walnut Creek, AltaMira Press).

Falk, J. & L. Dierking (2013), *The Museum Experience Revisited* (Walnut Creek, Left Coast Press).

Findlen, P. (1989), 'The Museum: Its Classical Etymology and Renaissance Genealogy', *Journal of the History of Collections*, 1, 59–78.

Finer, S. (1976), *The Man on Horseback: The Role of the Military in Politics*, 2nd edn (Harmondsworth, Penguin)

Finer, S. (1997), *The History of Government* (Oxford, Oxford University Press).

Fink, L. (2007), *A History of the Smithsonian American Art Museum: The Intersection of Art, Science, and Bureaucracy* (Amherst, University of Massachusetts Press).

Fopp, M. (1997), *Managing Museums and Galleries* (London, Routledge).

Fortey, R. (2008), *Dry Store Room Number 1: The Secret Life of the Natural History Museum* (London, Harper).

Foucault, M. (1977), *Discipline and Punish: The Birth of the Prison* (London, Allen Lane).

Foucault, M. (2002), 'Governmentality', 201–22 in J. Faubion (ed.), *Power: Essential Works of Foucault 1954–84*, vol. 3 (London, Penguin).

Frankel, B. (ed.) (1996), *Roots of Realism* (London, Frank Cass).

Frey, B. (2003), *Arts and Economics: Analysis and Cultural Policy*, 2nd edn (Berlin, Springer).

Friedson, E. (2001), *Professionalism: The Third Logic* (Cambridge, Polity).

Frumkin, P. & J. Galaskiewicz (2004), 'Institutional Isomorphism and Public Sector Organizations', *Journal of Public Administration Theory and Research*, 14, 283–307.

Fukuyama, F. (1992), *The End of History and the Last Man* (London, Penguin).

Fyfe, G. (1996), 'A Trojan Horse at the Tate: Theorizing the Museum as Agency and Structure', 203–28 in S. Macdonald & G. Fyfe (eds), *Theorizing Museums: Representing Identity and Diversity in a Changing World* (Oxford, Blackwell).

Galloway, S. & J. Stanley (2004), 'Thinking Outside the Box: Galleries, Museums and Evaluation', *Museum and Society*, 2, 30–46.

Garland, D. (1990), *Punishment and Modern Society: A Study* (Oxford, Clarendon Press).

Garud, R. & A. Van de Ven (2002), 'Strategic Change Processes', 206–31 in A. Pettigrew, H. Thomas & R. Whittington (eds), *Handbook of Strategy and Management* (London, Sage).

Gibson, L. (2008), 'In Defence of Instrumentality', *Cultural Trends*, 17, 247–57.

Gieryn, T. (1998), 'Balancing Acts: Science, *Enola Gay* and History Wars at the Smithsonian', 197–228 in S. Macdonald (ed.), *The Politics of Display: Museums, Science, Culture* (Abingdon, Routledge).

Gilmore, A. & R. Rentschler (2002), 'Changes in Museum Management: A Custodial or Marketing Emphasis?' *Journal of Management Development*, 21, 745–60.

Goldfarb, J. (2012), *Reinventing Political Culture: The Power of Culture versus the Culture of Power* (Cambridge, Polity).

Golding, V. (2007), 'Learning at the Museum Frontiers: Democracy, Identity and Difference', 315–29 in S. Knell, S. MacLeod & S. Watson (eds), *Museum Revolutions: How Museums Change and Are Changed* (Abingdon, Routledge).

Gonzalez, P. (2015), 'Museums in Revolution: Changing National Narratives in Revolutionary Cuba between 1959 and 1990', *International Journal of Heritage Studies*, 21, 264–79.

Goodnow, K. & H. Akman (eds) (2008), *Scandinavian Museums and Cultural Diversity* (Oxford, Berghahn Books).

Gramsci, A. (1971), *Selections from the Prison Notebooks of Antonio Gramsci*, ed. Q. Hoare & G. Smith (London, Lawrence and Wishart).

Grant, W. (2000), *Pressure Groups and British Politics* (Basingstoke, Macmillan).

Gray, C. (1994), *Government Beyond the Centre* (Basingstoke, Macmillan).

Gray, C. (2000), *The Politics of the Arts in Britain* (Basingstoke, Macmillan).

Gray, C. (2002), 'Local Government and the Arts', *Local Government Studies*, 28 (1), 77–90.

Gray, C. (2007), 'Commodification and Instrumentality in Cultural Policy', *International Journal of Cultural Policy*, 13, 203–15.

Gray, C. (2008), 'Instrumental Policies: Causes, Consequences, Museums and Galleries', *Cultural Trends*, 17 (4), 209–22.

Gray, C. (2009), 'Managing Cultural Policy: Prospects and Pitfalls', *Public Administration*, 87, 574–85.

Gray, C. (2010), 'Analysing Cultural Policy: Incorrigibly Plural or Ontologically Incompatible?' *International Journal of Cultural Policy*, 16, 215–30.

Gray, C. (2011), 'Museums, Galleries, Politics and Management', *Public Policy and Administration*, 26, 45–61.

Gray, C. (2014), ' "Cabined, Cribbed, Confined, Bound in" or "We Are Not a Government Poodle": Structure and Agency in Museums and Galleries', *Public Policy and Administration*, 29, 185–203.

Gray, C. & M. Wingfield (2010), 'Are Governmental Culture Departments Important? An Empirical Investigation', *International Journal of Cultural Policy*, 17, 590–604.

Greenfield, J. (2007), *The Return of Cultural Treasures*, 3rd edn (Cambridge, Cambridge University Press).

Greenwood, T. (1888 [1996]), *Museums and Art Galleries* (London, Routledge/Thoemmes Press).

Gulliford, A. (2007), 'Bones of Contention: The Repatriation of Native American Human Remains', 284–91 in S. Knell (ed.), *Museums in the Material World* (Abingdon, Routledge).

Habermas, J. (1991), *The Structural Transformation of the Public Sphere: An Inquiry into a Category of Bourgeois Society* (Cambridge, MA, MIT Press).

Hall, P (1986), *Governing the Economy: The Politics of State Intervention in Britain and France* (Cambridge, Polity).

Handler, R. (1985), 'On Having a Culture: Nationalism and the Preservation of Quebec's Patrimoine', 192–217 in G. Stocking (ed.), *Objects and Others: Essays on Museums and Material Culture* (Madison, University of Wisconsin Press).

Hanks, L. (2012), 'Writing Spatial Stories: Textual Narratives in the Museum', 21–33 in S. MacLeod, L. Hanks & J. Hale (eds), *Museum Making: Narratives, Architectures, Exhibitions* (Abingdon, Routledge).

Harrison, J. (1993), 'Ideas of Museums in the 1990s', *Museum Management and Curatorship*, 13, 160–76.

Harrison, R. (2013), *Heritage: Critical Approaches* (Abingdon, Routledge).

Harrison, R. & L. Hughes (2010), 'Heritage, Colonialism and Postcolonialism', 234–69 in R. Harrison (ed.), *Understanding the Politics of Heritage* (Manchester, Manchester University Press/Open University).

Hatton, A. (2012), 'The Conceptual Roots of Modern Museum Management Dilemmas', *Museum Management and Curatorship*, 27, 129–47.

Hayward, J. (1983), *Governing France: The One and Indivisible Republic*, 2nd edn (London, Weidenfeld and Nicolson).

Hearn, J. (2012), *Theorizing Power* (Basingstoke, Palgrave Macmillan).

Hein, G. (1998), *Learning in the Museum* (London, Routledge).

Held, D. & A. McGrew (2007), *Globalization and Anti-Globalization: Beyond the Great Divide*, 2nd edn (Cambridge, Polity).

Held, D., A. McGrew, D. Goldblatt & J. Perraton (1999), *Global Transformations: Politics, Economics and Culture* (Cambridge, Polity).

Hill, K. (2005), *Culture and Class in English Public Museums, 1850–1914* (Aldershot, Ashgate).

Hill, M. (2009), *The Public Policy Process*, 5th edn (Harlow, Pearson).

Hill, R. (2007), 'Regenerating Identity: Repatriation and the Indian Frame of Mind', 313–23 in S. Watson (ed.), *Museums and Their Communities* (Abingdon, Routledge).

Hindess, B. (1996), *Discourses of Power: From Hobbes to Foucault* (Oxford, Blackwell).

Hindmoor, A. (2006), *Rational Choice* (Basingstoke, Palgrave Macmillan).

Hobbes, T. (1997 [1651]), *Leviathan* (New York, W. W. Norton).

Holmes, K. & A. Hatton (2008), 'The Low Status of Management within the UK Museums Sector', *Museum Management and Curatorship*, 23, 111–17.

Hood, C. (2006), 'Gaming in Targetworld: The Targets Approach to Managing British Public Services', *Public Administration Review*, 66, 515–21.

Hooper-Greenhill, E. (1991), *Museum and Gallery Education* (Leicester, Leicester University Press).

Hooper-Greenhill, E. (1992), *Museums and the Shaping of Knowledge* (London, Routledge).

Hooper-Greenhill, E. (1997), *Cultural Diversity: Developing Museum Audiences in Britain* (London, Leicester University Press).

Hooper-Greenhill, E. (2000), *Museums and the Interpretation of Visual Culture* (Abingdon, Routledge).

Hooper-Greenhill, E. (2007), *Museums and Education: Purpose, Pedagogy, Performance* (Abingdon, Routledge).

Hughes, P. (2010), *Exhibition Design* (London, Laurence King).

Hunter, J. (1991), *Culture Wars: The Struggle to Define America* (New York, Basic Books).

ICOM (2013), *Museum Definition* (available at: http://icom.museum/the-vision/museum-definition/ accessed 25 February 2015).

Illich, I., I. Zola, J. McKnight, J. Caplan & H. Shaiken (1977), *Disabling Professions* (London, Marion Boyars).

Janes, R. (2007), 'Museums, Corporatism and the Civil Society', *Curator*, 5, 219–37.

Janes, R. (2009), *Museums in a Troubled World: Renewal, Irrelevance or Collapse?* (Abingdon, Routledge).

Janes, R. (2013), *Museums and the Paradox of Change: A Case Study in Urgent Adaptation*, 3rd edn (Abingdon, Routledge).

Jensen, E. (2013), 'Reconsidering *The Love of Art*: Evaluating the Potential of Art Museum Outreach', *Visitor Studies*, 16, 144–59.

Johnson, C., T. Dowd & C. Ridgeway (2006), 'Legitimacy as a Social Process', *Annual Review of Sociology*, 32, 53–78.

Johnson, T. (1972), *Professions and Power* (London, Macmillan).

Jones, A. (2007), *Britain and the European Union* (Edinburgh, Edinburgh University Press).

Jones, I., R. Macdonald & D. McIntyre (eds) (2008), *City Museums and City Development* (Plymouth, AltaMira Press).

Kaluza, K. (2011), 'Reimagining the Nation in Museums: Poland's Old and New National Museums', 151–62 in S. Knell et al. (eds), *National Museums: New Studies from around the World* (Abingdon, Routledge).

Kearney, A. (2009), 'Intangible Cultural Heritage: Global Awareness and Local Interest', 209–25 in L. Smith & N. Akagawa (eds), *Intangible Heritage* (Abingdon, Routledge).

Kingdon, J. (1984), *Agendas, Alternatives and Public Policies* (Boston, Little, Brown).

Kiwan, N (2007), 'When the Cultural and the Social Meet: A Critical Perspective on Socially Embedded Cultural Policy in France', *International Journal of Cultural Policy*, 13, 153–67.

Knell, S. (2011), 'National Museums and the National Imagination', 3–28 in S. Knell et al. (eds), *National Museums: New Studies From Around the World* (Abingdon, Routledge).

Knell, S., P. Aronsson, A. Amundsen, A. Barnes, S. Burch, J. Carter, S. Hughes & A. Kirwan (eds) (2011), *National Museums: New Studies from around the World* (Abingdon, Routledge).

Knell, S. (ed.) (1994), *Care of Collections* (London, Routledge).

Knell, S. (ed.) (2007), *Museums in the Material World* (Abingdon, Routledge).

S. Knell, S. MacLeod & S. Watson (eds) (2007), *Museum Revolutions: How Museums Change and Are Changed* (Abingdon, Routledge).

Koppell, J. (2005), 'Pathologies of Accountability: ICANN and the Challenge of "Multiple Accountabilities Disorder" ', *Public Administration Review*, 65 (1), 94–108.

Kovach, C. (1989), 'Strategic Management for Museums', *Museum Management and Curatorship*, 8, 137–48.

Krejci, J. (1983), *Great Revolutions Compared: The Search for a Theory* (Brighton, Wheatsheaf).

Lanoszka, A. (2009), *The World Trade Organization: Changing Dynamics in the Global Political Economy* (Boulder, CO, Lynne Rienner).

Law, K. (2014), 'The Red Line Over European Colonialism: Comparison of the Macao Museum and Hong Kong Museum of History after Their Return to China', *International Journal of Heritage Studies*, 20, 534–55.

Lawley, C. (2003), 'Local Authority Museums and the Modernizing Government Agenda in England', *Museum and Society*, 1 (2), 75–86.

Lee, J. (2011), 'The National Museum as Palimpsest: Postcolonial Politics and the National Museum of Korea', 373–85 in S. Knell et al. (eds), *National Museums: New Studies from around the World* (Abingdon, Routledge).

Lindblom, C. (1959), 'The Science of Muddling Through', *Public Administration Review*, 19, 79–88.

Lipsky, M. (1980), *Street-Level Bureaucracy: Dilemmas of the Individual in Public Services* (New York, Russell Sage Foundation).

Lloyd, K. (2014), 'Beyond the Rhetoric of an "Inclusive National identity": Understanding the Potential Impact of Scottish Museums on Public Attitudes to Issues of Identity, Citizenship and Belonging in an Age of Migrations', *Cultural Trends*, 23, 148–58.

Lockyer, A. (2008), 'National Museums and Other Cultures in Modern Japan', 97–123 in D. Sherman (ed.), *Museums and Difference* (Bloomington, Indiana University Press).

Looseley, D. (1995), *The Politics of Fun: Cultural Policy and Debate in Contemporary France* (Oxford, Berg).

Looseley, D. (2005), 'The Return of the Social: Thinking Postcolonially About French Cultural Policy', *International Journal of Cultural Policy*, 11, 145–55.

Lord, B. (ed.) (2007), *The Manual of Museum Learning* (Lanham, AltaMira Press).

Lord, B. (2014), 'The Purpose of Museum Exhibitions', 7–21 in B. Lord & M. Piacente (eds), *Manual of Museum Exhibitions*, 2nd edn (Lanham, Rowman & Littlefield).

Lorente, P. (1996), 'Museums as Catalysts for the Revitalisation of Ports in Decline: Lessons from Liverpool and Marseilles', 36–60 in P. Lorente (ed.), *The Role of Museums and the Arts in the Urban Regeneration of Liverpool* (Leicester, Centre for Urban History, University of Leicester).

Lovell, R. (1994), 'Gaining Support', 40–47 in R. Lovell (ed.), *Managing Change in the New Public Sector* (Harlow, Longman).

Lowndes, V., L. Pratchett & G. Stoker (2006), 'Local Political Participation: The Impact of Rules-in-Use', *Public Administration*, 84, 539–61.

Luke, T. (2002), *Museum Politics: Power Play at the Exhibition* (Minneapolis, University of Minnesota Press).

Lukes, S. (1986), 'Introduction', 1–18 in S. Lukes (ed.), *Power* (Oxford, Blackwell).

Lukes, S. (2005), *Power: A Radical View*, 2nd edn (Basingstoke, Palgrave Macmillan).

Lynn, L. (2005), 'Public Management: A Concise History of the Field', 27–50 in E. Ferlie, L. Lynn & C. Pollitt (eds), *The Oxford Handbook of Public Management* (Oxford, Oxford University Press).

McCall, V. (2009), 'Social Policy and Cultural Policies: A Study of Scottish Border Museums as Implementers of Social Inclusion', *Social Policy and Society*, 8, 319–31.

McCall, V. & C. Gray (2014), 'Museum Policies and the "New" Museology: Theory, Practice and Organizational Change', *Museum Management and Curatorship*, 29, 19–35.

McClellan, A. (1994), *Inventing the Louvre: Art, Politics and the Origins of the Modern Museum in Eighteenth-Century Paris* (Cambridge, Cambridge University Press).

McCormick, J. (2011), *European Union Politics* (Basingstoke, Palgrave Macmillan).

Macdonald, S. (1998) (ed.), *The Politics of Display: Museums, Science, Culture* (London, Routledge).

Macdonald, S. (2002), *Behind the Scenes at the Science Museum* (Oxford, Berg).

McGuigan, J. (2005), 'Neo-Liberalism, Culture and Policy', *International Journal of Cultural Policy*, 11, 229–41.

MacKenzie, J. (2009), *Museums and Empire: Natural History, Human Cultures and Colonial Identities* (Manchester, Manchester University Press).

McLean, F. (1998), 'Museums and the Construction of National Identity: A Review', *International Journal of Heritage Studies*, 3, 244–52.

McLeod, M. (2004), 'Museums without Collections: Museum Philosophy in West Africa', 52–61 in S. Knell (ed.), *Museums and the Future of Collecting*, 2nd edn (Farnham, Ashgate).

MacLeod, S. (2005), 'Rethinking Museum Architecture: Towards a Site-Specific History of Production and Use', 9–25 in S. MacLeod (ed.), *Reshaping Museum Space: Architecture, Design, Exhibitions* (Abingdon, Routledge).

MacLeod, S. (2013), *Museum Architecture: A New Biography* (Abingdon, Routledge).

McMaster, G. (2007), 'Museums and the Native Voice', 70–9 in G. Pollock & J. Zemans (eds), *Museums After Modernism: Strategies of Engagement* (Oxford, Blackwell).

Madden, C. (2005), 'Indicators for Arts and Cultural Policy: A Global Perspective', *Cultural Trends*, 14, 217–47.

Madden, C. & T. Bloom (2004), 'Creativity, Health and Arts Advocacy', *International Journal of Cultural Policy*, 10, 133–56.

Mann, M. (1986), *The Sources of Social Power: Vol. I A History of Power from the Beginning to AD 1760* (Cambridge, Cambridge University Press).

March, J. & J. Olsen (2006), 'Elaborating the "New Institutionalism"', 3–21 in R. Rhodes, S. Binder & B. Rockman (eds), *The Oxford Handbook of Political Institutions* (Oxford, Oxford University Press).

Martin, P. (1999), *Popular Collecting and the Everyday Self: The Reinvention of Museums?* (London, Leicester University Press).

Marx, K. (1973), 'The Eighteenth Brumaire of Louis Napoleon', 143–249 in *Surveys from Exile: Political Writings*, vol. 2 (Harmondsworth, Penguin).

Mason, R. (2005), 'Museums, Galleries and Heritage: Sites of Meaning-Making and Communication', 200–14 in G. Corsane (ed.), *Heritage, Museums and Galleries: An Introductory Reader* (Abingdon, Routledge).

Mason, R. (2007), *Museums, Nations, Identities: Wales and Its National Museums* (Cardiff, University of Wales Press).

Mathur, S. (2005), 'Museums and Globalization', *Anthropological Quarterly*, 78, 697–708.

May, E. & M. Jones (eds) (2006), *Conservation Science: Heritage Materials* (Cambridge, Royal Society of Chemistry).

Mead, S. (1983), 'Indigenous Models of Museums in Oceania', *Museum*, 138, 98–101.

Merriman, N. (2012), 'Transforming the University Museum: The Manchester Experience', 36–61 in S. Jandl & M. Gold (eds), *A Handbook for Academic Museums: Beyond Exhibitions and Education* (Edinburgh, MuseumsEtc).

Message, K. (2006), *New Museums and the Making of Culture* (Oxford, Berg).

Message, K. (2014), *Museums and Social Activism: Engaged Protest* (Abingdon, Routledge).

Middlemas, K. (1975), *The Double Market: Art Theft and Art Thieves* (Farnborough, Saxon House).

Mill, J. (1974 [1859]), *On Liberty* (Harmondsworth, Penguin).

Mintzberg, H. (1979), *The Structuring of Organizations* (Englewood Cliffs, Prentice-Hall).

Mintzberg, H. (1983), *Structure in Fives: Designing Effective Organizations* (Englewood Cliffs, Prentice-Hall).

Moore, H. (2008), 'The Problem of Culture', 21–28 in D. Held & H. Moore (eds), *Cultural Politics in a Global Age: Uncertainty, Solidarity and Innovation* (Oxford, Oneworld).

Moore, K. (1994), *Museum Management* (London, Management).

Morcol, G. (2012), *A Complexity Theory for Public Policy* (New York, Routledge).

Morgan, G. (2006), *Images of Organization* (updated edn, Thousand Oaks, CA, Sage).

Morriss, P. (2002), *Power: A Philosophical Analysis*, 2nd edn (Manchester, Manchester University Press).

Moses, J. & T. Knutsen (2007), *Ways of Knowing: Competing Methodologies in Social and Political Research* (Basingstoke, Palgrave Macmillan).

Mueller, D. (2003), *Rational Choice III* (Cambridge, Cambridge University Press).

Mulcahy, K. (2006), 'Cultural Policy', 265–79 in B. Peters & J. Pierre (eds), *Handbook of Public Policy* (London, Sage).

Murray, D. (1996 [1904]), *Museums: Their History and Their Use* (London, Routledge/Thoemmes Press).

Nairne, S. (2011), *Art Theft and the Case of the Stolen Turners* (London, Reaktion).

Newman, A. (2013), 'Imagining the Social Impact of Museums and Galleries: Interrogating Cultural Policy through an Empirical Study', *International Journal of Cultural Policy*, 19, 120–37.

Newman, A. & F. McLean (1998), 'Heritage Builds Communities: The Application of Heritage Resources to the Problem of Social Exclusion', *International Journal of Heritage Studies*, 4 (3–4), 143–53.

Newman, A. & F. McLean (2002), 'Architectures of Inclusion: Museums, Galleries and Inclusive Communities', 56–68 in R. Sandell (ed.), *Museums, Society, Inequality* (London, Routledge).

Newman, A. & F. McLean (2004), 'Presumption, Policy and Practice: The Use of Museums and Galleries as Agents of Social Inclusion', *International Journal of Cultural Policy*, 10, 167–81.

Nisbett, M. (2013), 'New Perspectives on Instrumentalism: An Empirical Study of Cultural Diplomacy', *International Journal of Cultural Policy*, 19, 557–75.

Niskanen, W. (1971), *Bureaucracy and Representative Government* (Chicago, Aldine Atherton).

O'Hagan, J. (1998), *The State and the Arts: An Analysis of Key Economic Policy Issues in Europe and the United States* (Cheltenham, Edward Elgar).

O'Neill, M. (2004), 'Enlightenment Museums: Universal or Merely Global?' *Museum and Society*, 2, 190–202.

O'Neill, P. (2012), *The Culture of Curating and the Curating of Culture(s)* (Cambridge, MA, MIT Press).

Parry, G. (2005 [1969]), *Political Elites* (Colchester, ECPR Press).

Parry, R. (2007), *Recoding the Museum: Digital Heritage and the Technologies of Change* (Abingdon, Routledge).

Parsons, T. (1937), *The Structure of Social Action* (New York, McGraw-Hill).

Parsons, T. (1951), *The Social System* (London, Routledge & Kegan Paul).

Parsons, W. (1995), *Public Policy: An Introduction to the Theory and Practice of Policy Analysis* (Aldershot, Edward Elgar).

Peacock, A. & I. Rizzo (2008), *The Heritage Game: Economics, Policy, and Practice* (Oxford, Oxford University Press).

Peacock, D. (2008), 'Making Ways for Change: Museums, Disruptive Technologies and Organisational Change', *Museum Management and Curatorship*, 23, 333–51.

Pearce, S. (ed.) (1994), *Interpreting Objects and Collections* (London, Routledge).

Peele, G. (2004), *Governing the UK: British Politics in the 21st Century*, 4th edn (Oxford, Blackwell).

Peters, B. (2007), *American Public Policy: Promise and Performance*, 7th edn (Washington, CQ Press).

Peters, B. (2010), *The Politics of Bureaucracy: An Introduction to Comparative Public Administration*, 6th edn (Abingdon, Routledge).

Peters, B. (2012), *Institutional Theory in Political Science: The New Institutionalism*, 3rd edn (New York, Continuum).

Pickering, M. (2007), 'Where to from Here?: Repatriation of Indigenous Human Remains and "The Museum" ', 250–59 in S. Knell, S. MacLeod & S. Watson (eds), *Museum Revolutions: How Museums Change and Are Changed* (Abingdon, Routledge).

Pollitt, C. & G. Bouckaert (2011), *Public Management Reform: A Comparative Analysis: New Public Management, Governance and the Neo-Weberian State*, 3rd edn (Oxford, Oxford University Press).

Pollock, G. (2007), *Encounters in the Virtual Feminist Museum: Time, Space and the Archive* (Abingdon, Routledge).

Poulot, D. (2009), *Musée et Muséologie* (Paris, La Découverte).

Pressman, J. & A. Wildavsky (1973), *Implementation: Or, How Great Expectations in Washington are Dashed in Oakland* (Berkeley, University of California Press).

Preziosi, D. (2011), 'Myths of Nationality', 55–66 in S. Knell et al. (eds), *National Museums: New Studies from around the World* (Abingdon, Routledge).

Prosler, M. (1996), 'Museums and Globalization', 21–40 in S. Macdonald & G. Fyfe (eds), *Theorizing Museums* (Oxford, Blackwell).

Prott, L (ed.) (2009), *Witnesses to History: A Compendium of Documents and Writing on the Return of Cultural Objects* (Paris, UNESCO).

Radnor, Z. (2008), 'Muddled, Massaging, Manoeuvring or Manipulated? A Typology of Organisational Gaming', *International Journal of Productivity and Performance Management*, 57, 316–28.

Rentschler, R. & A. Hede (2007), *Museum Marketing: Competing in the Global Marketplace* (Oxford, Butterworth-Heinemann).

Robbins, N. (2011), 'Disposals Protected by Values: Museums as Owners of the Process', 490–503 in P. Davies (ed.), *Museums and the Disposals Debate: A Collection of Essays* (Edinburgh, Museums).

Robinson, W. (2012), 'Global Capitalism Theory and the Emergence of Transnational Elites', 54–73 in A. Kakabadse & N. Kakabadse (eds), *Global Elites: The Opaque Nature of Transnational Policy Determination* (Basingstoke, Palgrave Macmillan).

Roskin, M. & N. Berry (2015), *IR: The New World of International Relations*, 10th edn (Boston, Pearson).

Ross, W. (1960), 'Story of a Scottish Museum', *Public Administration*, 38, 381–85.

Royseng, S. (2008), *The Ritual Logic of Cultural Policy* (Paper to the 5th International Conference on Cultural Policy Research, Istanbul).

Runnel, P., T. Tatsi & P. Pruulmann-Vengerfeldt (2011), 'Who Authors the Nation?: The Debate Surrounding the Building of the New Estonian National Museum', 325–38 in S. Knell et al. (eds), *National Museums: New Studies from around the World* (Abingdon, Routledge).

Rushefsky, M. (2008), *Public Policy in the United States at the Dawn of the Twenty-First Century*, 4th edn (Armonk, NY, M. E. Sharpe).

Sabatier, P. & H. Jenkins-Smith (1999), 'The Advocacy Coalition Framework: An Assessment', 117–66 in P. Sabatier (ed.), *Theories of the Policy Process* (Boulder, CO, Westview).

Saint-Martin, D. & C. Allison (2011), 'Rationalism and Public Policy: Mode of Analysis or Symbolic Politics?' *Policy and Society*, 30, 19–27.

Sandell, R. (1998), 'Museums as Agents of Social Inclusion', *Museum Management and Curatorship*, 17, 401–18.

Sandell, R. & E. Nightingale (eds) (2012), *Museums, Equality and Social Justice* (Abingdon, Routledge).

Schattschneider, E. (1960), *The Semi-Sovereign People: A Realist's View of Democracy in America* (London, Holt, Rinehart & Winston).

Sharenkova, R. (2011), 'After the Fall of the Berlin Wall: Nationalism and Multiculturalism at the Bulgarian National Ethnographic Museum', 418–28 in S. Knell et al. (eds), *National Museums: New Studies from around the World* (Abingdon, Routledge).

Shaw, G. (1911 [1946]), *The Doctor's Dilemma* (London, Penguin).

Shelby, K. (2014), *Flemish Nationalism in the Great War: The Politics of Memory, Visual Culture and Commemoration* (Basingstoke, Palgrave Macmillan).

Sherman, D. (1989), *Worthy Monuments: Art Museums and the Politics of Culture in Nineteenth-Century France* (Cambridge, MA, Harvard University Press).

Sherman, D. (ed.) (2008), *Museums and Difference* (Bloomington, Indiana University Press).

Simpson, M. (2007), 'Charting the Boundaries: Indigenous Models and Parallel Practices in the Development of the Post-Museum', 235–49 in S. Knell, S. MacLeod & S. Watson (eds), *Museum Revolutions: How Museums Change and are Changed* (Abingdon, Routledge).

Singh, K. (2009), 'Universal Museums: The View from Below', 123–29 in L. Prott (ed.), *Witnesses to History: A Compendium of Documents and Writing on the Return of Cultural Objects* (Paris, UNESCO).

Singh, S. (2011), *United Nations Educational, Scientific and Cultural Organization (UNESCO): Creating Norms for a Complex World* (Abingdon, Routledge).

Skocpol, T. (1994), *Social Revolutions in the Modern World* (Cambridge, Cambridge University Press).

Smith, A. (1971), *Theories of Nationalism* (London, Duckworth).

Smith, A. (1995), *Nations and Nationalism in a Global Era* (Cambridge, Polity).

Smith, A. (1999), *Myths and Memories of the Nation* (Oxford, Oxford University Press).

Smith, L. (2004), *Archaeological Theory and the Politics of Cultural Heritage* (Abingdon, Routledge).

Smith, L. (2006), *Uses of Heritage* (Abingdon, Routledge).

Stam, D. (1993), 'The Informed Muse: The Implications of "The New Museology" for Museum Practice', *Museum Management and Curatorship*, 12, 267–83.

Steans, J. & L. Pettiford (2001), *International Relations: Perspectives and Themes* (Harlow, Pearson).

Su, X. & P. Teo (2009), *The Politics of Heritage Tourism in China: A View from Lijiang* (Abingdon, Routledge).

Sully, D. (2007), 'Colonising and Conservation', 27–43 in D. Sully (ed.), *Decolonising Conservation: Caring for Maori Meeting Houses Outside New Zealand* (Walnut Creek, West Coast Press).

Swinbank, A. (2005), 'The Challenge of the Agriculture Trade Negotiations in the WTO Doha Round', 87–108 in N. Perdikis & R. Read (eds), *The WTO and the Regulation of International Trade: Recent Trade Disputes between the European Union and the United States* (Cheltenham, Edward Elgar).

Sylvester, C. (2009), *Art/Museums: International Relations Where We Least Expect It* (Boulder, CO, Paradigm Press).

Thompson, G. (2003), 'Public Control of Museums in New Zealand and the United Kingdom: Implications for Entrepreneurship', *Journal of Arts Management, Law and Society*, 33, 228–39.

Thornhill, A., P. Lewis, M. Millmore & M. Saunders (2000), *Managing Change: A Human Resource Strategy Approach* (Harlow, Pearson).

Timothy, D. (2011), *Cultural Heritage and Tourism: An Introduction* (Britsol, Channel View).

Tlili, A. (2008), 'Behind the Policy Mantra of the Inclusive Museum: Receptions of Social Exclusion and Inclusion in Museums and Science Centres', *Cultural Sociology* 2, 123–47.

True, J., B. Jones & F. Baumgartner (2007), 'Punctuated-Equilibrium Theory: Explaining Stability and Change in Public Policymaking', 155–87 in P. Sabatier (ed.), *Theories of the Policy Process*, 2nd edn (Boulder, CO, Westview Press).

Tullock, G. (1965), *The Politics of Bureaucracy* (Boston, University Press of America).

UNESCO (2003), *Convention for the Safeguarding of the Intangible Cultural Heritage* (Paris, UNESCO).

Varutti, M. (2014), *Museums in China: The Politics of Representation after Mao* (Woodbridge, Boydell).

Vergo, P. (ed.) (1989), *The New Museology* (London, Reaktion Books).

Vestheim, G. (1994), 'Instrumental Cultural Policy in Scandinavian Countries: A Critical Historical Perspective', *European Journal of Cultural Policy*, 1, 57–71.

Viotti, P. & M. Kauppi (2010), *International Relations Theory*, 4th edn (New York, Longman).

Wan-Chen, C. (2012), 'A Cross-Cultural Perspective on Musealization: The Museum's Reception by China and Japan in the Second Half of the Nineteenth Century', *Museum and Society*, 10, 15–27.

Watson, S. (2007), 'History Museums, Community Identities and a Sense of Place: Rewriting Histories', 160–72 in S. Knell, S. MacLeod & S. Watson (eds), *Museum Revolutions: How Museums Change and Are Changed* (Abingdon, Routledge).

Watson, S. (2015), 'Communities and Museums: Equal Partners?' 228–45 in R. Silverman (ed.), *Museum as Process: Translating Local and Global Knowledges* (Abingdon, Routledge).

Weber, M. (1978), *Economy and Society: An Outline of Interpretive Sociology* (Berkeley, University of California Press).

West, C. & C. Smith (2005), ' "We Are Not a Government Poodle": Museums and Social Inclusion under New Labour', *International Journal of Cultural Policy*, 11, 275–88.

Whitehead, C. (2009), *Museums and the Construction of Disciplines: Art and Archaeology in Nineteenth-Century Britain* (London, Duckworth).

Wilson, D. (2002), *The British Museum: A History* (London, British Museum).

Winter, T. (2014), 'Beyond Eurocentrism? Heritage Conservation and the Politics of Difference', *International Journal of Heritage Studies*, 20, 123–37.

Witcomb, A. (2003), *Re-Imagining the Museum: Beyond the Mausoleum* (London, Routledge).

Witz, A. (1992), *Professions and Patriarchy* (London, Routledge).

Zahariadis, N. (2007)., 'The Multiple Streams Framework: Structure, Limitations, Prospects', 65–92 in P. Sabatier (ed.), *Theories of the Policy Process*, 2nd edn (Boulder, CO, Westview).

Zhdanov, A. (1950), *On Literature, Music and Philosophy* (London, Lawrence & Wishart).

Zittoun, P. (2014), *The Political Process of Policymaking: A Pragmatic Approach to Public Policy* (Basingstoke, Palgrave Macmillan).

Zolberg, V. (1996), 'Museums as Contested Sites of Remembrance: the Enola Gay Affair', 69–82 in S. Macdonald & G. Fyfe (eds), *Theorizing Museums* (Oxford, Blackwell).

Index

accountability, 22, 27, 44, 104,
114–15, 121, 133, 157, 169
agency/agents, 11, 22, 43, 80, 83,
93, 120, 122, 123, 136, 145,
160, 168
arm's-length, 68, 100, 107, 116,
153, 162
attachment, 68, 93, 99, 167

British Museum, 74, 87, 89, 107,
111, 129

collections, 1, 4, 5, 6, 7, 17, 29, 30, 34,
40, 51, 52–4, 56, 57, 65, 66, 87,
88–90, 94, 97, 98, 103, 109, 122,
126, 127, 128–31, 132, 134, 142,
152, 156, 166, 168
colonialism/neo-colonialism/post-
colonialism, 1, 27, 30, 31, 40, 51,
52, 56, 59, 64, 85, 102, 122, 165
communities, 1, 7, 12, 13, 15, 19, 22,
27, 30, 34, 36, 39, 40, 41, 43, 48,
49, 51, 52, 54, 56, 59, 62, 69, 86,
105, 114, 120, 121, 122, 124,
126–7, 131, 134–9, 140, 141–9,
153, 156, 164, 165
conservation, 1, 4, 6, 29, 30–1, 34, 39,
57, 61, 94, 115, 120, 146
conservators, 2, 25, 30, 123, 157
culture, 12, 14, 15, 16, 18, 23, 29, 53,
62, 71, 145, 166
curator/s, 2, 21, 22, 25, 30, 40, 48, 68,
97, 98, 110, 123–4, 127, 157

depoliticisation, 10, 34, 62, 102, 120,
146, 147, 155
see also politicisation
display, 4, 6, 17, 21, 23, 29, 40, 49, 52,
56, 62, 65, 66, 67, 68, 69, 81,
82–3, 84, 86, 90, 97–8, 122,
124–5, 126–8, 130, 133, 134–5,
141–2, 144, 146, 152, 166

education, 2, 4, 5–6, 12, 22, 24, 27, 30,
37, 61, 74, 81, 83–4, 91, 93, 97,
98, 110, 113, 115, 120, 123, 124,
126, 132, 135, 143, 146,
150–1, 157
exhibition, 4, 8, 17, 21, 23, 29, 48, 49,
52, 56, 65, 66, 68, 82–3, 86, 90,
106, 120, 124–5, 126–7, 130, 131,
134, 141, 152

functions, 3–8, 12, 19, 27, 32, 33, 34,
35, 36, 37, 50, 51, 53, 55, 56–7,
61, 63, 64, 65–9, 70–1, 77, 78, 81,
85, 86, 89–96, 101, 104, 107, 109,
110, 113–14, 115, 117, 119, 120,
123, 124, 126, 127, 130, 131, 132,
133, 135, 141, 142, 144, 150,
151, 153
funding/expenditure, 16, 24, 45, 68,
70, 72–8, 108, 125, 143

globalisation, 1, 26, 30, 31, 41, 42–51,
55, 64
government/s, 2, 11, 12, 16, 18, 19,
21, 24, 27, 33, 36, 37, 38, 39, 40,
55, 59, 67, 68, 70–7, 81, 82, 89,
90–1, 92, 93–7, 99, 101, 114, 133,
140, 143
groups, 2, 6, 7, 8, 9, 11, 18, 19, 21, 23,
29, 32, 36, 38, 39, 40, 47, 48, 49,
51, 55, 57, 58, 59, 60, 61, 62, 67,
69, 80, 85, 86, 99, 105, 108, 109,
110, 112, 113, 114, 118, 119, 126,
129, 130, 131, 132, 133, 134,
136–9, 144–5, 146, 148, 154, 158,
163, 165, 166, 168, 169, 170
Guggenheim, 45, 49, 89, 90

health, 27, 55, 74, 126, 151, 158

ICOM, 5, 6, 26, 33, 38, 50, 56, 62, 85,
120, 123, 139, 153, 154, 159, 160,
161, 162, 165

CPI Antony Rowe
Eastbourne, UK
December 05, 2019